KT-198-605

LIVING ROOM WARS

Living Room Wars brings together Ien Ang's recent writings on media audiences to ask what it means to live in a world saturated by media. What does our media audiencehood say about our everyday lives and social relations, and how does it illuminate the condition of contemporary culture?

Ang suggests that we cannot understand media audiences without deconstructing the category of 'audience' itself as an institutional and discursive construct. Her accessible style throws light on some of the complexities of media consumption in a postmodern world, including those related to gender politics and the globalization of culture.

Living Room Wars points to the inherently contradictory nature of the media's role in shaping our identities, fantasies and pleasures, imbricated as they are in the exigencies of capitalist consumption and the institutions of the modern nation-state. *Living Room Wars* presents an indispensable tool for bridging audience studies, media studies and the larger concerns of cultural studies.

Ien Ang is Professor of Cultural Studies at the University of Western Sydney, Nepean, Australia. She is the author of *Watching Dallas* (1985) and *Desperately Seeking the Audience* (1991).

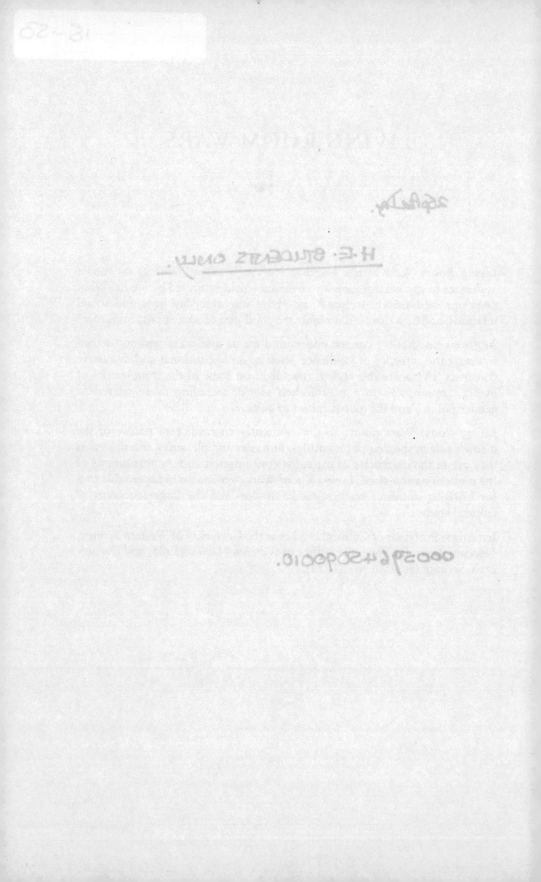

LIVING ROOM WARS

Rethinking media audiences for a
postmodern world

Ien Ang

First published 1996
by Routledge
11 New Fetter Lane, London EC4P 4EE

Simultaneously published in the USA and Canada
by Routledge
29 West 35th Street, New York, NY 10001

Reprinted in 1996

© 1996 Ien Ang

Typeset in Linotype Sabon by
Ponting–Green Publishing Services, Chesham, Bucks
Printed and bound in Great Britain by
Clays Ltd, St Ives plc

British Library Cataloguing in Publication Data
A catalogue record for this book is available from the
British Library

Library of Congress Cataloguing in Publication Data
A catalogue record for this book is available from the Library
of Congress

ISBN 0–415–12800–5 (hbk)
ISBN 0–415–12801–3 (pbk)

Contents

v

CONTENTS

Acknowledgements

This book feels like the end of an era for me: the finishing touch of some ten years work in the field of audience studies. Most essays collected in this book are slightly revised and updated versions of previously published material. I would like to thank the following publishers and journals for the kind permission they gave to reprint this material here:

- Chapter 1 was first published under the title 'The Battle between Television and Its Audiences: The Politics of Watching Television', in Philip Drummond and Richard Paterson (eds), *Television in Transition*, British Film Institute, London, 1985.
- Chapter 2 was first published as 'Wanted: Audiences. On the Politics of Empirical Audience Studies', in Ellen Seiter, Hans Borchers, Gabriele Kreutzner and Eva Maria Warth (eds), *Remote Control: Television Audiences and Cultural Power*, Routledge, London, 1989.
- Chapter 3 was first published as 'Living Room Wars: New Technologies, Audience Measurement, and the Tactics of Television Consumption', in Roger Silverstone and Eric Hirch (eds), *Consuming Technologies*, Routledge, London, 1992.
- Chapter 4 was first presented as a paper at the conference 'Towards a Comprehensive Theory of the Audience?', held at the University of Illinois at Urbana-Champaign in 1990, and will be published in James Hay, Lawrence Grossberg and Ellen Wartella (eds), *The Audience and Its Landscape*, Westview Press, Boulder, Co. I thank James Hay for permission to publish this essay in this collection.
- Chapter 5 was first published in Mary-Ellen Brown (ed.), *Television and Women's Culture*, Currency Press, Sydney, 1990.
- Chapter 6 was first published in *Camera Obscura*, no. 16, January 1988. I thank Indiana University Press for permission to reprint.
- Chapter 7 was first published in James Curran and Michael Gurevitch (eds), *Mass Media and Society*, Edward Arnold, London, 1991. I thank Edward Arnold and my co-author Joke Hermes for agreeing to have this essay included in this collection.

- Chapter 8 was first published under the title 'Culture and Communication: Towards an Ethnographic Critique of Media Consumption in the Transnational Media Age', in the *European Journal of Communication*, vol. 5, no. 2–3, June 1990. I thank Sage Publications for granting me permission to republish.
- Chapter 9 is a much expanded version of an article first published under the same title in *Media Information Australia*, no. 62, November 1991.
- Chapter 10 was first published in David Crowley and David Mitchell (eds), *Communication Theory Today*, Polity Press, Oxford, 1994.

This work has evolved over a long period of time, during which many people have given me support and help. Without naming them, I want to thank them all. I wish, however, to express my special gratitude to Charlotte Brunsdon and David Morley for their longstanding and continuous camaraderie and friendship, even now that I have moved to the other side of the globe, from the 'heart' of Europe – Amsterdam – to the 'end' of the world – Perth, Australia.

I would like to thank Murdoch University for offering me a Special Research Grant in 1993. My special thanks also to the School of Humanities at Murdoch for providing me with an exceptionally stimulating academic environment and for the SHRAF grant, which provided me with research assistance to finish this project. I thank Paula O'Brien for her diligent work in preparing the manuscript. Within the Communication Studies programme, I thank Irma Whitford and Alec McHoul for being such supportive and appreciative programme chairs, Tom O'Regan for the long conversations on Australian television and many other things, Dona Kolar-Panov for being the best tutor a course coordinator could hope for, and Merrylyn Braden for the warm secretarial assistance. For the all-important comprehensive feminine life-support, both intellectual and emotional, I thank Zoë Sofoulis, Krishna Sen and, especially, Mitzi Goldman. My final thanks go to Jon Stratton, from whose insights I have learned more than is imaginable.

Fremantle, January 1995

Introduction: media audiences, postmodernity and cultural contradiction

The essays collected in this book have been written in the course of a decade – a decade which has been characterized by irrevocable and accelerated postmodernization in many fields of social and cultural practice. Since the 1970s the discourse of postmodernity has gradually but definitively taken hold of the Western world. These essays bear the mark of this present mood and can be read as attempts to come to terms with some of its theoretical and practical implications. They do this with respect to a rather humble site of discursive knowledge: media audiences. In this Introduction, I will indicate how the postmodern – as a historical trend and as a mode of knowing – has impacted on (our understanding of) media audiences, especially television audiences. At the same time, I will also suggest how a critical theoretical and analytical engagement with audiences – which, as I have argued elsewhere (Ang 1991) and throughout the essays to follow, necessarily involves a deconstruction of the very unity and solidity of 'audience' as an object of analysis – can highlight and illuminate some of the consequences of what some have called 'the condition of postmodernity' (Lyotard 1984; Harvey 1989; Jameson 1991).

In the course of the 1980s, the label 'postmodern' to describe the world became virtually inescapable – that is, increasingly pertinent and widely accepted, a part of popular commonsense. I remember occasions, earlier in the decade, when those annoyed by the hype could still afford either to dismiss any talk about 'postmodernism' as a passing fad, or to reject the very notion of the postmodern as a vacuous, meaningless category. As the end of the century approaches this is clearly no longer possible: the implications of the so-called postmodernization of the contemporary world – economic, social, cultural – have become too insistent to ignore or refute, if still incompletely understood in its diverse, complex and contradictory facets. Dick Hebdige (1988: 182) has noted that as the 1980s wore on 'postmodern' has clearly become a buzzword with an enormous degree of semantic complexity and overload. But while many of us have by now become rather blasé about anything having to do with postmodern*ism* – and in some respects rightly so – I still think it is necessary to continue to learn

1

in much greater detail and with much more nuance about postmodern*ity*, or about what 'living in a postmodern world' might mean; to go beyond the many sweeping generalizations and platitudes enunciated about it. In my understanding, one of the most prominent features of living in a postmodern world means living with a heightened sense of permanent and pervasive cultural contradiction. But if this is so, how does this manifest itself in the concrete texture of our daily lives? The essays in this volume can all be read as emanating from this concern with the concrete, even 'empirical' level of the cultural contradictions of postmodernity. From a variety of angles they attempt to clarify not only that contemporary television audiencehood can best be understood as a range of social experiences and practices shot through with cultural contradiction, but also that looking at these experiences and practices provides us with an excellent inroad into what it means, concretely and empirically, to live in a culture that can be described as 'postmodern'.

All too often 'the postmodern condition' is constructed as a structural *fait accompli*, a homogenized, one-dimensional and increasingly global reality, as if there were a linear, universal and radical historical transformation of the world from 'modernity' to 'postmodernity'. Such totalizing accounts run counter to what I see as some of the more enabling aspects of what the postmodern – as a heuristic category – signifies, namely the very dispersal of taken for granted universalist and progressivist assumptions of the modern. If the Enlightenment project of modernity was based on a belief in the possibility of a world singularly organized around the principles of universal reason, rationality and truth, then postmodernity signals not so much a radical end of the modern era, its wholesale supersession and negation by an alternative set of beliefs, but rather an awareness and recognition of the political and epistemological *limits* of those principles – what Lyotard (1984) has called the loss of master narratives. This prevailing incredulity towards modern metanarratives has been the result not only of having gone through, but also of living with the not altogether sanguine consequences of a historical phase in which modernist self-confidence and optimism literally ruled and shaped the world. The current appeal of the phrase 'new world disorder' – meant not only as an ironic debunking of the lofty pronouncement of a New World Order after the collapse of state socialism in Eastern Europe but also to signify a more general sense that the world today is in a state of malaise, if not 'out of control' – suggests the pervasiveness and intensity of a postmodern 'structure of feeling', to use Raymond Williams's (1977) term. Postmodernity here 'denote[s] a way of (. . .) living with the realisation that the promise of modernity to deliver order, certainty and security will remain unfulfilled' (Smart 1993: 27). This doesn't mean that chaos is the order of the day, but that any sense of order, certainty and security – i.e., of structure and progress – has now become provisional, partial and circumstantial. The postmodern doesn't cancel out

the modern, but highlights the impossibility of the latter's completion as a universal project while still having to grapple with the complex and contradictory heritage of an unfinished (and unfinishable) modern, warts and all. In this sense, the postmodern articulates the deepening and elongation of the cultural contradictions which were inherent in the modern itself. Living in a postmodern world, in the words of Angela McRobbie, is living 'within the cracks of a crumbling culture where progress is in question and society seems to be standing still' (1994: 22).

The essays in this book have all been written, in one way or another, under the influence of such a questioning of modern certainty. They also aim to question – implicitly rather than explicitly – the globalizing narratives of postmodernism itself. Thus we have to ask: which culture is crumbling, for whom is progress in question, and when/where does society seem to be standing still? The intellectual challenge posed by the postmodern, as I see it, consists of the need to come to grips with the emergence of a cultural space which is no longer circumscribed by fixed boundaries, hierarchies and identities and by universalist, modernist concepts of truth and knowledge. In this sense, what this book – in line with my earlier books *Watching Dallas* (1985) and *Desperately Seeking the Audience* (1991) – hopes to contribute to is a move away from various modernist ways of understanding television audiences, which I believe have dominated established traditions of communication research and which now have generally reached their point of exhaustion. Why? Because television itself has undergone massive postmodernization – manifested in a complex range of developments such as pluralization, diversification, commercialization, commodification, internationalization, decentralization – throwing established paradigms of understanding how it operates in culture and society into disarray. This transformation of television points to the central 'mover' of postmodern culture: an increasingly global, transnational, postindustrial, post-Fordist capitalism, with its voracious appetite to turn 'culture' into an endlessly multiplying occasion for capital accumulation. This has resulted in a seemingly unstoppable ballooning of the volume and reach of television and other media culture in the last few decades, which can therefore no longer be conceived as an easily researchable, contained and containable reality. The 'dominant paradigm' of mass communication research, firmly locating itself in modernist social science, has become obsolete because its scholarly apparatus was not able to grasp the new questions and issues which emerged out of the 'mess' created by the postmodernization of television.[1] This 'crisis' of the dominant paradigm, addressed in some of the essays in this book, was significantly paralleled by the simultaneous growth since the mid-1970s of what we now know as 'cultural studies', a mode of intellectual work which readily addresses the elusiveness of the postmodern in its ongoing commitment to interdisciplinarity and openness of theorizing (Hall 1986b). Since the early 1980s, it is within the emerging discourses of

3

cultural studies that new ways of understanding audiences, not only of television but also of other media, have been most productively developed.

What the essays in this book perhaps most pertinently unfold – what they 'represent' – is the gradual, uneven and not always easy carving out of *some* interpretive frameworks for such an understanding, which I by no means want to present as in any way definitive or complete (indeed, this would run against the postmodern spirit itself). They explore the implications of what I believe are not only the central theoretical assumptions of cultural studies, but also a key historical feature of postmodern culture itself: that the cultural pervades everyday life and that cultural meanings are not only constructed, but also subject to constant contestation.

Once we move from a modernist to a postmodern understanding, from a disciplinary discourse to a cultural studies one, the very status of 'media audiences' as a discursive category changes. 'The audience' no longer represents simply an 'object of study', a reality 'out there' constitutive of and reserved for the discipline which claims ownership of it, but has to be defined first and foremost as a discursive trope signifying the constantly shifting and radically heterogeneous ways in which meaning is constructed and contested in multiple everyday contexts of media use and consumption. As I have put it elsewhere, any representation of the social world of television audiences can only be conceived as:

> a provisional shorthand for the infinite, contradictory, dispersed and dynamic practices and experiences of television audiencehood enacted by people in their everyday lives – practices and experiences that are conventionally conceived as 'watching', 'using', 'receiving', 'consuming', 'decoding', and so on, although these terms too are already abstractions from the complexity and the dynamism of the social, cultural, psychological, political and historical activities that are involved in people's engagements with television.
>
> (Ang 1991: 14)

To put it differently, as far as I am concerned, studying media audiences is not interesting or meaningful in its own right, but becomes so only when it points towards a broader critical understanding of the peculiarities of contemporary culture. Not only is it important to remember that audience-related practices only acquire significance, and can only be meaningfully comprehended, when they are articulated with other, non-audience practices (after all, people are not always acting out their membership of a variety of media audiences). What we also need to take into account is the very historical distinctiveness of living in a world where the presence of mass media – and therefore of media audiences – has become naturalized. We should resist what mass media research has generally done, that is, in Todd Gitlin's words, '[certify] as normal precisely what it might have been

investigating as problematic, namely the vast reach and scope of the instruments of mass broadcasting, especially television' (1978: 206). Gitlin continues by pointing to the 'the significance of the fact that mass broadcasting exists in the first place, in a corporate housing and under a certain degree of State regulation' (ibid.).Gitlin here obviously refers to the close connection between mass broadcasting and the emergence and maturation of social modernity. And while Gitlin tends to argue against any emphasis on audience research as a result of its, in his view, inevitable collusion with the 'dominant paradigm', I believe that we cannot do without some, non-reductionist, non-fetishizing, perspective on the 'audience' if we are to come to grips with life in 'the postmodern condition'.

Broadcast television has been one of the most powerful media of modernity. As a medium of mass communication, it was generally put into motion in the social realm throughout the core of the Western world at the apex of social modernity, the 1950s and 1960s, a time when confidence in the possibility and superiority of a modernity based on infinite economic growth and 'Western' values (e.g. individual freedom, democracy and affluence for all) was riding high. These modern societies thought of themselves in self-contained, national terms, each capable of maintaining order and harmony through the consent of the vast majority of the population. This was a modernity ideally built out of a nationally coherent, if not culturally homogeneous citizenry, whose private lives were organized within nuclear families living in comfortable, suburban middle-class homes. Television, typically institutionalized in the centralized mode of broadcasting (Williams 1974; Ellis 1982), was thought to play a central role in the orchestration of the millions of these individual families into the national imaginary, the rhythms and rituals of the life of the nation. In 1946, an American TV producer could enthuse about the integrative power of the then very new medium this way:

> Picture a program each afternoon with a chef inviting the house-frau to cook the evening meal along with him. Right then in the television studio and in millions of homes across the country, step by step, an entire meal is prepared for evening's consumption. All over the country millions of husbands will come home to identical dinners prescribed by this chef. All this may seem a little patterned and regimented, but just think for a moment how our government will make use of this type of program to maintain our economic stability. For example, if the farmers have just harvested a surplus crop of potatoes, the chef in preparing the daily meal can feature many potato dishes. On the other hand, if there was a shortage of any commodity on the market the chef can arrange to work around that commodity over the economic elements of the country.
>
> (Marlowe 1946: 15)

This cosy functionalist fantasy exemplifies how the articulation of 'centralised transmission and privatised reception' (Williams 1974: 30) embodied by broadcast television operated as a modernist cultural technology *par excellence*. It served to contain the centrifugal tendencies of spatial dispersion and social privatization which went along with the suburbanization of modern life because it could, so it was assumed, cement the isolated households together in a symbolic 'imagined community' of the nation (Anderson 1983). In this sense, high modernity depended upon, and was sustained by, the transformation of populations into regular and dedicated television audiences (see, e.g., Spigel 1992; Silverstone 1994). The dependable existence of such a television audience can be seen as a founding myth of suburbanized, nationalized modernity. Here we have the political significance of the television audience in modern culture – as a rhetorical figure if not a social reality.

For in social reality, television audiences – as historical constructs of populations in general – have always behaved in less than perfect ways; perfect, that is, in the modern sense of orderly, responsible, willing. They watch the 'wrong' programmes, or they watch 'too much', or they watch for the wrong reasons, or, indeed, they just don't get the 'correct' things out of what they watch. Scholarly interest in television audiences has generally been consistent with such perceptions of 'imperfect' audience behaviour. Mass communication research, to a large extent a subdiscipline of American functionalist sociology, has been fuelled by a neverending concern with television's 'effects' and 'uses' – a concern which betrays an implicit ideological connivance with the modernist framework.[2] After all, what theoretically undergirds this type of investigation is a perspective where audience behaviour or activity is problematized in the light of their potential conformation to, or disruption of, 'normal' social processes and ordered social structure. The persistent worry about the 'dysfunctional' effects of television on 'vulnerable' sections of the audience is indicative of this. For example, in the voluminous study *Television and Human Behavior* (Comstock *et al.* 1978), one of the largest empirical surveys on this topic ever done in the United States, four such 'vulnerable' groups have been singled out for special research attention: women, blacks, the poor and the elderly. Comstock *et al.* legitimize this special focus with the liberal argument that '[t]hese groups are heavy viewers and the object of concern over whether society is fulfilling its responsibilities and obligations to them' (ibid.: 289). It would be more to the point to say that the very focus on these groups articulates their construction as deviant from the (white male middle-class) norm which forms the implicit and explicit cultural core of American social modernity. The frequently resurging moral panic over televised violence – a panic all too often accompanied by the purposeful ambition among researchers to find scientifically supported 'solutions' to the problem – is another example of the intellectual bias towards 'rational control' in the

'dominant paradigm'. In short, in its 'tendency to serve either the media industry, its clients, or the official guardians of society and public morality' (McQuail 1994: 296), mass communication research, by offering scientific knowledge about the audience (or, more precisely, about what could be done in order to 'administer' the audience), has performed a power/ knowledge function which is particularly characteristic of the modern desire for social order (Foucault 1980; Bauman 1987; Ang 1991).

My own critical engagement with audience studies took off from what I perceived to be the limitations of this kind of positivist and functionalist scientific knowledge, for both epistemological and political reasons. It is clear that there was always something written out of this knowledge, that the discourse of mass communication research effectively makes it imposs- ible for us to think about what it means, in qualitative cultural terms, to *be* a television audience – or, better, to live in a world where we are all interpellated to television audiencehood. Relegated to the plebeian receiving end of the highly visible and public mass communication process, television audiences have been reified as the invisible, silent majorities of the suburban wasteland, subjected to the objectifying gaze of social science and authoritat- ive arbiters of taste, morality and social order. What increasingly became an epistemological straitjacket was the myth of cultural integration which underpinned the dominant, functionalist view of audiences – a myth which, ironically, was reproduced in neo-Marxist critical theory through a re- writing of 'cultural integration' as something *imposed* on audiences by a 'dominant ideology'. In both cases the relative autonomy of the 'receiving end' outside and beyond the mass communicational order was unthinkable: the audience was merely a function of the systemic design, and privatized reception completely subjected to the requirements of centralized trans- mission. This, of course, was the source of the looming image of the 'passive audience'.

Watching Dallas was a direct intervention in this discursive vanishing act. The book foregrounded the cultural complexity of the site of that receiving end, the diversity and sophistication, but also the contentiousness of viewer interpretations circulating about the TV serial which became one of the most prominent symbols of the dreaded Americanization of European culture. But I would like to stress that the book was never merely intended as a debunking of the 'passive audience'. What the book aimed to bring to the surface, more than anything else, was precisely the heightened sense of cultural contradiction elicited by the massive popularity of this famous and controversial American soap opera, especially in Western Europe. It is perhaps not exaggerated to see the moment of *Dallas* – the early 1980s – as a key one in the slow unravelling of modern European culture, based as it has traditionally been on a firm, modernist containment of commercial mass culture. In this sense, the moment of *Dallas* was quintessentially post- modern!

The dissatisfaction I had with the assumptions and presumptions of mainstream mass communication research was shared by many colleagues. This may itself be seen as a sign of postmodern times emerging. Thus it was that the 1980s saw the emergence of a new interest in studying media audiences, all concerned with uncovering and highlighting the importance of 'struggles over meaning' in the reception process of the media. In short, what these new approaches – discussed extensively in some of the essays in this book – have brought to the attention was that complex and contra- dictory 'living room wars' are taking place wherever and whenever television (and other media) sway people's daily lives in the modern world. Indeed, the popular television audience has been one of the key analytical sites in the expansion of cultural studies in the 1980s (for the best overview, see Morley 1992). Mostly, the emphasis has been on how audiences are active meaning producers of texts and technologies, and that meaning production is dependent on the very intricate requirements of the micro-politics of everyday life (those related to gender being one of them). Given the interest in exploring the micro-politics of media consumption in everyday contexts, it is not surprising that there has been a great investment in ethnographic methods of research. I do not need to elaborate on this methodological dimension here – it is a theme I return to in several of the following chapters.

These studies have produced a wealth of new knowledge about media audiences, so much so that they are now sometimes called 'the new audience research' – a label I utterly dislike because it reinforces the misleading assumption that 'audience' is a self-contained object of study ready-made for specialist empirical and theoretical analysis. In light of this pigeonholing, there is a pressing need to position this kind of work more squarely in a broader context of cultural and social theorizing. This is especially necessary because, as they have become more established and more popular, the 'new audience research' have also suffered from an image problem in cultural studies. Most importantly, they have been accused of exaggerating the power of audiences in constructing their own meanings, promoting a 'cultural populism' (McGuigan 1992) where the audience is celebrated as cultural hero. And true, there is certainly a redemptive bent in the inclination of this work to 'save' the audience from their mute status as 'cultural dopes' (Brunsdon 1989). However, I contend that there is nothing inevitably populist about the suggestion that audiences appropriate television in ways suitable to their situated practices of living. John Fiske (1993) is right to stress that this appropriative power of the audience is the power of the weak; it is the power not to change or overturn imposed structures, but to negotiate the potentially oppressive effects of those structures where they cannot be overthrown, where they have to be lived with. The romanticization of this position, often inspired by a superficial adoption of Michel de Certeau's (1984) theory of everyday life as the site of subversive tactics, comes when the term 'resistance' is adopted *tout court*, without qualification, to evoke

people's resourcefulness and creativity in 'making do' in less than ad-
vantageous circumstances.[3] But the recognition that audiences are active
meaning makers does not have to lead to their romanticization. Rather, it
can be the starting point for a discussion about both the reach and the limits
of modern designs of ordered social life, about the cultural contradictions
of life in (post)modernity.

One of the problems here is precisely that the new audience studies have
been seen as promoting the idea of 'the active audience' – the very notion
that engenders its populist credentials. The 'active audience' has been held
up as a rejection of all that classical critical theory – especially that of the
Frankfurt School trajectory – has been committed to criticize: the increasing
commercialization and commodification of the cultural and media indus-
tries. The emphasis on the 'active audience' has been taken to be a refutation
of the thesis, derived from this line of critical theory, that the masses are
'victims' of the system, arguing instead that because audiences are 'active'
in their pursuit of pleasure from watching TV – making their own choices
and meanings – popular television is a site of cultural democracy rather than
cultural oppression. But this rendering of the 'active audience' is an
unnecessarily narrow one, too preoccupied with finding a 'correct' critical
position about popular television – a position which, depending on your
standpoint, would be either optimistic or pessimistic. Such priority given to
the need for 'legislative' political judgement – which, incidentally, mirrors a
dominant tendency in debates pro and contra postmodernism – is itself, as
Bauman (1987) has pointed out, a particularly modernist intellectual
preoccupation which obscures rather than illuminates what is at stake in the
'cultural turn' in audience studies. Far from just advocating the optimistic
and self-congratulatory liberal mirage of consumer freedom and sovereignty,
I want to suggest that the new figure of the 'active audience' within cultural
studies can be taken as a marker of the very transition from the modern to
the postmodern I have been talking about here. In other words, I want to
see the discursive emergence of the 'active audience' as a sign of heightened
cultural contradiction in contemporary society.

Of course, the idea that audiences are 'active' in their encounters and
engagements with the media is in itself a rather banal observation (Morris
1988a). But it becomes more theoretically substantial if we understand it
precisely in the context of the postmodernization of television and of culture
and society more generally. Jim McGuigan observes:

> Active audience research and the meaning of television in everyday life
> took a certain priority during the 1980s. Such research was rarely
> linked to the complex economic determinations, technological and
> policy changes occurring around television nationally and inter-
> nationally.
>
> (McGuigan 1992: 128)

Similarly, John Corner remarks that 'so much conceptual effort has been centered on audiences' interpretative activity that even the preliminary theorization of [media power] has become *awkward*' (1991: 267). McGuigan's and Corner's comments do ring true – there has indeed not been much attention paid to the relation between the cultural and the economic in most audience studies, new or otherwise, although the same can be said about most work in the political economy of the media (Golding and Murdock 1991). But I want to suggest that if we shift the perspective somewhat, if we take the 'active audience' not just as an empirical phenomenon but as the sign for a particular new problematic, then the apparent gap between the cultural and economic – or that between emphasis on interpretation and emphasis on effects – ceases to be so great. I want to go beyond the view that attention to the 'active audience' is necessarily antagonistic to a consideration of media power. Far from it. The 'active audience', I suggest, can be taken as a condensed image of the 'disorder of things' in a postmodernized world – a world which has seriously destabilized the functionalist connection between television and modernity. This doesn't mean an end to television's power, but a reconfiguration of it in postmodern terms.

There have indeed been rapid alterations surrounding the place and operation of television itself during the last twenty years or so. We know the symptoms: national public broadcast TV hegemony (in Europe) was undermined by increasing commercialization and internationalization; the sweeping reach of network TV (in the United States) was eroded by the advent of dozens, if not hundreds, of smaller, more specialized and localized channels; not only in the industrialized world but also in the Third World cable, satellite and video cassette recorders have begun to destabilize and decentralize the institutional and technological arrangements of TV provision which had been in place for decades. In short, scarcity has been replaced by abundance, state control by commercial initiative. These are signs of the irrevocable postmodernization of television, which has corroborated a radically altered landscape for television audiences. In industry and advertising circles there is talk of the diversification, fragmentation and demassification of the audience. They have become acutely aware that audiences are not gullible consumers who passively absorb anything they're served, but must be continuously 'targeted' and fought for, grabbed, seduced. This shift in institutional awareness throughout the rapidly globalizing media industries, which intensified during the 1980s, signifies the emergence of the spectre of the 'active audience' at the very heart of corporate concerns. It is common industry wisdom that it is *never* possible to predict the success or failure of a particular film or programme, despite all sorts of safety valves such as formulaic production, use of stars and celebrities, and market research. Here the 'activeness' of the audience is associated rather frantically with its imputed fickleness, recalcitrance and

10

unpredictability. And with the anticipated expansion and transnational-ization of the communications industries under global capitalism, the battle for audiences throughout the world will only heat up further as new 'frontiers' – e.g. China – are being opened up.

So the 'active audience' is not just a scholastic academic invention, populist, liberal pluralist or otherwise, but a mythical discursive figure quintessentially attached to the postmodernization of the capitalist cultural industries. In political economic terms, the shift involves a transition from Fordist to post-Fordist consumption, where audience markets are in-creasingly thought of in terms of 'niches', made up of flexible tastes and preferences, rather than in terms of fixed demographics. With increasing competition, shows are no longer churned out to an anonymous mass audience, but tailored for specific, hard-to-get audiences. The 'active audi-ence', then, is both an expression and a consequence of what Lash and Urry (1987; 1994) have called disorganized capitalism, where the instabilities of the free market economy are built into the production system itself, which has now embraced notions of flexibility, mobility and flow.

The emphasis on audiences as active meaning makers in the new audience studies is indeed congruent with this modification in industry perspective – and some would argue that this is exactly why it is theoretically and politically suspect – but to leave it at this observation would overlook what I see as the more complex, *critical* significance of the notion of the 'active audience'. Let me explain how the figure of the 'active audience' can be used productively to illuminate the way in which contradiction, in-consistency and incoherence pervade contemporary, postmodern culture.

The rapid take-up of video recorders since the late 1970s is a case in point. The popularity of the video recorder represents a key instance of a symbolic opting out of the centralized transmission structure of the broadcasting framework. It also effected a major disturbance of the modern arrangement of television where the distribution and scheduling of programmes was monopolized by a limited number of powerful central providers. Signific-antly, the VCR was (and is) especially popular among groups who have traditionally been poorly served by centralist, modernist television (such as migrant groups) or is used to watch material generally excluded from the official imaginary of 'normal' social order (such as hardcore porn). What we have here is a clear manifestation of the 'active audience', but of course this does not imply a conscious intentionality on the part of VCR users to 'resist'. It would make more sense to suggest that when given the opportun-ity, people opted for 'choice': they wanted to decide for themselves what to watch (and thus contributed to the successful emergence of the video shop), or at least they wanted to be able to watch programmes at times convenient to them (using the 'time shift' facility of the VCR). In other words, audiences simply *retreated* from the integrative pull of modern television here. The VCR disrupted the modern entanglement between centralized transmission

11

and privatized reception because it displaced the locus of control over the circulation of cultural texts to more local contexts. With the VCR, then, we have witnessed the 'active audience' in action. This does not mean, however, that audiences are moving out of the industry's sphere of influence: rather, that their relation to the industry is shifting from that of the more or less passive audience-mass to that of the selective individual consumer.

'Choice' is now promoted as one of the main appeals of television to its audiences and is presented as the ultimate realization of audience freedom. The proliferation of new technologies – such as satellite TV, fibre-optic cable, interactive television and so on – and the ever greater range of specialized programming for ever more specialized audiences is creating an image world which seems to suggest that 'there is something for everyone's taste' – a delirium of consumer sovereignty and unlimited choice. As Jody Berland has observed: 'In locating their "audiences" in an increasingly wider and more diverse range of dispositions, locations, and contexts, contemporary cultural technologies contribute to and seek to legitimate their own spatial and discursive expansion' (1992: 42). The discourse of choice is a core element of that legitimation. Seen this way, the figure of the 'active audience' has nothing to do with 'resistance', but everything to do with incorporation: the imperative of choice *interpellates* the audience as 'active'!

What we have here is a contradiction which is built into the very formation of postmodern culture. 'Choice' is now one of the prime discursive mechanisms through which people are drawn into the seductions of consumption, but at the same time, because 'choice' is by definition an open-ended, procedural mechanism – it can be manipulated but not imposed – there can be no guarantee that people will make the 'right' choices, that is, the ones which sustain the reproduction of the 'system'. Uncertainty is thus inherently built into the 'system' of postmodern capitalism. On the other hand, if consumers are seen positively as 'making space', 'winning space', etc., by activating their own choice – as much of the 'new audience studies' have highlighted – this can also be seen as their final cooption into the political economy of the cultural industries. In other words, the 'active audience' is both subject and object of postmodern consumer culture.

Mike Featherstone suggests quite rightly that 'the much-talked-about cultural ferment and disorder, often labelled postmodernism, may not be the result of a total absence of controls, a genuine disorder, but merely point to a more deeply embedded integrative principle' (1991: 20). This 'more deeply embedded integrative principle' might not be a central(izing) mechanism which ensures something like a 'common culture', but a decentralized, self-perpetuating mechanism which operates through an endless proliferation of choice insistently put on offer by the market forces of an increasingly global, disorganized capitalism.

One observer estimates that as interactive television enters living rooms in some US cities, consumers will have a choice of 7000 to 14,000

programmes a week. To help consumers find what they want to watch, an interactive electronic programme guide is being developed with which they can navigate through this enormous menu (Clancey 1993). By the end of 1995, there will be some 800 transponders available for satellite TV transmission over the Eastern Asian region, deemed to be the most lucrative market for global broadcasters today. In a region which is described by some commentators as 'TV-starved', the prospect of increased choice is unsurprisingly and unthinkingly hailed as 'progress'. But even here '[t]he million-dollar question is: how many [channels] are enough?' (*Asiaweek* 1994).

In postmodern culture the discourse of choice has expanded exponentially – it is a discourse in which the rhetoric of the liberatory benefits of personal autonomy and individual self-determination has become hegemonic. No longer tied to 'tradition' or the restrictions of class, gender or race, subjects in the postmodern world are now impelled to constantly reconstruct and reinvent themselves; in pursuit of happiness, life is defined as the ability to make an ever-increasing number of choices. The concept of 'life-style' articulàtes this particularly postmodern predicament. Life-styles are the fluid and changeable popular aesthetic formations of identity produced through self-reflexive consumption and disembedded from stable social networks (Chaney 1994: 208; Lash and Urry 1994: 142). But if such postmodern life-styles suggest a liberation from social necessity, don't they also imply a compulsion to activeness, to self-reflexivity, to creative self-construction? Seen this way, the 'active audience' represents a state of being *condemned* to freedom of choice.

Far from being romanticized or celebrated, then, it is in this context that the practices of active meaning making in the process of media consumption – as part of creating a 'life-style' for oneself – need to be understood. I want to suggest that the significance of the new audience studies should not be sought in their deconstruction of the idea of the 'passive audience' – that figure of an older, arguably modernist paradigm – but in their exploration of how people live within an increasingly media-saturated culture, in which they *have* to be active (as choosers and readers, pleasure seekers and interpreters) in order to produce any meaning at all out of the overdose of images thrown before us. Paradoxically, then, postmodern consumer culture requires people to be more semiotically skilled, more sophisticated or educated in their meaning making abilities. As Lash and Urry put it, it

is not that the inflation of images leads to an inability to attach meanings or 'signifieds' to images, or even the triumph of spectacle over narrative. It is instead that the speed at which we attach meanings to signifiers has and will greatly increase.

(Lash and Urry 1994: 55)

But Lash and Urry speak in the name of a too abstracted, generalized 'we'. After all, for whom does all this apply? And how do different people

13

in different places, living in different conditions and under different circum-
stances, with more or less semiotic skills and familiarity with postmodern
aesthetics, actually attach meanings to the images they encounter, whether
or not they are of their own choosing? I believe that that it is this concern
with specificity and particularity which has been the special contribution of
the new audience studies – and which I hope the essays in this book further
expound. The ethnographic impulse in this work should be understandable
from here. Kirsten Drotner is lucidly succinct when she says that 'it is
precisely the complexity of ethnography that makes it popular: it seems
better equipped to prise open for analysis the ambivalences of modernity in
its present phase of development' (1994: 343).

McGuigan has made the terse remark that 'it is not much help for falsely
modest intellectuals merely to record how well ordinary people are doing
against the overwhelming odds' (1992: 249). This is true, but I suggest that
what is at issue is not so much to give ordinary audiences a pat on their
backs for doing so well in 'resisting'; what is at stake, and what this book
attempts to come to grips with, are the contradictions encountered and
negotiated in the ordinary practices of living in a postmodern world. The
cultural politics of these encounters and negotiations are themselves
contradictory. On the one hand, then, McRobbie is right to suggest that
'[a]s the media extends its sphere of influence, so also does it come under
the critical surveillance *and* usage of its subjects' (1994: 23). But on the
other hand, as I have argued above, active usage as such doesn't guarantee
any critical purchase, let alone resistance or subversion. As semiotic skills
become more valued and exploited within the cultural logic of postmodern
capitalism, semiotics itself, with its once pathbreaking emphasis on the
constitutive role of codes in the operation of signs, ceases to be a radical
theoretical toolkit. As Terry Eagleton wrily observes: 'It would be possible
to see semiotics as the expression of an advanced capitalist order' rather
than a critical instrument to expose it (1994: 3). Here we have one instance
of what Drotner calls 'the ambivalences of modernity', or what I have
referred to as the heightening of cultural contradiction in postmodernity.

This brings me, however, to one last word of caution. This has to do with
the danger of overstating the relevance of audience studies within cultural
studies. In this respect, I want to argue for the need to be aware of the *limits*
of using the trope of media audiences for understanding contemporary
culture. Berland has cogently pointed to the problems of such an emphasis:

As the production of meaning is located in the activities and agencies
of audiences, the topography of consumption is increasingly identified
as (and thus expanded to stand in for) the map of the social. This
reproduces in theory what is occurring in practice: just as the spaces
of reception expand in proportion to the number of texts in circula-

14

tion, so the time accorded to reception expands in proportion to (and through appropriation of) other modes of interaction.

(Berland 1992: 42)

Indeed, what is occurring in practice worldwide, under the aegis of postmodern capitalism, *is* the increasing colonization of the times and spaces of people's everyday lives for the purposes of media audiencehood. But Berland is right to suggest that this process shouldn't be mistaken, in theory, as encompassing our 'whole way of life', not even in the postmodern world. Unless we succumb to the fallacy of conceiving postmodernity as a one-dimensional, totalized reality, then, we must remain sensitive to those spatio-temporal instances when/where the social exceeds the topography of consumption, where/when people enter into modes of interaction (still) not appropriated by, or which cannot be properly understood from the perspective of, their subject position(ing)s as media audiences.

Part I

RETHINKING AUDIENCES

1

The battle between television
and its audiences

Recently, television studies has been confronted with the difficulty of reconciling two theoretical approaches, the histories of which have largely been unfolding independently from or in opposition to each other: the 'sociological' and the 'semiological' approach. Whereas the sociological approach (embodied in such diverse research trends as the political economy of the media and the uses and gratifications paradigm) has traditionally been dominant in mass communications theory, a semiological point of view has gained popularity during the last two decades or so, as a result of the limitations felt in the preoccupations of the 'sociologists'. In summary, these limitations concern the neglect of the *specificity* of television as a system of representation, and an over-simplistic idea of communication as the transmission of transparent messages from and to fully autonomous subjects.

Instead, semiological approaches have put forward the conception of media products as texts. The analysis of the construction of meanings in and through televisual discourses is stressed, as are questions relating to the modes of address presented in televisual texts, influencing the way the receiver ('reader') is positioned in relation to those texts. Thus, the semiological approach has attempted to overcome any notion of conscious institutional or commercial manipulation, on the one hand, and of free audience choice, on the other.

However, discontent with this relatively new theoretical point of view has also been voiced. The nearly exclusive attention to textual structures is seen to have created new blind spots: the established semiological approach tends to ignore the social, political and ideological conditions under which meaning production and consumption take place. As a way out, more and more researchers insist nowadays on the necessity of combining sociological and semiological insights. As Carl Gardner and Julie Sheppard have recently put it:

> analysis of any mass medium has to recognise its complex *dual* nature
> – both an economic and industrial system, a means of production,
> increasingly turning out standardised commodities *and* at the same

time a system of representation, producing meanings with a certain autonomy which are necessarily multivalent and unpredictable.

(Gardner and Sheppard 1984: 38)

This new credo in television studies has usually been translated into a formulation of the so-called text/context problematic. It is stressed that an analysis of a text must be combined with an analysis of its social conditions of existence. One important dimension of this text/context problematic refers to the delicate relationship of texts and viewers, theorized by Stuart Hall (1980a) and others in the so-called encoding/decoding model. One of the goals of this model was to undermine the implicit assumptions of many sophisticated, semiologically based analyses, according to which the subject/ viewer of a text coincides with the subject position constructed in the text. For instance, David Morley (1980a, also 1981) has attempted to develop an 'ethnography of viewing', by sorting out the different readings or decodings made by different groups of viewers (defined according to socio-cultural criteria) in relation to a specific set of texts. Working within a similar theoretical model, Charlotte Brunsdon has adopted a different strategy to tackle the same problematic: her concern is how female viewers are capable of reading and enjoying soap operas, a capability which she locates in the specific cultural competences women have, that is, their familiarity with the narrative structure of the soap opera genre, their knowledge of soap opera characters and their sensitivity to codes of conduct of personal life and interpersonal relationships. In other words, instead of emphasizing the differences between readings or decodings, Brunsdon (1981) has tried to account for the specificity of the confrontation between one type of texts (soap operas) and one category of viewers (women).

Both theoretically and politically, this new problematic constructs a more dynamic conception of the relation between texts and viewers. It acknow-ledges the fact that factors other than textual ones play a part in the way viewers make sense of a text. Thus it places the text/viewer encounter within a firm socio-cultural context. It conceives of viewers as more than just passive receivers of already fixed 'messages' or mere textual constructions, opening up the possibility of thinking about television viewing as an area of cultural *struggle*. However, the model has limitations. Apart from various problems having to do with, for example, an adequate theorization of the concept of decoding (see Wren-Lewis 1983), the encoding/decoding model can be said to have a quite narrow view of the role of the audience: its effectivity is limited to negotiations open to viewers within the given range of significations made possible by a text or genre of texts. Moreover, this model's very conception of the audience tends to be a limited one. Within this theoretical model, the sole problem is the way in which texts are received/ decoded in specific socio-cultural contexts, failing to take into account that decodings are embedded in a more general practice of television viewing as

such. It then becomes possible to question the relevance of the concept of decoding, with its connotations of analytical reasoning, for describing the viewer's activity of making sense of a text, as watching television is usually experienced as a 'natural' practice, firmly set within the routines of everyday life (see, e.g., Dahlgren 1983). It goes without saying that a practice which is *felt* to be 'natural' structurally is not natural at all. However, it seems reasonable to assume that the 'naturalness' of the experience of watching television has an effect on the ways in which individual texts are received and dealt with.

What is at stake here is the way in which television audiences relate to watching television as a cultural practice. What does that practice mean and how are those meanings produced? One cannot deal with this question without an analysis of the way in which televisual discourse as a complex whole of representations is organized and structured, as it is through this discourse that a relationship between television and its audiences is mediated and constructed. In other words, here too an articulation of the 'semiological' and the 'sociological' perspectives will be necessary.

In this chapter I would like to propose that different conceptions of the social meaning of watching television as a cultural practice are at play, and that these differences are related to the structuring of televisual discourse, with its heterogeneity of representations and modes of address. In doing this, I would like to stress the specific position of popular audiences as an effective category in organizing the 'television apparatus'. First, I shall try to show that televisual discourse constructs a variety of types of involvement for viewers; in the second part, I shall illustrate how this heterogeneity of positionings has functioned socially and culturally in the history of Dutch television. However, much of what I am to say will not be more than (theoretically informed) speculation, which will need further refinement.

THE TELEVISION INSTITUTION AND HETEROGENEITY OF ADDRESS

An institutional approach will serve as a starting point. I use the term 'institutional' in its comprehensive meaning, as applied, for example, by Christian Metz in relation to cinema: 'The cinematic institution is not just the cinema industry [. . .] it is also the mental machinery [. . .] which spectators "accustomed to cinema" have internalised historically and which has adapted them to the consumption of films' (1975: 18–19). Although this formulation remains caught within the well-known semiological framework in so far as the position of the spectator/audience is only dealt with as a discursive/institutional effect, such a starting point has the advantage that it analyses cinema-as-such as a distinctive system of representation, to which people are 'drawn' in peculiar ways. An analogous argument may be applied to television. It enables us to move away from the isolated text towards an

analysis of the ways in which television-as-such, as a discursive system, addresses and 'interpellates' people as potential viewers.

More precisely, an institutional approach opens up the possibility of reflecting on how the contextual is already structurally implied in the textual. That is to say, the structures within which televisual discourse is produced necessarily create an environment within which a certain type of consumer activity is assumed and 'propagated'. Thus, the production of texts and the organization of a general context of consumption are closely interlinked. Again, Metz has given an imaginative description of the problem concerned (although I will not follow his psychoanalytic colouring of the picture here). Thus he writes about the task set to the cinematic institution:

> In a social system in which the spectator is not forced physically to go to the cinema but in which it is still important that he should go so that the money he pays for his admission makes it possible to shoot other films and thus ensures the auto-reproduction of the institution – and it is the specific characteristic of every true institution that it takes charge of the mechanisms of its own perpetuation – there is no other solution than to set up arrangements whose aim and effect is to give the spectator the 'spontaneous' desire to visit the cinema and pay for his ticket.
>
> (Metz 1975: 19)

Applied to television, then, the question can be formulated as follows: how does television as an institution succeed in making people buy TV sets and in making the idea of watching television seem attractive? Which strategies has it developed to persuade people to become members of the TV audience? It might be useful here to bear in mind that television has tended to be very successful in completing this 'mission', in making its existence and presence as a cultural form so taken for granted. Television, after all, has in all industrial societies become an institution which is central to both the public and private spheres. From an institutional point of view, analogous to that outlined by Metz, it is the 'arrangements' (both 'outside' and 'inside' the viewer) set up by the television institution through which a desire to watch television is roused and sustained which must have been essential to this success. If the arrangements constructed by the cinematic institution are based on legitimized voyeurism, as Metz and many other film theorists have put forward, can we find an analogous construction in relation to television?

However, to avoid a determinist stance, we can only accept Metz's formulation of the problem in a qualified form. The setting-up of specific arrangements, the social channelling of desire, does not take place within a cultural void. These arrangements can only get rooted when they can be fitted into existing cultural patterns and ways of life. They cannot be imposed in an authoritarian manner, as the above quotation of Metz might wrongly suggest. In other words, it is not enough that the cinematic or

televisual institutions set up (psycho-institutional) arrangements which construct and offer a position of involvement for the spectator/viewer, it is also necessary that the spectator/viewer, given her or his cultural dispositions, considers such modes of involvement to be not only sensible and acceptable, but also attractive and pleasurable. The question to be asked is then twofold. First, which are the arrangements constructed by the television institution for attracting viewers? And second, in which ways do the modes of involvement inscribed in televisual discourse relate to the audience's cultural orientations towards watching television?

In his book *Visible Fictions* John Ellis has developed a consistent view of the specificity of televisual address. In a certain sense, Ellis has relied on the institutional approach outlined above as a guideline for his book, which he presents as 'an attempt to sketch out cinema and broadcast TV as social forms, particular forms of organization of meaning for particular forms of spectator attention' (1982: 20). He argues that 'broadcast TV has developed distinctive aesthetic forms to suit the circumstances within which it is used' (ibid.: 111). Central to his argument is the idea that television adapts the material it presents to the situation within which television viewing is normally assumed to take place: in the private homes of isolated nuclear families. This everyday domestic setting makes it very difficult for television to make its presence more than merely casually noticed and to hold the audience's attention – as a matter of fact, the private home does not seem to be a very favourable context for a concentrated spectatorial activity, as the cinema is. It is to ensure that the viewer will keep on watching, says Ellis, that television has developed distinctive discursive forms:

> TV draws the interest of its viewers through its own operations of broadcasting. The viewer is cast as someone who has the TV switched on, but is giving it very little attention: a casual viewer relaxing at home in the midst of the family group. Attention has to be solicited and grasped segment by segment. Hence both the amount of self-promotion that each broadcast TV channel does for itself, the amount of direct address that occurs, and the centrality given to sound in TV broadcasting. Sound draws the attention of the look when it has wandered away.
>
> (Ellis 1982: 162)

Ellis's position is interesting here as he treats the aesthetic modes developed by television not as neutral or arbitrary forms, but as rhetorical strategies to attract viewers. One could say that every rhetorical strategy is based upon assumptions about the best way to reach the target group. Thus, Ellis suggests that television recruits the interest of its viewers by creating a complicity of viewing: through its discursive organization television is able to pose itself as an institutional eye which looks to the world *on behalf of the* viewers. It is especially through the device of direct address (i.e.

presenters, newscasters, talk-show hosts, and so on, apparently speaking directly to the viewer at home, thereby creating an illusion of immediate presence) that television explicitly invites viewers to join it in its looking at the world. According to Ellis, television not only assumes that it has certain kinds of viewers, it also attempts to bind these viewers by pretending to speak for them and look for them. (In this respect, one of the favourite promotion slogans used by TROS, one of the most popular/ populist Dutch broadcasting organizations, is instructive: 'TROS is there for you!' The other side of the coin, namely that 'you are there for TROS!', is very sensibly suppressed.)

It is on the basis of this generalized view of the rhetoric of television that Ellis puts forward his thesis about the place of the TV viewer in relation to televisual discourse. He stresses that the position offered to the TV viewer is not the voyeuristic position, as is the case with the cinema spectator. Instead, the TV viewer is invited/summoned to delegate her/his look to TV itself: to trust in television 'as a safe means of scanning the world outside' (Ellis 1982: 170). And, by presenting 'the world' in a specific way, that is, as an endless flow of events and things which have no connection to one another (just as every news item is separate from the next one; each one of them is written down on a separate sheet of paper), the TV viewer is placed in a very specific ideological relation to that world: according to Ellis, the formal strategies of televisual discourse give rise to the ideological positioning of the TV viewer as a 'normal citizen'. Ellis typifies this position as follows:

> The viewer-as-citizen is uninvolved in the events portrayed. [. . .] Citizenship recognises problems outside the self, outside the immediate realm of responsibility and power of the individual citizen. [. . .] Citizenship therefore constitutes the viewer as someone powerless to do anything about the events portrayed other than sympathise or become angry. The whole domestic arrangement of broadcast TV and the aesthetic forms it has evolved to come to terms with this domestic arrangement provides broadcast TV with the capability to do this and no more. The citizenship that it provides as the position for its viewers is a position of impotence: TV viewers are able to see 'life's parade at their fingertips', but at the cost of exempting themselves from that parade for the duration of their TV viewing.
>
> (Ellis 1982: 169–70)

It is doubtful whether this account of the subject position implied in the practice of watching television is a satisfactory one. This doubt becomes stronger when we take into consideration that, in so far as Ellis is concerned with the rhetorical strategies of televisual discourse, it will be necessary to explain that the position proposed to the viewer must somehow be attractive to her/him. In this sense, it seems to be a particular weakness in Ellis's

account that the position of 'normal citizenship' as he defines it tends to be so contradictory. On the one hand, it is a position of entering the world, a position of knowledge (of being informed), but on the other hand it is at the same time a position of withdrawal from the world, a position of 'sceptical non-involvement'. It seems hard to imagine how and for whom such a contradictory position can be a position of pleasure, and thus a positioning which can explain why people like watching television so much. It will be more adequate, then, to state that the position of 'normal citizen' only exists in a formal sense, abstracted from concrete encounters between viewers and televisual discourse. Real viewers will never take up the position of 'normal citizen': if they find it pleasurable to be informed, they will be involved somehow in the representations offered (for both feelings of sympathy and anger *are* forms of involvement); if they really are uninvolved they won't be interested in being informed in the first place and probably won't watch at all, or won't watch attentively. However, as Ellis's theoretical framework remains within the problematic of semiologically informed discourse theory, in which viewer practices only appear from the point of view of textual effectivity, he doesn't pay attention to the readability or rather acceptability of televisual discourse from the point of view of the viewers themselves.

But there is another, related problem which is relevant here. Ellis continually speaks about broadcast TV in general and tends to give a generalized account of televisual discourse which is consciously abstracted from the specificities of different programme categories, modes of representation and types of (direct) address (indeed, his preoccupation seems to be with what *unifies* televisual discourse into one 'specific signifying practice') (see Heath and Skirrow 1977). As a result, it becomes difficult to theorize the possibility that television constructs more than one position for the viewer. For example, it is characteristic that Ellis's elaboration of the formal and ideological structuring of televisual discourse is mainly based on a more or less implicit reference to news and current affairs programmes. That these parts of television programming are indeed built on the discursive elements stressed by Ellis seems convincing enough: not only is there the familiar, though 'objective' direct address of the newscaster, but there is also the mosaic-like, ever-continuing compilation of relatively autonomous, short segments about the world's events – a structure based on an implicit appeal to a viewer's self-conception as someone who is interested in finding out 'what's happening in the world', from the position of a disengaged onlooker. The pleasure of this position has less to do with the impotence of the 'normal citizen', as Ellis would have it, than with the (imaginary) mastery of the world. In this case, then, the rhetoric of televisual discourse is based on the call: 'Watch, so that you will keep yourself posted!' It is a rhetoric which tends to be inscribed in a journalistic ideology, with its values of interest in public affairs, topicality and mediated responsibility.

However, many other programme categories do not seem to make the

same appeal. In family quiz programmes, for instance, the direct address of the quiz master tends to be used to create an atmosphere of cosy togetherness, by literally inviting the viewers to join the club, as it were, thereby placing the viewer in a position of (imaginary) participation. (Some quiz formulas even create the possibility for viewers to play their own game at home.) Here, the rhetoric of televisual discourse is based upon the call: 'Watch, so that you will be one of us!' – an appeal which is part and parcel of a more populist ideology, in which values of communality, emotional involvement and humour predominate.

It seems, then, that different types of involvement, based upon different ideological positions, can be constructed by televisual discourse. It does not make sense, therefore, to see televisual discourse as a basically unified text without essential internal contradictions, despite its apparent diversity. An analysis of televisual discourse as a whole might prove to be more fruitful if we look for the real tensions in it, for the contradictions in the appeals it attempts to create for the viewers. In other words, we should analyse the *different* positions offered to viewers in relation to televisual discourse, and the ways in which these positions are inscribed within different parts or levels of TV programming. From here, we can then go on to ask how viewers relate to those positions. Or to put it in a slightly different way: how do socially defined audience preferences correspond to the variety of televisual address?

It is an empirical fact, for instance, that different sections of the social audience relate differently to specific programme categories. To avoid a wholly sociological explanation of this we should attempt to relate the alternation of acceptance and rejection of what TV offers its viewers to the heterogeneous structure of televisual discourse itself, and to the fact that the types of involvement suggested by televisual discourse don't all have the same rhetorical power. In this way, the socio-cultural effectivity of television, which is merely stated in Ellis's work, can be returned to the analysis, for it is the connection of rhetorical strategies (or the failure to achieve such a connection) to the audience's perspective of viewing which is at issue here.

THE POLITICS OF 'TROSSIFIED' TELEVISION

To make this theoretical argument rather less abstract, I shall now provide an interpretation of the history of Dutch television. More precisely, I would like to say something about one particular moment in this history, which has come to be known as the moment of 'trossification' (*vertrossing*'). This neologism stands for the increase of commercialized programming within Dutch broadcast television from the early 1970s onwards – a development which has led to a lot of worried debates among media specialists, journalists, politicians and other intellectuals. I would like to take issue with their gloomy reflections here and will try to show that 'trossified television'

26

can be seen as a consequence of the failure of Dutch broadcasting politics to take into account the audience's perspective of viewing and to make the viewers feel involved with its programming policies. First, however, it is necessary briefly to outline the Dutch broadcasting system.

It is relevant here to note that heterogeneity of televisual discourse is a legal requirement laid down in the 1967 Broadcasting Act. This Act contains a clause which decrees that every broadcasting organization entitled to transmission time should present a 'comprehensive' programme schedule, consisting of 'cultural, informative, educative and entertainment' programmes.[1] Although this formalized heterogeneity does not necessarily coincide with a heterogeneity of modes of address, as the formal categories refer primarily to a prescribed heterogeneity of social functions of televisual discourse, it should be clear that, ideologically speaking, this formal distinction of programme categories reveals an official aversion to one-sidedness. It reflects the wish that televisual discourse *should* address viewers in different ways. More precisely, it reflects the wish that television should not only be producing what is popular among the viewers (usually located in the category of 'entertainment'), but should also offer them 'serious' stuff (i.e. 'culture', 'information' and 'education').

What is noteworthy is not so much the existence of this opposition between the 'serious' and the 'popular' (after all, a distinction is also made between a 'serious' press and a 'popular' press), but that both modes are intermingled within televisual discourse. Although serious television and popular television can be seen as two ideologically contradictory projects which seek to address viewers in contradictory ways and whose ideals are aimed at creating very different types of textual involvement (see, e.g., Corrigan and Willis 1980), they are not expected to be watched by different categories of viewers. On the contrary, it is one of the ideals of the television institution as it is organized in the Netherlands – as in the tradition of European public service broadcasting more generally – to present serious television and popular television as parts of a package: an evening of television programming usually consists of an amalgam of serious and popular programmes, and of serious and popular modes of address within programmes. Thus the two modes are considered as parts of a whole, and not as independent entities which have no relation to each other. Clearly, this reflects a definition of how television *should* be watched: viewers are invited to take up 'serious' and 'popular' positions in turn; a varied 'viewing diet' should be composed.

This seems to be the politics of 'comprehensive programming': ideally, it should be mirrored in 'comprehensive viewing'. Unfortunately, it is obvious that this is not how audiences *actually* watch television. It cannot be denied that an uncontrollable and 'spontaneous' split between 'serious' and 'popular' audiences exists, which is reflected in the well-known fact that the various programme categories have different rates of popularity (in terms

of audience ratings). In other words, the 'comprehensive viewer' (the 'normal citizen'?) turns out to be non-existent. Surprisingly enough, then, despite its success in transforming so many people into TV viewers, television as an institution doesn't seem to have a hold on the way television watching has developed into a cultural practice of consumption, or on the meanings given to television viewing by the audiences themselves. Television has largely become an 'entertainment machine', whether we like it or not.

However, the Dutch broadcasting system has yet another important strategy for securing and regulating heterogeneity in televisual discourse. Since its inception, the Dutch broadcasting system has been based upon a unique, what could be called 'subcultural', or, to use the Dutch term, 'pillarized' approach: broadcasting time on the national TV channels is filled for the most part by organizations which 'represent a specific social, cultural or religious current within the population', as the Broadcasting Act formulates it. They are then assumed to satisfy the cultural needs of a specific, socially relevant subsection of the audience, who are defined in terms of their belonging to a particular religious or ideological 'pillar' within society. From the beginning of broadcasting in the Netherlands (radio started in the 1920s, television in the early 1950s), five broadcasting organizations have monopolized the system: the Roman Catholic KRO, the Protestant NCRV, the socialist VARA, the Liberal Protestant VPRO and the 'neutral' AVRO. The whole system then was organized around the conception of plurality of ideologically defined, pre-existent cultural or religious identities among the Dutch people/nation, reflecting the myth of Dutch tolerance and of the Netherlands as a country of 'unity in diversity'. It is assumed that the programming policies of each organization should comprehensively reflect both its founding ideology and the needs and concerns of the 'pillar' it represents, although it is clear that there cannot be a direct translation of an overarching ideology or world view into all concrete programmes (e.g. how do you produce a Roman Catholic quiz show or sitcom?).

Nevertheless, for a long time Dutch television was generally assumed to be a fair reflection of the plurality of existing ideologies structuring national life. The Dutch broadcasting system has been celebrated for its perfect incorporation of principles of democracy and freedom, as well as cultural pluralism. It has been regarded as a superior model within which television can be used as a medium which justly caters for people's needs as citizens of a pluralist society. Implicitly inscribed in the system is a definition of television viewing as a very respectable practice: your television-viewing activity should be in accordance with your pre-existent ideological world view. In other words, the ideal viewer is not only a 'comprehensive' viewer, but also an ideologically motivated one. For instance, if you are a socialist, you are supposed to be a member of VARA and your favourite programmes must be VARA's programmes. Thus, your television viewing is determined by the fact that you are part of the 'Red Family'.

Basically, however, the system represents a *paternalistic* relationship between television and its audiences: audience preferences only become explicit and legitimized in so far as they fit into the imputed needs, values and concerns of the respective 'pillars'. It is a system in which the elites governing the broadcasting organizations claim to know what is good for the people and what they like to see, because they are assumed to represent and speak for their audiences: it is assumed that production and consumption stem from the same ideological community. In this system, the 'serious' and the 'popular' are not conceived of as opposite to each other, but as parts of an organic, communal whole, with the 'serious' occupying the position of a vanguard.[2]

This represents only the ideal functioning of the system, however. It does not say anything about how audiences actually watch television. The lack of fit between ideal and reality became apparent in the late 1960s with the foundation of a new broadcasting organization, TROS. The philosophy on which TROS's programming is based is essentially populist and devoid of any explicit ideology: its aim is 'to give people the programmes they want to see'. TROS doesn't claim to represent any ideologically defined 'pillar', but the people in general. The success of this strategy was overwhelming: according to an inquiry held in 1975, 36 per cent of the Dutch population preferred TROS above all other broadcasting organizations (followed by AVRO with 13 per cent and VARA with 10 per cent), whereas 47 per cent held that TROS's programmes (mainly entertainment, American series and very light information) were the best (Jungman 1975). As a consequence, panic resulted. Except for VPRO, which developed a non-conformist, artistic style of programming to construct its distinctive identity (which had little to do with its original religious background), the traditional broadcasting organizations felt obliged to react to TROS's success by copying its programming policy and modes of address. For example, during the 1960s current affairs programmes were the flagship of the broadcasting organizations and were scheduled at prime time. In the face of the new competition, however, these 'serious' programmes adopted more popular modes of address and were moved to a later hour in the evening. Instead, prime time became filled with popular entertainment programmes (TV series, shows, quizzes, and so on). While still trying to maintain their ideological identity as the basis of their existence, the broadcasting organizations now wanted to address a general mass audience.

In Dutch intellectual circles, the advent of TROS was blamed for introducing an 'Americanized' commercial logic into the system of Dutch broadcasting. Even the word 'trossification' was invented to denote the process of decay – a word which dominated all Dutch debates about television in the 1970s. In these debates, the 1960s were constructed as 'the Golden Age of Dutch television', during which the broadcasting organizations accepted their cultural responsibility, whereas the 1970s have

been deplored as a period of decline, in which television became the repository of irresponsible and debased mass culture. According to Herman Wigbold, a leading Dutch journalist with socialist affiliations, TROS has been a major cause of this decline because the broadcasting system

> could not hold its own against a new broadcasting organization that was the very negation of [that] system based as it was upon a conception of giving broadcasting time to groups that had something to say. It did not know how to react to an organization that had nothing to say but nevertheless became a great success.
>
> (Wigbold 1979: 225)

Yet is it not possible to interpret this history in another way? What is painfully absent in Wigbold's account is the active role of audiences in the whole process of 'trossification'; their position is reduced to that of passive target or even victim of developments in which they have no effectivity of their own. In short, what has been suppressed is that large numbers of audiences actively welcomed TROS when it came into existence. Thus it is not true to assert, as Wigbold does, that TROS had 'nothing to say', for it is its 'great success' which speaks for itself. At the very least, TROS's success (and later that of Veronica)[3] can be read as an indication of the fact that many people were not involved in the existing broadcasting politics, that they didn't feel represented by the traditional organizations, and that they were not satisfied with the television offered them. It may be said that TROS's success is based on a discontent with the moralizing surveillance or denial of popular tastes and preferences by the traditional organizations. In other words, through TROS the 'silent majority' spoke. More specifically, it signified a refusal by the popular audiences to be put into a position from which they were incited to be watching television: a position from which 'serious information' is postulated as the most valuable part of televisual discourse and 'entertainment' is tolerated as a diversion as long as it gives 'enjoyment' and not 'fun' (see Smiers 1977: 57).

The success of TROS, then, can be interpreted as an articulation of a contradiction between the way large parts of the television audience define watching television as a cultural practice, and the ideas about the use of television inscribed within the institution. Of course, it would be wrong to assert that, with the advent of TROS, the people finally got what they wanted, as TROS officials would have it. 'Trossified television' could only become so popular because it filled a space left unfilled by the traditional broadcasting organizations, and because it brought a distinctive mode of address into televisual discourse which had until then been absent and which could be experienced as something new and different: a popular mode of address which is presented as independent from ideological world views and fixed cultural identities. Instead, this address is constructed around another type of involvement: one which is characterized by *instant pleasure*. It is an

address in which pleasure is equated with 'entertainment'; in which fun is not only presented as perfectly legitimate but also as being in opposition to 'boring information' or 'education'.

Most explanations of 'trossification' usually refer to changes in the ideological make-up of Dutch society during the late 1960s, in which the influence of solid ideological subcultures as the basis for constructing identities and as guidelines for living was waning and was being replaced by valueless pragmatism and superficial and senseless consumerism. For instance, an often-heard ironical remark in this respect points to the observed paradox that so many working-class people who vote for the Labour Party become members not of the socialist broadcasting organization (which they supposedly should have done had they been conscious of their social position), but of TROS, thereby proving to be too weak to resist the seductions of commercialism! What is overlooked in this explanation is the relative autonomy of watching television as a cultural practice, and the distinctive micro-politics inscribed in it. What is at stake here is a struggle for pleasure: or, more precisely, a struggle about the definition of watching television *with pleasure*, and not about the definition of watching television in a socialist way (or as a Roman Catholic, or as 'normal citizen', and so on). In other words, what matters from the audience's point of view is whether television discourse constructs positions of pleasure in its representations, and not whether these positions are ideologically correct.

Of course, this doesn't mean that audience preferences are only directed towards programmes which fall into the category of 'entertainment'. Indeed, the institutional categorization of televisual discourse, which constructs an opposition between the serious (= what really matters) and the popular (= easy pleasure), obscures the fact that, from the point of view of audiences, 'information' can also be pleasurable. The problem is that in televisual discourse 'informative' programmes, especially when they are about 'serious' politics and culture, are too often constructed as the important – and thus unpleasurable – which viewers are supposed to watch because it is 'good for them'. As a result of such an address these parts of televisual discourse will often be rejected as 'useless knowledge' and as attempts to put something over on you.

Of course, it is not true that the traditional organizations don't make use of the pleasurable as a working principle for creating audience involvement. However, from *their* point of view, pleasure in itself is not enough. It even seems to be something dirty to them. They mostly seem to claim to give *more* than simple pleasure, thereby marginalizing the pleasurable itself and making it instrumental to the overall 'pedagogic' framework of their programming. It is this ambivalent attitude towards pleasure and the pleasurable which has given the explicitly commercially oriented organizations the space to monopolize the work of constructing and defining the

pleasurable in an active and positive way. Ideologically, watching television with pleasure is the only thing they claim to offer.

At the very least, then, this should lead us to another ironical remark. It seems that it is the very logic of commercialism, because it is a wholly opportunistic logic without any explicit missionary impulses, which, to quote Ian Connell, 'led the way in making connection with and expressing popular structures of feeling' (1983: 76). What has made debates about commercial television (or about public service television using the methods of commercial thinking, as is increasingly the case in the Netherlands) so obscure is the conflation of commercialism as an economic principle of production, which is utterly capitalist, with commercialism as a cultural principle of producing goods for consumption, which certainly has connections with the popular. The success of the commercial logic lies in the fact that it takes the pleasure of consumption and consumption for pleasure seriously, in the fact that it actively engages in the construction of what is pleasurable, and the fact that it has used the pleasurable as a structuring principle for addressing viewers.

CONCLUSION

Ellis's basic proposition that television's aesthetic forms can be explained by the necessity to come to terms with the familial, domestic conditions within which television is watched should now be given some nuance. After all, that domestic setting itself is not given. When it comes to constructing the meaning of watching television, it is part of the problem. It is this very domestic setting which was seen by some as an excellent opportunity to integrate people's personal lives into the official life of the nation; in short, to continue to educate them even when they are at home. As one Dutch scholar wrote:

> Exactly because television reaches man [sic] when he is on his own or is to be found in the smallest social unit, the family, it is worth the trouble [. . .] to use the medium to drive a wedge between the often collective prejudices which impede a healthy development of the (national) community.
>
> (Schaafsma 1965: 19–20)

However, because in our culture the home is often felt to be a 'haven in a heartless world', watching television is mostly experienced and cherished as one of those activities in which one is one's own master or mistress,[4] and it is thus perfectly understandable why so many viewers resist being made to use television as an extension of the classroom.

Thus, in a formal sense, it is correct to say that television's rhetoric is aimed at holding the viewer's attention by modes of direct address, by dividing programmes into short segments, by using sound to catch the gaze,

and so on. But underlying these formal discursive strategies are ideological principles which can be traced back to a continuing struggle over the meaning of watching television as a cultural practice, a struggle which, at least in the case of Dutch television, is constructed as a struggle between television-as-education and television-as-pleasure. In televisual discourse, this struggle is expressed in a continual attempt to secure heterogeneity by combining the two constructed options. Thus, almost every news and current affairs programme is structured in such a way as to find a compromise between the 'educative' and the 'pleasurable': the light popular tone, the magazine format with 'difficult' items sandwiched between more 'frivolous' ones, the populist stance from which events are represented, etc. However, these developments can merely be seen as attempts to make a pedagogic ideology work in front of an 'unwilling' popular audience; they don't represent a positive intervention in the definition of the 'pleasurable' itself.

Ultimately, then, it is the impossibility of controlling television consumption and the audience's desire to watch television for pleasure which accounts for the contradictions in television's rhetoric and the heterogeneity of its address. And as long as popular desires and preferences are merely seen as negatives which have to be overcome or as an alibi for placing audiences in a paternalist framework, and as long as the pleasurable itself is not taken seriously as something to be actively constructed, the agents of commercialism will be, to use a Dutch expression, the laughing third.

POSTSCRIPT

In the mid-1990s, the landscape of Dutch television has changed completely. The process of 'trossification' that set in twenty years ago has proven to be an irreversible trend, marking the slow death of the nation's revered and time-honoured 'pillarized' broadcasting system. Commercial Dutch language TV stations operating from outside the national borders (i.e. Luxemburg) and beaming their entertainment packages down from satellite now consistently stake the largest claim of the audience market, in the face of which the old broadcasting organizations – with their residual idealism and obsolete concepts of what watching television should be about – are left helpless and impotent. While their protracted struggle for survival may continue for a while, it is certain that their glory days will never return. This history is not wholly idiosyncratic: in fact, the Dutch case only exemplifies a much more general demise. Across Europe, the last twenty years have seen a gradual unravelling of the philosophy and practice of public service broadcasting, arguably one of the most important vehicles of social modernism in the twentieth century. By the end of the century, the agents of commercialism are, just as everywhere else in the world, hegemonic: they are not only 'the laughing third', they are also having, for the time being at

least, the last laugh. They now have virtually complete power in defining our televisual pleasures for us: hedonism is now the official ideology of the television institution, intimately linked to the desire-producing logic of consumer capitalism. This is one way we can understand television in the 'postmodern age'.

2

On the politics of empirical audience research

In his pioneering book, *The 'Nationwide' Audience*, David Morley situates his research on which the book reports as follows:

> The relation of an audience to the ideological operations of television remains in principle an empirical question: the challenge is the attempt to develop appropriate methods of empirical investigation of that relation.
>
> (Morley 1980a: 162)

Although this sentence may initially be interpreted as a call for a methodological discussion about empirical research techniques, its wider meaning should be sought in the theoretical and political context of Morley's work. To me, the importance of *The 'Nationwide' Audience* does not so much reside in the fact that it offers an empirically validated, and thus 'scientific', account of 'the ideological operations of television', nor merely in its demonstration of some of the ways in which the television audience is 'active'. Other, more wide-ranging issues are at stake – issues related to the *politics* of research.

Since its publication in 1980, *The 'Nationwide' Audience* has played an important role in media studies. The book occupies a key strategic position in the study of media audiences – a field of study that went through a rapid development in the 1980s. It seems fair to say that this book forms a major moment in the growing popularity of an 'ethnographic' approach on media audiences – Morley himself has termed his project an 'ethnography of reading' (1981: 13). This type of qualitative empirical research, usually carried out in the form of in-depth interviews with a small number of people (and at times supplemented with some form of participant observation), is now recognized by many as one of the best ways to learn about the differentiated subtleties of people's engagements with television and other media.

This 'ethnographic' approach has gained popularity in both 'critical' media studies and 'mainstream' mass communications research (see, e.g.,

Hobson 1980 and 1982; Lull 1980 and 1988; Radway 1984; Ang 1985; Jensen 1986; Lindlof 1987; Liebes and Katz 1990). A sort of methodological consensus has emerged, a common ground in which scholars from divergent epistemological backgrounds can thrive. On the one hand, qualitative methods of empirical research seem to be more acceptable than quantitative ones because they offer the possibility to avoid what C. Wright Mills (1970) has termed abstracted empiricism – a tendency often levelled at the latter by 'critical' scholars. On the other hand, some 'mainstream' audience researchers are now acknowledging the limitations on the kind of data that can be produced by large-scale, quantitative survey work, and believe that ethnographically oriented methods can overcome the shortcomings observed. Given this enthusiastic, rather new interest in qualitative research methods, I would like to reflect upon its general implications for our understanding of television audiences. What kind of knowledge does it produce? What can this manner of doing empirical research on audiences mean? In short, what are the politics of audience 'ethnography'?[1]

In exploring these questions, I want to clarify some of the issues that are at stake in developing a *critical* perspective in empirical audience studies. The term 'critical' as I would like to use it here refers first of all to a certain intellectual-political *orientation* towards academic practice: whatever its subject matter or methodology, essential to doing 'critical' research would be the adoption of a self-reflective perspective, one that is, first, conscious of the social and discursive nature of any research practice, and, second, takes seriously the Foucauldian reminder that the production of knowledge is always bound up in a network of power relations (Foucault 1980). By characterizing 'critical' research in this way, that is, as an orientation rather than as a fixed 'paradigm', I aim to relativize the more rigid ways in which 'critical' and 'mainstream' research have often been opposed to one another.

Formally speaking, positions can only be 'critical' or 'mainstream' in relation to other positions within a larger discursive field. The two terms thus do not primarily signify fixed contents of thought, but their status within a whole, often dispersed, field of statements, claims and knowledges, what Foucault calls a 'regime of truth'. The relations of force in that field can change over time: what was once 'critical' (or marginal) can become part of the 'mainstream'; what was once 'mainstream' (or dominant) can lose its power and be pushed aside to a marginal(ized) position. Furthermore, as Larry Grossberg (1987) has usefully remarked, the term 'critical' can bear uneasy arrogant connotations: after all, is there any scholar whose work is not 'critical' in some sense?

This does not mean, of course, that the distinction is totally devoid of any substantive bearings. In media studies, for instance, the 'critical' tradition, whose beginnings can be located in the work of the Frankfurt School, has generally derived its philosophical and political inspiration from European

schools of thought such as Marxism and (post)structuralism. In terms of research problematics, 'critical' media researchers have mainly been concerned with the analysis of the ideological and/or economic role of the media in capitalist and patriarchal society. Furthermore, the epistemological underpinnings of this kind of work are generally characterized by a strident anti-positivist and anti-empiricist mentality.[2]

This distrust of positivist empiricism on the part of 'critical' theorists, however, does not necessarily imply an *inherent* incompatibility between 'critical' and empirical research, as is often contended by 'mainstream' scholars.[3] Indeed, if doing 'critical' research is more a matter of intellectual-political orientation than of academic paradigm building, then no fixed, universal yardstick, theoretical or methodological, for what constitutes 'critical' knowledge is possible. On the contrary, in my view what it means to be critical needs to be assessed and constantly reassessed in every concrete conjuncture, with respect to the concrete issues and directions that are at stake in any concrete research field. In other words, I am proposing an *open* and *contextual* definition of 'critical' research, one that does not allow itself to rest easily on pre-existent epistemological foundations but, on the contrary, is reassessed continuously according to the ways in which it contributes to our understanding of the world. In the following, I hope to clarify some of the implications of this perspective on doing 'critical' research for an evaluation of the current developments in audience studies as I indicated above.

More concretely, what I will discuss and try to elaborate in this chapter is what I take as the political and theoretical specificity of the *cultural studies* approach as a 'critical' perspective, from which David Morley, coming from the Birmingham Centre for Contemporary Cultural Studies, has developed his work (see Hall *et al.* 1980; Streeter 1984; Fiske 1987b). I will set this perspective on audience studies against some developments in and around the uses and gratifications approach, where an interest in 'ethnographic' methods has been growing recently. In doing this I will not be able to discuss the wide range of concrete studies that have been made in this area. Rather I will restrict myself, somewhat schematically and all too briefly, to the more programmatic statements and proposals pertaining to the identity and the future development of the field, and evaluate them in the light of what I see as important for a critical cultural studies approach. Furthermore, it is not my intention to construct an absolute antagonism between the two approaches. Rather, I would like to highlight some of the differences in preoccupation and perspective, in order to specify how ethnographic or ethnographically oriented studies of media audiences can contribute to a 'critical' approach in the sense I have outlined. Before doing this, I will first give a short sketch of the intellectual arena in which Morley intervened.

THE PROBLEM OF THE DISAPPEARING AUDIENCE

The 'Nationwide' Audience appeared at a time when critical discourse about film and television in Britain was heavily preoccupied with what Morley (1980a: 161), following Steve Neale, calls an 'abstract text/subject relationship', formulated within a generally (post)structuralist and psycho-analytic theoretical framework. In this discourse, primarily developed in the journal Screen, film and television spectatorship is almost exclusively theorized from the perspective of the 'productivity of the text'. As a consequence, the role of the viewer was conceived in purely formalist terms: as a position inscribed in the text. Here, the subject-in-the-text tends to collapse with 'real' social subjects. In this model, there is no space for a dialogical relationship between texts and social subjects. Texts are assumed to be the only source of meaning; they construct subject positions which viewers are bound to take up if they are to make sense of the text. In other words, the reading of texts is conceived in 'Screen theory' as entirely dictated by textual structures.

It is this model's textual determinism that fuelled Morley's dissatisfaction. Theoretically, it implied an ahistorical, asocial and generalist conception of film and TV spectatorship. Methodologically, the analysis of textual structures alone was considered to be sufficient to comprehend how viewers are implicated in the texts they encounter. Politically, this model left no room for manoeuvre for television viewers. They are implicitly conceived as 'prisoners' of the text. It was against this background that Morley decided to undertake an empirical investigation of how groups of viewers with different social positions read or interpret one particular text: an episode of the British TV magazine programme Nationwide. One of the most important motivations of Morley's intervention, then, was to overcome the textualism of Screen theory's discourse, in which the relation of text and subject is dealt with 'as an a priori question to be deduced from a theory of the ideal spectator "inscribed" in the text' (Morley 1980a: 162). By looking at how one text could be decoded in different ways by different groups of social subjects, Morley's intention, in which he was successful, was to demonstrate that encounters between texts and viewers are far more complex than the textualist theory would suggest; they are overdetermined by the operation of a multiplicity of forces – certain historical and social structures, but also other texts – that simultaneously act upon the subjects concerned.[4] What The 'Nationwide' Audience explores is the notion that the moment of decoding should be considered as a relatively autonomous process in which a constant struggle over the meaning of the text is fought out. Textual meanings do not reside in the texts themselves: a certain text can come to mean different things depending on the interdiscursive context in which viewers interpret it.

The significance of Morley's turn towards empirical research of the

television audience should be assessed against this critical background. It is first of all a procedure that is aimed at opening up a space in which watching television can begin to be understood as a complex cultural practice full of dialogical negotiations and contestations, rather than as a singular occurrence whose meaning can be determined once and for all in the abstract. Doing empirical research, then, is here used as a strategy to break out of a hermetically closed theoreticism in which an absolute certainty about the ideological effectivity of television is presumed. Thus, when Morley says that the relation of an audience to television 'remains an empirical question', what he is basically aiming at is to open up critical discourse on television audiences, and to sensitize it for the possibility of struggle in the practices of television use and consumption – a struggle whose outcome cannot be known in advance, for the simple reason that encounters between television and audiences are always historically specific and context-bound.

ACADEMIC CONVERGENCE?

The 'Nationwide' Audience has generally been received as an innovative departure within cultural studies, both theoretically and methodologically. If Screen theory can be diagnosed as one instance in which critical discourse on television suffered from 'the problem of the disappearing audience' (Fejes 1984), Morley's project represents an important acknowledgement within cultural studies that television viewing is a practice that involves the active production of meanings by viewers. But the book has not only made an impact in cultural studies circles. Curiously, but not surprisingly, it has also been welcomed by adherents of the uses and gratifications approach, one of the most influential 'mainstream' strands of audience research in mass communication scholarship. These scholars see books such as Morley's as an important step on the part of 'critical' scholars in their direction, that is, as a basic acceptance of, and possible contribution to, a refinement of their own basic axiomatic commitment to 'the active audience'. At the same time, some uses and gratifications researchers, for their part, have now incorporated some of the insights developed within the 'critical' perspective into their own paradigm. For example, they have adopted semiologically informed cultural studies concepts such as 'text' and 'reader' in their work. This move indicates an acknowledgement of the symbolic nature of negotiations between media texts and their readers which they, in their narrow functionalist interest in the multiple relationships between audience 'needs' and media 'uses', had previously all but ignored. As Jay Blumler, Michael Gurevitch and Elihu Katz admit:

> Gratifications researchers, in their paradigmatic personae, have lost sight of what the media are purveying, in part because of an over-commitment to the endless freedom of the audience to reinvent the

text, in part because of a too rapid leap to mega-functions, such as surveillance or self-identity.

(Blumler *et al.* 1985: 272)

On top of this conceptual rapprochement, they have also expressed their delight in noticing a methodological 'concession' among 'critical' scholars: at last, so they exclaim, some 'critical' scholars have dropped their suspicion of doing empirical research. In a benevolent, rather fatherly tone, Blumler, Gurevitch and Katz, three senior ambassadors of the uses and gratifications approach, have thus proclaimed a gesture of 'reaching out' to the other 'camp' (1985: 275). Therefore the prospect is evoked of a merger of the two approaches, to the point that they may ultimately fuse into a happy common project in which the perceived hostility between the two 'camps' will have been unmasked as academic 'pseudo-conflicts'. As one leading gratifications researcher, Karl Erik Rosengren, optimistically predicts: 'To the extent that the same problematics are empirically studied by members of various schools, the present sharp differences of opinion will gradually diminish and be replaced by a growing convergence of perspectives' (1983: 203).[5]

However, to interpret these recent developments in audience studies in terms of such a convergence is to simplify and even misconceive what is at stake in the 'ethnographic turn' within cultural studies. For one thing, I would argue that cultural studies and uses and gratifications research only superficially share 'the same problematics', as Rosengren would have it. Also, what separates a 'critical' from a 'mainstream' perspective is more than merely some 'differences of opinion', sharp or otherwise. Rather, it concerns fundamental differences not only in epistemological but also in theoretical and political attitudes towards the aim and status of doing empirical work in the first place.

The academic idealization of joining forces in pursuit of a supposedly common goal as if it were a neutral, scientific project is a particularly depoliticizing strategy, because it tends to neutralize all antagonism and disagreement in favour of a forced consensus. If I am cautious and a little wary about this euphoria around the prospect of academic convergence, it is not my intention to impose a rigid and absolute, eternal dichotomy between 'critical' and 'mainstream' research. Nor would I want to assert that Morley's project is entirely 'critical' and the uses and gratifications approach completely 'mainstream'. As I have noted before, the relationship between 'critical' and 'mainstream' is not a fixed one; it does not concern two mutually exclusive, antagonistic sets of knowledge, as some observers would imply by talking in terms of 'schools', 'paradigms' or even 'camps'. In fact, many assumptions and ideas do not, in themselves, intrinsically belong to one or the other perspective. For example, the basic assumption that the audience is 'active' (rather than passive) and that watching television is a social (rather than an individual) practice is currently accepted in both

perspectives. There is nothing spectacular about that.[6] What matters is how this idea of 'activeness' is articulated with a more general theory of social agency and power. Also, I would suggest that the idea that texts can generate multiple meanings because readers/viewers can 'negotiate' textual meanings is not in itself a sufficient condition for the declared convergence. For example, Tamar Liebes has suggested that 'the focus of the convergence is on the idea that the interaction between messages and receivers takes on the form of negotiation, and is not predetermined' (1986: 1). However, as I will try to show below, what makes all the difference is the way in which 'negotiation' is conceived. After all, 'not predetermined' does not mean 'undetermined'; on the contrary.

While uses and gratifications researchers generally operate within a liberal pluralist conception of society where individuals are seen as ideally free, that is, unhindered by external powers, in cultural studies, following Marxist/(post)structuralist assumptions, people are conceived as always-already implicated in, and necessarily constrained by, the web of relationships and structures which constitute them as social subjects. This doesn't mean that they are stripped of agency like preprogrammed automatons, but that that agency itself, or the 'negotiations' subjects undertake in constructing their lives, is *over*determined (i.e. neither predetermined nor undetermined) by the concrete conditions of existence they find themselves in. Following Hall (1986b: 46), 'determinacy' here is understood in terms of the setting of limits, the establishment of parameters, the defining of the space of operations, rather than in terms of the absolute predictability of particular outcomes. This is what Hall (1986c) calls a 'Marxism without guarantees', a non-determinist theory of determination, or, to put it simply, a recognition of the virtual truism that 'people make their own history but under conditions not of their own making'.

How complex structural and conjunctural determinations of viewership and audiencehood should be conceived remains therefore an important point of divergence between 'critical' and 'mainstream' studies. Finally, it is also noteworthy to point out that, while uses and gratifications researchers now seem to be 'rediscovering the text', researchers working within a cultural studies perspective seem to be moving away from the text. This is very clear in Morley's second book, *Family Television* (1986), on which I will comment later. In fact, it becomes more and more difficult to delineate what 'the television text' is in a media-saturated world.

In other words, in evaluating whether we can really speak of a para-digmatic convergence, it is not enough to establish superficially similar research questions, nor to take at face value a shared acknowledgement of the usefulness of certain methods of inquiry. Of course, such commonalities are interesting enough and it would be nonsense to categorically discard them. I do think it is important to avoid a dogmatism or antagonism-for-the-sake-of-it, and to try to learn from others wherever that is possible. But

at the same time we should not lose sight of the fact that any call for a convergence itself is not an innocent gesture. It tends to be done from a certain point of view, and therefore necessarily involves a biased process in which certain issues and themes are highlighted and others suppressed. And it is my contention that an all too hasty declaration of convergence could lead to neglecting some of the most important distinctive features of cultural studies as a critical intellectual enterprise.

A difference in conceptualizing the object of study is a first issue that needs to be discussed here. As I have already suggested, in a cultural studies perspective 'audience activity' cannot and should not be studied nominal-istically, decontextualized from the larger network of social relationships in which it occurs. The aim of cultural studies is not a matter of dissecting 'audience activity' in ever more refined variables and categories so that we can ultimately have a complete and generalizable formal 'map' of all dimensions of 'audience activity' (which seems to be the drive behind the uses and gratifications project; e.g. Levy and Windahl 1984, 1986). Rather, the aim, as I see it, is to arrive at a more historicized and contextualized insight into the ways in which 'audience activity' is articulated within and by a complex set of social, political, economic and cultural forces. In other words, what is at stake is not the understanding of 'audience activity' as such as an isolated and isolatable object of research, but the embeddedness of 'audience activity' in a complex network of ongoing cultural practices and relationships.

As a result, an audience researcher working within a cultural studies sensibility cannot restrict herself or himself to 'just' studying audiences and their activities (and, for that matter, relating those activities with other variables such as gratifications sought or obtained, dependencies, effects, and so on). She or he will also engage herself/himself with the structural and cultural *processes* through which the audiences she or he is studying are constituted and being constituted. Thus, one essential theoretical point of the cultural studies approach of the television audience is its foregrounding of the notion that the dynamics of watching television, no matter how heterogeneous and seemingly free, are always related to the operations of forms of social power. It is in this light that we should see Morley's decision to do research on viewers' decodings: it was first of all motivated by an interest in what he in the quote at the beginning of this chapter calls 'the ideological operations of television'.

It is important then to emphasize that the reference to 'the active audience' does not occupy the same theoretical status in the two approaches. From a cultural studies point of view, evidence that audiences are 'active' cannot simply be equated with the rather triumphant, liberal pluralist conclusion, often displayed by gratificationists, that media consumers are 'free' or even 'powerful' – a conclusion which allegedly undercuts the idea of 'media hegemony'. The question for cultural studies is not simply one of 'where the

42

power lies in media systems' (Blumler *et al.* 1985: 260) – i.e. with the audience or with the media producers – but rather how relations of power are organized within the heterogeneous practices of media use and consumption. In other words, rather than constructing an opposition between 'the' media and 'the' audience, as if these were separate ontological entities, and, along with it, the application of a distributional theory of power – i.e. power conceived as a 'thing' that can be attributed to either side of the opposing entities – cultural studies is interested in understanding media consumption as a site of cultural struggle, in which a variety of forms of power are exercised, with different sorts of effects.[7] Thus if, as Morley's study has shown, viewers decode a text in different ways and sometimes even give oppositional meanings to it, this should be understood not as an example of 'audience freedom', but as a moment in that cultural struggle, an ongoing struggle over meaning and pleasure which is central to the fabric(ation) of everyday life.

I hope to have made it clear by now that in evaluating the possibility or even desirability of a paradigmatic convergence, it is important to look at how 'audience activity' is theorized or interpreted, and how research 'findings' are placed in a wider theoretical framework. So, if one type of 'audience activity' which has received much attention in both approaches has been the 'interpretive strategies' used by audiences to read media texts (conceptualized in terms of decoding structures, interpretive communities, patterns of involvement, and so on), how are we to make sense of those interpretive strategies? The task of the cultural studies researcher, I would suggest, is to develop *strategic interpretations* of them, different not only in form and content but also in scope and intent from those offered in more 'mainstream' accounts.[8] I will return to this central issue of interpretation below.

BEYOND METHODOLOGY

A troubling aspect about the idea of (and desire for) convergence, then, is that it tends to be conceptualized as an exclusively 'scientific' enterprise. Echoing the tenets of positivism, its aim seems to be the gradual accumulation of scientifically confirmed 'findings'. It is propelled by the hope that by seeking a shared agreement on what is relevant to study and by developing shared methodological skills, the final scientific account of 'the audience' can eventually be achieved. In this framework, audience research is defined as a specialized niche within an academic discipline (e.g. 'mass communication'), in which it is assumed that 'the audience' is a proper object of study whose characteristics can be ever more accurately observed, described, categorized, systematized and explained until the whole picture is 'filled in'. In other words, this scientific project implicitly claims in principle (if not in practice) to be able to produce total knowledge, to reveal

the full and objective 'truth' about 'the audience'. The audience here is imagined as, and turned into, an object with researchable attributes and features (be it described in terms of preferences, uses, effects, decodings, interpretive strategies, or whatever) that can be definitively known – if only researchers of different breeding would stop quarrelling with each other and unite to work harmoniously together to accomplish the task.[9]

From such a point of view, the question of *methodology* becomes a central issue. After all, rigour of method has traditionally been seen as the guarantee *par excellence* for the 'scientific' status of knowledge. In positivist social science, the hypothetico-deductive testing of theory through empirical research, quantitative in form, is cherished as the cornerstone of the production of 'scientific' knowledge. Theory that is not empirically tested or that is too complex to be moulded into empirically testable hypotheses has to be dismissed as 'unscientific'. These assumptions, which are more or less central to the dominant version of the uses and gratifications approach as it was established in the 1970s, are now contested by a growing number of researchers who claim that reality cannot be grasped and explained through quantitative methods alone. Stronger still, they forcefully assert that to capture the multidimensionality and complexity of audience activity the use of qualitative methods – and thus a move towards the 'ethnographic' – is desperately called for (cf. Lull 1986; Jensen 1987; Lindlof and Meyer 1987).

From a 'scientific' point of view, it is this methodological challenge that forms the condition of possibility of the perceived convergence. However, although I think that the struggle for legitimization of qualitative research is a very important one, I do believe that it is not the central point for critical cultural studies. This is the case because, as the struggle is defined as a matter of methodology, its relevance is confined to the development of audience research as an *academic* enterprise. Of course, this development is in itself interesting given the decades-long hegemony of positivism and the quantifying attitude in audience research. Furthermore, the growing influence of alternative 'paradigms' such as ethnomethodology and symbolic interactionism should certainly be welcomed. The problem with many 'mainstream' claims about the usefulness of qualitative methods, however, is that they are put forward in the name of 'scientific progress', without questioning the epistemological distinction between Science and common-sense which lies at the heart of positivism. The aim still seems to be the isolation of a body of knowledge that can be recognized as 'scientific' (in its broadest meaning), the orientation being one towards the advancement of an academic discipline, and, concomitantly, the technical improvement of its instruments of analysis.

A cultural studies perspective on audience research cannot stop short at this level of debate. For a critical cultural studies, it is not questions of methodology, nor 'scientific progress' that prevail. On the contrary, we

should relativize the academic commitment to increasing knowledge *per se*, and resist the temptation of what Stuart Hall (1986b: 56) has called the 'codification' of cultural studies into a stable realm of established theories and canonized methodologies. In this respect, the territorial conflict between 'mainstream' and 'critical' research, quantitative and qualitative methods, humanistic and social-scientific disciplines, and so on, should perhaps not bother us too much at all in the first place. As James Carey once remarked, '[p]erhaps all the talk about theory, method, and other such things prevents us from raising, or permits us to avoid raising, deeper and disquieting questions about the purposes of our scholarship' (1983: 5). And indeed: why are we so interested in knowing about audiences in the first place? In empirical audience research, especially, it is important to reflect upon the politics of the knowledge produced. After all, scrutinizing media audiences is not an innocent practice. It does not take place in a social and institutional vacuum. As we all know, historically, the hidden agenda of audience research, even when it presents itself as pure and objective, has all too often been its commercial or political usefulness. In other words, what we should reflect upon is the *political* interventions we make when studying audiences – political not only in the sense of some external societal goal, but, more importantly, in that we cannot afford to ignore the political dimensions of the process and practice of the production of knowledge itself. What does it mean to subject audiences to the researcher's gaze? How can we develop insights that do not reproduce the kind of objectified knowledge served up by, say, market research or empiricist effects research? How is it possible to do audience research which is 'on the side' of the audience?[10] These are nagging political questions which cannot be smoothed out by the comforting canons of epistemology, methodology and Science.

Of course it is not easy to pin down what such considerations would imply in concrete terms. But it could at least be said that we should try to avoid a stance in which 'the audience' is relegated to the status of exotic 'other' – merely interesting in so far as 'we', as researchers, can turn 'them' into 'objects' of study, and about whom 'we' have the privileged position of acquiring 'scientific' knowledge.[11] To begin with, I think, critical audience studies should not strive and pretend to tell 'the truth' about 'the audience'. Its ambitions should be much more modest. As Grossberg has suggested, 'the goal of [critical research] is to offer not a polished representation of the truth, but simply a little help in our efforts to better understand the world' (1987: 89). This modesty has less to do with some sort of false humility than with the basic acknowledgement that every research practice unavoidably takes place in a particular historical situation, and is therefore in principle of a partial nature. As Hammersley and Atkinson have provocatively put it, 'all social research takes the form of participant observation: it involves participating in the social world, in whatever role, and reflecting on the products of that participation' (1983: 16). The collection of data, either

quantitative or qualitative in form, can never be separated from its interpretation; it is only through practices of interpretive theorizing that unruly social experiences and events related to media consumption become established as meaningful 'facts' about audiences. Understanding 'audience activity' is thus caught up in the discursive representation, not the transparent reflection, of diverse realities pertaining to people's engagements with media.

These considerations lead to another, more politicized conception of doing research. It is not the search for (objective, scientific) Truth in which the researcher is engaged, but the construction of *interpretations*, of certain ways of understanding the world, always historically located, subjective and relative. It is the decisive importance of this interpretive moment that I would like to highlight in exploring the possibilities of a critical audience studies.[12]

In positivism, the necessarily worldly nature of interpretation is repressed, relegated to the refuted realm of 'bias'. It is assumed to follow rather automatically – i.e. without the intervention of the subjective 'whims' of the researcher – from the controlled process of 'empirical testing of theory'. An apparent innocence of interpretation is then achieved, one that is seemingly grounded in 'objective social reality' itself. In fact, the very term 'interpretation' would seem to have definite negative connotations for positivists because of its connection with 'subjectivism'. And even within those social science approaches in which the interpretive act of the researcher – i.e. the moment of data analysis that comes after data collection – is taken more seriously, interpretation is more often than not problematized as a technical rather than a political matter, defined in terms of careful inference making rather than in terms of discursive constructions of reality.

It should be recognized, however, that because interpretations always inevitably involve the construction of certain representations of reality (and not others), they can never be 'neutral' and merely 'descriptive'. After all, the 'empirical', captured in either quantitative or qualitative form, does not yield self-evident meanings; it is only through the interpretive framework constructed by the researcher that understandings of the 'empirical' come about. No 'theory' brought to bear on the 'empirical' can ever be 'value-neutral'; it is always 'interested' in the strong sense of that word. Here, then, the thoroughly political nature of any research practice manifests itself. What is at stake is a *politics of interpretation*: '[T]o advance an interpretation is to insert it into a network of power relations' (Pratt 1986: 52).

Of course, this also implies a shift in the position of the researcher. She or he is no longer a bearer of the truth, but occupies a 'partial' position in two senses of the word. On the one hand, she or he is no longer the neutral observer, but is someone whose job it is to produce historically and culturally specific knowledges that are the result of equally specific discursive encounters between researcher and informants, in which the subjectivity of

the researcher is not separated from the 'object' s/he is studying. The interpretations that are produced in the process can never claim to be definitive: on the contrary, they are necessarily incomplete (for they always involve simplification, selection and exclusion) and temporary. 'If neither history nor politics ever comes to an end, then theory (as well as research) is never completed and our accounts can never be closed or totalized' (Grossberg 1987: 89). On the other hand, and even more important, the position of the researcher is also more than that of the professional scholar: beyond being a capable interpreter she or he is also inherently a political and moral subject. As an intellectual s/he is responsible not only to the Academy, but to the social world s/he lives in as well, consciously or unconsciously so. It is at the interface of 'ethics' and 'scholarship' that the researcher's interpretations take on their distinctive political edge (cf. Rabinow 1986).

Of course, all this entails a different status for empirical research. Material obtained by ethnographic fieldwork or depth-interviews with audience members cannot simply be treated as direct slices of reality, as in naturalist conceptions of ethnography. Viewers' statements about their relation to television cannot be regarded as self-evident facts. Nor are they immediate, transparent reflections of those viewers' 'lived realities' that can speak for themselves. What is of critical importance, therefore, is the way in which those statements are made sense of, that is, interpreted. Here lies the ultimate political responsibility of the researcher. The comfortable assumption that it is the reliability and accuracy of the methodologies being used that will ascertain the validity of the outcomes of research, thereby reducing the researcher's responsibility to a technical matter, is rejected. In short, to return to Morley's opening statement, audience research is undertaken because the relation between television and viewers is an empirical *question*. But the empirical is not the privileged domain where the *answers* should be sought. Answers – partial ones, to be sure, that is, both provisional and committed – are to be constructed, in the form of interpretations.[13]

TOWARDS INTERPRETIVE ETHNOGRAPHY

I would now like to return to Morley's work, and evaluate its place in the research field in the light of my reflections above. To be sure, Morley himself situates his work firmly within the academic context. And parallel to the recent calls for convergence and cross-fertilization of diverse perspectives, Morley seems to have dropped his original antagonistic posture. For example, while in *The 'Nationwide' Audience* he emphasizes that 'we need to break fundamentally with the "uses and gratifications" approach' (1980a: 14),[14] in *Family Television*, he simply states that this new piece of research draws 'upon some of the insights' of this very approach (1986: 15). The latter book is also in a more general sense set in a less polemical tone than

the first one: rather than taking up a dissident's stance against other theoretical perspectives, which is a central attribute of *The 'Nationwide' Audience*, *Family Television* is explicitly presented as a study that aims to combine the perspectives of separate traditions in order to overcome what Morley calls an 'unproductive form of segregation' (ibid.: 13). Furthermore, both books have been written in a markedly conventional style of academic social science, structured according to a narrative line which starts out with their contextualization within related academic research trends, followed by a methodological exposition and a description of the findings, and rounded off with a chapter containing an interpretation of the results and some more general conclusions. In both books Morley's voice is exclusively that of the earnest researcher; the writer's 'I', almost completely eliminated from the surface of the text, is apparently a disembodied subject solely driven by a disinterested wish to contribute to 'scientific progress'.[15]

Morley's academistic inclination tends to result in a lack of clarity about the critical import and political relevance of his analyses. For example, the relevance of *Family Television* as a project designed to investigate at the same time two different types of questions regarding television consumption – questions of television use, on the one hand, and questions of textual interpretation, on the other – is simply asserted by the statement that these are 'urgent questions about the television audience' (Morley 1986: 13). But why? What kind of urgency is being referred to here? Morley goes on to say that it is the analysis of the domestic viewing context as such which is his main interest, and that he wishes to identify the multiple meanings hidden behind the catch-all phrase 'watching television'. Indeed, central to *Family Television*'s discourse are, as Hall remarks in his introduction to the book, the notions of variability, diversity and difference:

> We are all, in our heads, several different audiences at once, and can be constituted as such by different programmes. We have the capacity to deploy different levels and modes of attention, to mobilise different competences in our viewing. At different times of the day, for different family members, different patterns of viewing have different 'saliences'. Here the monolithic conceptions of the viewer, the audience or of television itself have been displaced – one hopes forever – before the new emphasis on difference and variation.
>
> (Hall 1986a: 10)

Yet when taken in an unqualified manner it is exactly this stress on difference that essentially connects Morley's project with the preoccupations of the gratificationists. After all, it is their self-declared distinctive mission to get to grips with 'the gamut of audience experience' (Blumler *et al.* 1985: 271). For them too, the idea of plurality and diversity is pre-eminently the guiding principle for research. A convergence of perspectives after all?

Despite all the agreements that are certainly there, however, a closer look

at the ramifications of Morley's undertaking reveals other concerns than merely the characterization and categorizing of varieties within viewers' readings and uses of television. Ultimately, it is not difference as such that is of main interest in Morley's work. To be sure, differences are not just simple facts that emerge more or less spontaneously from the empirical interview material; it is a matter of interpretation what are established as *significant* differences – significant not in the formal, statistical sense of that word, but in a culturally meaningful, interpretive sense. In cultural studies, then, it is the meanings of differences that matter – something that can only be grasped, interpretively, by looking at their contexts, social and cultural bases, and impacts. Thus, rather than the classification of differences and varieties in all sorts of typologies, which is a major preoccupation of a lot of uses and gratifications work, cultural studies would be oriented towards more specific and conjunctural understandings of how and why varieties in experience occur – a venture, to be sure, that is a closer approach to the ethnographic spirit.

In *Family Television*, for example, Morley has chosen to foreground the pattern of differences in viewing habits that are articulated with gender. What Morley emphasizes is that men and women clearly relate in contrasting ways to television, not only as to programme preferences, but also in, for example, viewing styles. The wives interviewed by Morley tend to watch television less attentively, at the same time doing other things such as talking or doing some housework. The husbands, in contrast, state a clear preference for viewing attentively, in silence, without interruption, 'in order not to miss anything' (Morley 1986: chapter 6). These differences are substantiated and highlighted by Morley's research as empirical facts, but he is careful to avoid considering these as *essential* differences between men and women. As Charlotte Brunsdon has noted, it seems possible

> to differentiate a male – fixed, controlling, uninterrupted gaze – and a female – distracted, obscured, already busy – manner of watching television. There is some empirical truth in these characterizations, but to take this empirical truth for explanation leads to a theoretical short-circuit.
>
> (Brunsdon 1986: 105)

Indeed, in mainstream sociological accounts, gender would probably be treated as a self-evident pregiven factor that can be used as 'independent variable' to explain these differences. Male and female modes of watching television would then be constituted as two separate, discrete types of experience, clearly defined, fixed, static 'objects' in themselves as it were.[16] Such an empiricist account not only essentializes gender differences, but also fails to offer an understanding of how and why differentiations along gender lines take the very forms they do.

In contrast to this, both Morley and Brunsdon start out to construct a

tentative interpretation which does not take the difference between male and female relations to television as an empirical given. Neither do they take recourse to psychological notions such as 'needs' or 'socialization' – as is often done in accounts of gender differences, as well as in uses and gratifications research – to try to understand why men and women tend to watch and talk about television in the disparate ways they do. In their interpretive work Morley and Brunsdon emphasize the structure of domestic power relations as constitutive for the differences concerned. The home generally has different meanings for men and women living in nuclear family arrangements: for husbands it is the site of leisure, for wives it is the site of work. Therefore, television as a domestic cultural form tends to be invested with different meanings for men and women. Television has for men become a central symbol for relaxation; women's relation to television, on the other hand, is much more contradictory. Brunsdon has this to say on Morley's research:

> The social relations between men and women appear to work in such a way that although the men feel ok about imposing their choice of viewing on the whole of the family, the women do not. The women have developed all sorts of strategies to cope with television viewing they don't particularly like. The men in most cases appear to feel it would be literally unmanning for them to sit quiet during the women's programmes. However, the women in general seem to find it almost impossible to switch into the silent communion with the television set that characterises so much male viewing.
>
> (Brunsdon 1986: 104)

Women's distracted mode of watching television, then, does not have something to do with some essential femininity, but is a result of a complex of cultural and social arrangements which makes it difficult for them to do otherwise, even though they often express a longing to be able to watch their favourite programmes without being disturbed. Men, on the other hand, can watch television in a concentrated manner because they control the conditions to do so. Their way of watching television, Brunsdon concludes, 'seems not so much a masculine mode, but a mode of power' (1986: 106).

What clearly emerges here is the beginning of an interpretive framework in which differences in television-viewing practices are not just seen as expressions of different needs, uses or readings, but are connected with the way in which particular social subjects are structurally positioned in relation to each other. In the context of the nuclear family home, women's viewing patterns can only be understood in relation to men's patterns; the two are in a sense constitutive of each other. Thus, if watching television is a social and even collective practice, it is not a harmonious practice.[17] Because subjects are positioned in different ways towards the set, they engage in a continuing struggle over programme choice and programme interpretation,

styles of viewing and textual pleasure. What kind of viewer they become can be seen as the outcome of this struggle, an outcome, however, that is never definitive because it can always be contested and subverted. What we call 'viewing habits' are thus not a more or less static set of behaviours inhabited by an individual or group of individuals; rather they are the temporary result of a neverending, dynamic and conflictual process in which 'the fine-grained interrelationships between meaning, pleasure, use and choice' are shaped (Hall 1986a: 10).

Morley's empirical findings, then, acquire their relevance and critical value in the context of this emerging theoretical understanding. And of course it could only have been carried out from a specific interpretive point of view. Needless to say, the point of view taken up by Morley and Brunsdon is a feminist one, that is, a worldly intellectual position that is sensitive to the micro-politics of male/female relationships. Television consumption, so we begin to understand, contributes to the everyday construction of male and female subjectivities through the relations of power, contradiction and struggle that men and women enter into in their daily engagements with the TV sets in their homes. At this point, we can also see how Morley's research enables us to begin to conceive of 'the ideological operations of television' in a much more radical way than has hitherto been done. The relation between television and audiences is not just a matter of discrete 'negotiations' between texts and viewers. In a much more profound sense the process of television consumption – and the positioning of television as such in the culture of modernity – has created new areas of constraints and possibilities for structuring social relationships, identities and desires. If television is an 'ideological apparatus', to use that oldfashioned-sounding term, then this is not so much because its texts transmit certain 'messages', but because it is a cultural form through which those constraints are negotiated and those possibilities take shape.

But, one might ask, do we need empirical research, or, more specifically, ethnographic audience research, to arrive at such theoretical understandings? Why examine audiences empirically at all? After all, some critical scholars still dismiss the idea of doing empirical audience research altogether, because, so they argue, it would necessarily implicate the researcher with the strategies and aims of the capitalist culture industry (e.g. Modleski 1986: xi–xii). Against this background, I would like to make one last comment on Morley's work here. Due to his academistic posture Morley has not deemed it necessary to reflect upon his own position as a researcher. We do not get to know how he found and got on with his interviewees, nor are we informed about the way in which the interviews themselves took place. One of the very few things we learn about this in *Family Television* is that he gave up interviewing the adults and the young children at the same time, reportedly 'because after an initial period of fascination the young children quite quickly got bored' (Morley 1986: 174)! But what about the adults? What were the

reasons for their willingness to talk at such length to an outsider (or was David Morley not an outsider to them)? And how did the specific power relationship pervading the interview situation affect not only the families, but also the researcher himself? These are problems inherent to conducting ethnographic research that are difficult to unravel. But that does not mean that audience researchers should not confront them, and, eventually, draw the radical and no doubt uncomfortable conclusions that will emerge from that confrontation. We can think of Valerie Walkerdine's provocative and disturbing query:

> Much has been written about the activity of watching films in terms of scopophilia. But what of that other activity, [. . . .] this activity of research, of trying so hard to understand what people see in films? Might we not call this the most perverse voyeurism?
>
> (Walkerdine 1986: 166)

It is, of course, important for us to recognize the inherent symbolic violence of any kind of research. However, we cannot renounce our inevitable complicity simply by not doing research at all, empirical or otherwise. Indeed, such a retreat would only lead to the dangerous illusion of our own exemption from the realities under scrutiny, including the realities of living with the media – as if it were possible to keep our hands clean in a fundamentally dirty world. It is precisely for this reason that I believe that, in the expanding field of audience studies, an ethnographic approach can and does have a distinct critical value. Ethnographic work, in the sense of drawing on what we can perceive and experience in everyday settings, acquires its critical edge when it functions as a reminder that reality is always more complicated and diversified than our theories can represent, and that there is no such thing as 'audience' whose characteristics can be set once and for all.[18] The critical promise of the ethnographic attitude resides in its potential to make and keep our interpretations sensitive to concrete specificities, to the unexpected, to history; it is a commitment to submit ourselves to the possibility of, in Paul Willis's words, 'being "surprised", of reaching knowledge not prefigured in one's starting paradigm' (1980: 90). What matters is not the certainty of knowledge about audiences, but an ongoing critical and intellectual engagement with the multifarious ways in which we constitute ourselves through media consumption. Or, as in the words of Stuart Hall: 'I am not interested in Theory, I am interested in going on theorizing' (1986b: 60).

3

New technologies, audience measurement and the tactics of television consumption

THE PROBLEM OF THE AUDIENCE

In February 1990, Walt Disney Studios decided to prohibit cinema theatres in the United States from airing commercials before screening Disney-produced movies. The decision was made because the company had received a great number of complaints from spectators who did not want to be bothered by advertising after having paid $7.50 for seeing a film, leading the company to conclude that commercials 'are an unwelcome intrusion' into the filmgoing experience (Hammer 1990: 38). Of course, Disney's decision was informed by economic motives: it feared that commercials before films would have a negative effect on the number of people willing to go to the movies, and thus on its box-office revenues. As a result, the issue of in-theatre advertising is now a controversial one in Hollywood.

This case clarifies a major contradiction in the institutional arrangement of the cultural industries. More precisely, the conflicting corporate interests represented by two types of consumption are at stake here: a conflict between media consumption, on the one hand, which is the profit base for media companies such as Disney, and the consumption of material goods, on the other, presumably to be enhanced by the showing of commercials. In this case, the conflict inheres in the very logic of cinema spectatorship as a consumer activity, both economic and cultural. Films are discrete media products, to be watched one at a time by consumers who pay a fixed entrance fee in advance in order to be able to see the film of their choice. In this exchange, commercials are not included in the bargain. On the contrary, it is suggestive of the controversial social meaning of advertising that commercials are seen to hurt rather than enrich the value of cinemagoing. In the cinema, the consumption of the film is to be clearly marked off from the selling of goods and services through advertising, both in the experience of the film consumer and in the economic logic of the industry.

The situation is altogether different with television. The very corporate foundation of commercial television rests on the idea of 'delivering audiences to advertisers'; that is, economically speaking, television programming

is first and foremost a vehicle to attract audiences for the 'real' messages transmitted by television: the advertising spots inserted within and between the programmes (e.g. Smythe 1981). The television business, in other words, is basically a 'consumer delivery enterprise' for advertisers. So, in the context of this structural interdependence of television broadcasters and advertisers, television consumption takes on a double meaning: it is consumption both of programmes and of commercials; the two presuppose one another – at least, from the industry's point of view. Once a consumer has bought a TV set, s/he has bought access to all broadcast television output, and in exchange for this wholesale bargain s/he is expected to expose herself/ himself to as much output as possible, including most importantly the commercials which in fact make the financing of the programmes possible. This merging of the two types of consumption is corroborated in the occurrence of one single activity, a presumably one-dimensional type of behaviour: 'watching television'. This complex intermingling of economic conditions and cultural assumptions with regard to television consumption is a necessary precondition for the construction of an institutional agreement about the exchange value of the 'audience commodity' that is bought and sold. As is well known, this agreement is reached through the intermediary practice of audience measurement, producing ratings figures on the basis of the amount of 'watching television' done by the audience. These figures are considered to be the equivalent to box-office figures for cinema attendance (see, e.g., Meehan 1984; Ang 1991).

But this equivalence is fundamentally problematic, as I will try to show in this chapter. Undertaken by large research companies such as Nielsen and Arbitron in the United States and AGB in Britain and continental Europe, audience measurement is an entrenched research practice based upon the assumption that it is possible to determine the objective size of the 'television audience'. However, recent changes in the structure of television provision, as a result of the introduction of new television technologies such as cable, satellite and the VCR, have thrown this assumption of measurability of the television audience into severe crisis. The problem is both structural and cultural: it is related to the fact that 'watching television' is generally a *domestic* consumer practice, and as such not at all the one-dimensional, and therefore measurable, type of behaviour it is presumed to be.

The domestic has always been a contested terrain when it comes to the regulation of consumption. It is a terrain which, precisely because it is officially related to the 'private sphere', is difficult to control from outside. Of course it is true, as the young Jean Baudrillard once stated, that '[c]onsumption is not [. . .] an indeterminate marginal sector where an individual, elsewhere constrained by social rules, would finally recover, in the "private" sphere, a margin of freedom and personal play when left on his [*sic*] own' (1988 [1970]: 49). The development of the consumer society has implied the hypothetical construction of an ideal consuming subject

through a whole range of strategic and ideological practices, resulting in very specific constraints, structural and cultural, within which people can indulge in the pleasures of leisurely consumption.

Indeed, it is important to note that the day-to-day, domestic practice of television consumption is accompanied by the implicit and explicit promotion of 'ideal' or 'proper' forms of consumer behaviour, propelled by either ideological or economic motives and instigated by the social institutions responsible for television production and transmission.[1] More generally, the acceptance and integration of television within the domestic sphere did and does not take place 'spontaneously', but was and is surrounded by continuous discursive practices which attempt to 'normalize' television-viewing habits.

For example, Lynn Spigel (1988) has shown how American women's magazines in the late 1940s and early 1950s responded to the introduction of television in the home with much ambivalence and hesitation, against the background of the necessity for housewives to integrate household chores with the attractions (and distractions) promised by the new domestic consumer technology. Through the advice and suggestions put forward in these magazines, they helped establish specific cultural rules for ways in which 'watching television' could be managed and regulated without disturbing the routines and requirements of family life.

However, precisely because the home has been designated as the primary location for television consumption, a 'right' way of watching television is very difficult to impose. As Roger Silverstone has put it, '[t]he status of television as technology and as the transmitter of meanings is [. . .] vulnerable to the exigencies, the social structuring, the conflicts and the rituals of domestic daily life' (1990: 179). The domestic is a pre-eminent site of everyday life and the everyday is, according to Michel de Certeau, the terrain in which ordinary people often make use of infinite local tactics to 'constantly manipulate events in order to turn them into "opportunities"' (1984: xix). 'Watching television' can be seen as one everyday practice that is often tactical in character, articulated in the countless unpredictable and unruly ways of using television that elude and escape the strategies of the television industry to make people watch television in the 'right' way. And as we shall see, the home environment only reinforces the proliferation of such tactics in the age of new television technologies.

However, the fact that television consumption has been historically constructed as taking place within the private, domestic context has paradoxically also been quite *convenient* for the television industry. Precisely because the activities of 'watching television' usually take place in sites unseen, behind the closed doors of private homes, the industry could luxuriate in a kind of calculated ignorance about the tactics by which consumers at home constantly subvert predetermined and imposed conceptions of 'watching television'.

55

Again, the cinema provides a suitable comparison. Because the cinema audience is gathered together in a public theatre, spectators' reactions to the screen are immediately available and therefore not easily ignored. For example, Disney's decision to ban commercials in theatres was, at least in part, a response to observations that audiences had booed and hissed a Diet Coke commercial in which Elton John and Paula Abdul sing the soft drink's praises (Hammer 1990). Similar audience resistance in front of the television screen at home, however, remains largely invisible to the outsider. At the same time, it seems fair to suspect that television viewers are in a far better position to avoid messages they do not want to be subjected to than cinema spectators, who are trapped in their chairs in the darkened theatre, enforced to keep their gaze directed to the large screen. After all, television viewers have the freedom to move around in their own homes when their TV set is on; there is no obligation to keep looking and they can always divert their attention to something else whenever they want to. But it is precisely this relative freedom of television audiences to use television in ways they choose to which has been conveniently repressed in the industry's imaginings of its consumers.

This repression is reflected in the rather simplistic methods of information gathering used by ratings producers to measure the size of the television audience (or segments of it). Historically, two major audience measurement technologies have dominated the field: the diary and the setmeter. In the diary method, a sample of households is selected whose members are requested to keep a (generally, weekly) diary of their viewing behaviour. At the end of the week the diaries must be mailed to the ratings firm. In the second case, an electronic meter is attached to the television sets of a sample of households. The meter gives a minute-by-minute automatic registration of the times that the television set is on or off, and of the channel it is turned on to. The data are transmitted to a home storage unit, where they are stored until they are accessed by the central office computer during the night. The meter data, which only indicate numbers of sets on, form the basis for what are called 'gross ratings', while the diary data, which are more cumbersome to produce because they presuppose the active co-operation and discipline of viewers of sample homes in filling out their individual diaries, are used to compose demographic information about audiences for specific programmes.[2]

It should be noted that these methods of measurement are grounded upon a straightforward behaviourist epistemology. 'Watching television' is implicitly defined as a simple, one-dimensional and purely objective and isolatable act. As Todd Gitlin has rightly remarked in relation to the electronic setmeter, 'The numbers only sample sets tuned in, not necessarily shows watched, let alone grasped, remembered, loved, learned from, deeply anticipated, or mildly tolerated' (1983: 54). In other words, what audience measurement information erases from its field of discernment is any specific

consideration of the 'lived reality' behind the ratings. In the quantitative discourse of audience measurement TV viewers are merely relevant for their bodies: strictly speaking, they appear in the logic of ratings only in so far as they are agents of the physical act of tuning-in. More generally, the statistical perspective of audience measurement inevitably leads to emphasizing averages, regularities and generalizable patterns rather than particularities, idiosyncrasies and surprising exceptions. What all this amounts to is the construction of a kind of streamlined map of the 'television audience', on which individual viewers are readable in terms of their resemblance to a 'typical' consumer whose 'viewing behaviour' can be objectively and unambiguously classified. In other words, in foregrounding the stable over the erratic, the likely over the fickle, and the consistent over the inconsistent, ratings discourse symbolically turns television consumption into a presumably well-organized, disciplined practice, consisting of dependable viewing habits and routines.

Imagining television consumption in this way is very handy for the industry indeed: it supplies both broadcasters and advertisers with neatly arranged and easily manageable information, which provides the agreed upon basis for their economic negotiations. The *tactical* nature of television consumption is successfully disavowed, permitting the industry to build its operations upon an unproblematic notion of what 'watching television' is all about. This, at least, characterized the relatively felicitous conditions of existence for (American) commercial television for decades.

TECHNOLOGY AND MEASUREMENT

Since the mid-1970s, however, an entirely different television landscape has unfolded before the viewer's eyes, one characterized by abundance rather than scarcity, as a result of the emergence of a great number of independent stations, cable and satellite channels. This, at least, is the situation in the United States, but it also increasingly characterizes European television provisions. By 1987, 49 per cent of American homes had been connected to a basic cable system, giving them access to cable channels such as MTV, ESPN and CNN, while 27 per cent had chosen to subscribe to one or more pay cable channels, such as Home Box Office. All in all, thirty or more channels can be received in 20 per cent of American homes. Furthermore, after a slow start the number of homes with VCRs had grown exponentially in the early 1980s, reaching about 50 per cent in 1987 (*TV World* 1987). This multiplication of consumer options has inevitably led to a fragmentation of television's audiences, which in turn has led to a perceived inadequacy of the figures provided by the existing ratings services. What's happening in the millions of living rooms now that people can choose from so many different offerings? Consequently, diverse branches of the industry

began to call for more finely tuned audience information, to be acquired through better, that is, more accurate, measurement.

This call for better measurement was articulated by criticizing the prevailing techniques and methods of measuring the television audience: the diary and the setmeter. For example, the proliferation of channels has acutely dramatized the problems inherent in the diary technique. Suddenly, the built-in subjective (and thus 'unreliable') element of the diary technique was perceived as an unacceptable deficiency. David Poltrack, vice-president of research for CBS, one of the three major US networks, voiced the problem as follows:

> It used to be easy. You watched M*A*S*H on Monday night and you'd put that in the diary. Now, if you have thirty channels on cable you watch one channel, switch to a movie, watch a little MTV, then another program, and the next morning with all that switching all over the place you can't remember what you watched.
>
> (quoted in Bedell Smith 1985: H23)

And officials of the pop music channel MTV complained that their target audience, young people between 12 and 24, consistently comes off badly in the demographic data produced through diaries, because 'younger viewers tend not to be as diligent in filling out diaries as older household members' (quoted in Livingston 1986: 130). In short, agreement grew within the industry that the possibilities of 'channel switching' and 'zapping' (swiftly 'grazing' through different channels by using the remote control device) had made the diary an obsolete measurement tool. Viewers could no longer be trusted to report their viewing accurately: they lack perfect memory, they may be too careless. In short, they behave in too capricious a manner! In this situation, calls for a 'better' method to obtain ratings data began to be raised; and better means more 'objective', that is, less dependent on the 'fallibilities' of viewers in the sample. A method that erases all traces of wild subjectivity.

The video cassette recorder has also played a major destabilizing role in the measurability of the television audience. 'Time shifting' and 'zipping' (fastforwarding commercials when playing back a taped programme) threatened to deregulate the carefully composed TV schedules of the networks. This phenomenon has come to be called 'schedule cannibalization' (cf. Rosenthal 1987), a voracious metaphor that furtively indicates the apprehension, if not implicit regret, felt in network circles about the new freedoms viewers have acquired through the VCR. Through the VCR, the tactical nature of television consumption clearly begins to manifest itself. In response, the industry demanded the measurement of the VCR audience: it wanted answers to questions such as: how often is the VCR used by which segments of the audience? Which programmes are recorded most? And when are they played back?

In the face of this growing demand for more accurate and more detailed information about television consumption, the ratings business has now come up with the 'people meter', a new audience measurement technology that was introduced in the United States in 1987.[3] The people meter is supposed to combine the virtues of the traditional setmeter and the paper-and-pencil diary: it is an electronic monitoring device that can record individual viewing rather than just sets tuned in, as the traditional setmeter does. It works as follows.

When a viewer begins to watch a programme, s/he must press a numbered button on a portable keypad, which looks like the well-known remote control device. When the viewer stops watching, the button must be pressed again. A monitor attached to the television set lights up regularly to remind the viewer of the button-pushing task. Every member of a sample family has her or his own individual button, while there are also some extra buttons for guests. Linked to the home by telephone lines, the system's central computer correlates each viewer's number with demographic data about them stored in its memory, such as age, gender, income, ethnicity and education.

There is definitely something panoptic in the conceptual arrangement of this intricate measurement technology (Foucault 1979), in that it aims to put television viewers under constant scrutiny by securing their permanent visibility. This is attractive for the industry because it holds the promise of providing more detailed and accurate data on exactly when who is watching what. The people meter boosts the hope for better surveillance of the whole spectrum of television-viewing activities, including the use of the VCR. Smaller audience segments may now be detected and described, allowing advertisers and broadcasters to create more precise target groups. New sorts of information are made available; hitherto hidden and unknown minutiae of 'audience behaviour' can now be detected through clever forms of number crunching (see, e.g., Beville 1986a and 1986b).

Still, the existing versions of the people meter are by no means considered perfect measurement instruments, as they still involve too much subjectivity: after all, they require viewer co-operation in the form of pushing buttons. A professional observer echoes the widespread feelings of doubt and distrust when he wonders:

> Will the families in the sample really take the trouble? Will they always press the buttons as they begin watching? Will they always remember to press their buttons when they leave the room – as when the telephone rings, or the baby cries?
>
> (Baker 1986: 95)

It should come as no surprise, then, that furious attempts are being made to develop a so-called *passive* people meter – one with no buttons at all – that senses automatically who and how many viewers are in front of the screen.

For example, Nielsen, the largest ratings company in the United States, has recently disclosed a plan for a rather sophisticated passive people meter system, consisting of an image-recognition technology capable of identifying the faces of those in the room. The system then decides first whether it is a face it recognizes, and then whether that face is directed towards the set (unfamiliar faces and even possibly the dog in the house will be recorded as 'visitors'). If tested successfully, this system could eventually replace the imperfect, push-button people meter, so Nielsen executives expect (*San Francisco Chronicle* 1989). In short, what seems to be desired within the television industry these days is a measurement technology that can wipe out all ambiguity and uncertainty about the precise size of the audience for any programme and any commercial at any given time.

This recent utopian drive towards technological innovation in audience measurement can be interpreted as a desperate attempt to repair the broken consensus within the television industry as a whole as to the meaning of 'watching television'. Indeed, from the industry's perspective, a kind of 'revolt of the viewer' seems to have erupted with the emergence of the new television technologies: 'watching television' now appears to be a rather undisciplined and chaotic set of behaviourial acts as viewers zip through commercials when playing back their taped shows on their VCRs, zap through channels with their remote controls, record programmes so as to watch them at times to suit them, and so on. 'After years of submitting passively to the tyranny of [network] television programmers, viewers are taking charge', comments American journalist Bedell Smith (1985: H21). This 'taking charge' can be seen as the return of the tactical nature of television consumption to the realm of visibility, shattering the fiction of 'watching television' as a simple, one-dimensional and objectively measurable activity which has traditionally formed the basis for industry negotiations and operations.

In other words, what has become increasingly uncertain in the new television landscape is exactly what takes place in the homes of people when they watch television. Reduction of that uncertainty is sought in improvements in audience measurement technology, with its promise of delivering a continuous stream of precise data on who is watching what, every day, all year long. But beneath this pragmatic solution lurks an epistemological paradox.

For one thing, as the macroscopic technological 'gaze' of audience measurement becomes increasingly microscopic, the object it is presumed to measure becomes ever more elusive. The more 'watching television' is put under the investigative scrutiny of new measurement technology, the less unambiguous an activity it becomes. 'Zipping', 'zapping', 'time shifting' and so on, are only the most obvious and most recognized tactical manoeuvres viewers engage in in order to construct their own television experience. There are many other ways of doing so, ranging from doing other things

while watching to churning out cynical comments on what's on the screen (see, e.g., Sepstrup 1986). As a result, it can no longer be conveniently assumed – as has been the foundational logic and the strategic pragmatics of traditional audience measurement – that having the TV set on equals watching, that watching means paying attention to the screen, that watching a programme implies watching the commercials inserted in it, that watching the commercials leads to actually buying the products being advertised.

To speak with de Certeau (1984), it is that which happens beneath technology and disturbs its operation which interests us here. The limits of technology are not a matter of lack of sophistication, but a matter of actual practices, of 'the murmuring of everyday practices' that quietly but unavoidably unsettle the functionalist rationality of the technological project. In other words, no matter how sophisticated the measurement technology, television consumption can never be completely 'domesticated' in the classificatory grid of ratings research, because television consumption is, despite its habitual character, dynamic rather than static, experiential rather than merely behavioural. It is a complex practice that is more than just an activity that can be broken down into simple and objectively measurable variables; it is full of casual, unforeseen and indeterminate moments which inevitably make for the ultimate unmeasurability of *how* television is used in the context of everyday life.

The problem I refer to here has been foreshadowed by a classic study by Robert Bechtel *et al.* (1972), who in the early 1970s observed a small sample of families in their homes over a five-day period. Ironically, the method these researchers used is very similar to that of the passive people meter. The families were observed by video cameras whose operation, so the researchers state, was made as unobtrusive as possible: 'There was no way to tell [for the family members] whether the camera was operating or not. The camera did not click or hum or in any way reveal whether it was functioning' (ibid.: 277). More important, however, were the insights they gained from these naturalistic observations. Their findings were provocative and even put into question the very possibility of describing and delineating 'watching television' in any simple sense as 'a behaviour in its own right': they asserted that their 'data point to an inseparable mixture of watching and non-watching as a general style of viewing behavior', and that 'television viewing is a complex and various form of behavior intricately interwoven with many other kinds of behavior' (ibid.: 298–9).

Logically, this insight should have led to the far-reaching conclusion that having people fill out diaries or, for that matter, push buttons to demarcate the times that they watch television is in principle nonsensical because there seems to be no such thing as 'watching television' as a separate activity. If it is almost impossible to make an unambiguous distinction between viewers and non-viewers and if, as a consequence, the boundaries of 'television audience' are so blurred, how could it possibly be measured?

This study was certainly ahead of its time, and its radical consequences were left aside within the industry, because they were utterly unbearable in their impracticality.[4] Instead, technological innovations in audience measurement procedures are stubbornly seen as the best hope to get more accurate information about television consumption. Still, in advertising circles, in particular, growing scepticism can be observed as to the adequacy of ratings figures, no matter how detailed and accurate, as indicators for the reach and effectiveness of their commercial messages. For example, there is a growing interest in information about the relationship between television viewing and the purchase of products being advertised in commercials. After all, this is the bottom line of what advertisers care about: whether the audiences delivered to them are also 'productive' audiences (i.e. whether they are 'good' consumers). Thus, in more avant-garde commercial research circles the search for ever more precise demographic categories, such as the people meter provides, has already been losing its credibility. As one researcher put it:

> In many cases, lumping all 18–49 women together is ludicrous. [. . .] Narrow the age spread down and it still can be ludicrous. Take a 32½ year-old woman. She could be white or black, single or married, working or unemployed, professional or blue collar. And there's lots more. Is she a frequent flier? Does she use a lot of cosmetics? Cook a lot? Own a car? Then there's the bottom line. Do commercials get to her? These are the items the advertiser really needs to know, and demographic tonnage is not the answer.
>
> (Davis 1986: 51)

The kind of research that attempts to answer these questions, currently only in an experimental stage, is known as 'single-source' measurement: the same sample of households is subjected to measurement not only of its television-viewing behaviour but also of its product-purchasing behaviour (see, e.g., Gold 1988). Arbitron's ScanAmerica, for example, is such a system. In addition to measuring television viewing (using a push-button people meter device), it supplies sample members with another technological gadget: after a trip to the supermarket, household members (usually the housewife, of course) must remove a pencil-size electronic 'wand' attached to their meter and wave it above the universal product code that is stamped on most packaged goods. When the scanning wand is replaced in the meter, the central computer subsequently matches that information with the family's recent viewing patterns, thus producing data presumably revealing the effectiveness of commercials (Beville 1986b; *Broadcasting* 1988). Needless to say, this system is technically 'flawed' because it necessitates even more active co-operation than just button-pushing. But the tremendous excitement about the prospect of having such single-source, multi-variable information, which is typically celebrated by researchers as an opportunity of

'recapturing [. . .] intimacy with the consumer' (Gold 1988: 24) or getting in touch with 'real persons' (Davis 1986: 51), indicates the increasing discontent with ordinary ratings statistics alone as signifiers for the value of the audience commodity.

Similarly, one British advertising agency, Howell, Henry, Chaldecott and Lury (HHCL), has recently caused outrage in more orthodox circles of the advertising industry by launching a strong attack on the common practice of selling and buying advertising time on the basis of people meter ratings statistics. In an advertisement in the *Financial Times* it showed a man and a woman making love in front of a television set while stating: 'Current advertising research says these people are watching your ad. Who's really getting screwed?' (see Kelsey 1990).[5] HHCL's alternative of getting to know the 'real consumer', however, is not the high-tech method of computerized single-source research, but more small-scale, qualitative, in-depth, focus group interviews with potential consumers of the goods to be advertised.

What we see in this foregrounding of qualitative methods of empirical research is a cautious acknowledgement that television consumption practices, performed as they are by specific individuals and groups in particular social contexts, are not therefore generalizable in terms of isolated instances of behaviour. If anything, this marks a tendency towards a recognition of what could broadly be termed the 'ethnographic' in the industry's attempts to get to know consumers. This ethnographic move is in line with a wider recent trend in the advertising research community in the United States and elsewhere to hire cultural anthropologists to conduct 'observational research' into the minutiae of consumer behaviour that are difficult to unearth through standard surveys (Groen 1990) – an interesting and perhaps thought-provoking development in the light of the growing popularity of ethnography among critical cultural researchers!

CONCLUSION

What are we to make of these developments? To round off this chapter, then, some concluding remarks. First of all, it is important to emphasize that a research practice such as audience measurement is constrained by strict institutional pressures and limits. We are dealing here with an industry with vested interests of its own. Market research firms are for economic reasons bound to respond to changes in demand for types of research on the part of media and advertisers. Furthermore, it is important to stress the *strategic*, not analytic, role played by research in the organization and operations of the cultural industries. Research is supposed to deliver informational products that can serve as a shared symbolic foundation for industry negotiations and transactions, and epistemological considerations are by definition subservient to this necessity. Thus, innovations in audience measurement should be understood in this context: in the end, market-driven research will always

have to aim at constructing a 'regime of truth' (Foucault 1980) that enables the industry to improve its strategies to attract, reach and seduce the consumer. In this respect, recognition of some of the tactics by which viewers appropriate television in ways unintended and undesired by programmers and advertisers may under some circumstances be beneficial, even inevitable, as I have shown above. But the interests of the industry cannot and do not permit a complete acceptance of the tactical nature of television consumption. On the contrary, consumer tactics can be recognized only in so far as they can be incorporated in the strategic calculations of media and advertisers. In other words, despite its increasing attention to (ethnographically oriented) detail, market research must always stop short of acknowledging fully the permanent subversion inherent in the minuscule but intractable ways in which people resist being reduced to the imposed and presumed images of the 'ideal consumer'.

If we take full account of the inherently tactical nature of television consumption, however, we must come to the conclusion that any attempt to construct positive knowledge about the 'real consumer' will always be provisional, partial, fictional. This is not to postulate the total freedom of television viewers. Far from it. It is, however, to foreground and dramatize the continuing dialectic between the technologized strategies of the industry and the fleeting and dispersed tactics by which consumers, while confined by the range of offerings provided by the industry, surreptitiously seize moments to transform these offerings into 'opportunities' of their own, making 'watching television', embedded as it is in the context of everyday life, not only into a multiple and heterogeneous cultural practice, but also, more fundamentally, into a mobile, indefinite and ultimately ambiguous ·one, which is beyond prediction and measurement. But this idea, which if taken seriously would corroborate the adoption of a fully fledged ethnographic mode of understanding, is epistemologically unbearable for an industry whose very economic operation depends on some fixed and objectified description of the audience commodity. Therefore, it is likely that technological improvement of audience measurement will for the time being continue to be sought, stubbornly guided by the strategically necessary assumption that the elusive tactics of television consumption can in the end be recaptured in some clearcut and hard measure of 'television audience', if only the perfect measurement instrument could be found.[6]

De Certeau speaks of a 'strange chiasm':

[T]heory moves in the direction of the indeterminate, while technology moves towards functionalist distinction and in that way transforms everything and transforms itself as well. As if the one sets out lucidly on the twisting paths of the *aleatory* and the metaphoric, while the other tries desperately to suppose that the utilitarian and *functionalist* law of its own mechanism is 'natural'.

(de Certeau 1984: 199)

Meanwhile, American film producers worry that, as advertising in cinema theatres proliferates, more would-be moviegoers will stay at home and watch the film on video. Advertisers, unrelentingly in search of new ways to reach their potential consumers, have not been too keen on putting their commercials on video tapes, reportedly because they distrust one element missing from cinemas: the fast-forward button (Hammer 1990).

4

Ethnography and radical contextualism in audience studies

Our curiosity about the audience is never innocent. Specific interests and orientations, material and intellectual, generally shape the perspective from which we come to define our object of study, and the kinds of knowledge – their form and content, their scope and substance – we pursue. There is now clearly a sense of crisis in the study of media audiences: the ambiguous title of a recent conference dedicated to this subject, 'towards a comprehensive theory of the audience?', suggests an awareness of a confusing lack of such 'comprehensiveness'.[1] The crisis is neither purely theoretical nor merely methodological (as misleadingly suggested in the counterposing of quantitative and qualitative methods); it is, rather, both deeply epistemological and thoroughly political. The current popularity of cultural studies approaches to the audience has not only produced considerable epistemological confusion over the status of the concept of the 'audience' as an analytical object, but has also reanimated the persistent critical preoccupation with the political standing of scholarship: what does it mean to do 'audience research', and why do it in the first place?

In the past decade or more, the audience question has been especially acute in television studies. This is not only because the television audience has since the 1950s had the dubious privilege of being in the spotlight of attention from researchers, both within the industry and within the academy; more generally, it has become prototypical for the (real and imagined) 'problem of the audience' which has risen to prominence in light of practical and theoretical concerns about the nexus of modernity, the media industries and mass culture. More importantly, however, as I have already indicated in the Introduction, television's changing place in the late twentieth century has put our conventional understandings of the television audience under severe pressure. I would like to stress the notion of change here: we do live in a time of dramatic transformation of television's economic, institutional, technological and textual arrangements. The eclipse of the national public service broadcasting systems in Western Europe, as well as the worldwide ascendancy of a multiplicity of transnational, commercially organized satellite channels, the proliferation of local and regional channels, and the

ever more abundant availability of VCRs and other television-related technologies, have obviously thrown traditional models about television reception and consumption into disarray. This has been exacerbated by television's rising importance as a major actor in the enactment of global politics (as we have recently seen in the Gulf War [Wark 1994]), as well as our growing theoretical awareness about television's specificity as a popular cultural form – its eclectic but repetitive narratives, its socially heterogeneous yet textually imposing modes of address, its stubborn always-thereness – which greatly challenge the validity of traditional, literary models of audiencehood, in which the discrete text/reader relationship forms the basic analytical focus. (If anything, viewing television today is often more like browsing than reading a book.) It seems to me that the crisis in audience studies should be understood in the context of this postmodern momentum of change.

It is often said, and often not without a sense of modernist nostalgia, that the television audience is becoming increasingly fragmented, individualized, dispersed, no longer addressable as a mass or as a single market, no longer comprehensible as a social entity, collectively engaged and involved in a well-defined act of viewing. Indeed, television's proliferation has made it painfully clear that it does not make sense to speak about the 'television audience' as a neatly demarcated object of study. In my view, we should take this historical realization as an opportunity to finally mark out the productive end of the search for a 'comprehensive theory of the audience', which has often been the implicit motif of the diverse paradigms of audience research within communication studies. Acknowledging the inevitably *partial* (in the sense of unfinished and incomplete) nature of our theorizing and research would arguably be a more enabling position from which to come to grips with the dynamic complexity and complex dynamics of media consumption practices. In addition, a recognition of this sense of inexorable, *epistemological* partiality in the construction of knowledge would facilitate the foregrounding of the other, *political* meaning of being partial: the social and political importance of commitment and engagement in developing our understandings. I will return to the articulation of this double partiality in audience studies further on.

Recent cultural studies approaches to audience research are directly faced with the limits and limitations of comprehensiveness as an epistemological ideal. By these approaches I mean, very broadly, the kind of empirical and interpretive work that starts out from the recognition that media consumption is an ongoing set of popular cultural practices, whose significances and effectivities only take shape in the 'complex and contradictory terrain, the multidimensional context, in which people live out their everyday lives' (Grossberg 1988a: 25). But how to turn this insight, this abstract hunch, into more concrete knowledge, more tangible understanding?

Most of us would agree that in order to do this we need to contextualize

67

the media far more radically than we have done so far: we should stop conceptualizing television, radio, the press, and so on, in isolation, as a series of separable independent variables having more or less clearcut correlations with another set of dependent, audience variables. In the case of television, the consequences of this necessity of contextualization has been most resolutely problematized in David Morley and Roger Silverstone's research project carried out when they were affiliated to the Centre for Research into Innovation, Culture and Technology (CRICT) at Brunel University, London. It is not my intention to discuss this work substantially; instead, I will use it as a starting point to explore both the promises and the dilemmas, simultaneously epistemological and political, of what I would call 'radical contextualism' in culturalist audience studies, and the significance of ethnography in this respect.

In their inclusive, almost totalizing vision, Morley and Silverstone state that television 'has to be seen as embedded within a technical and consumer culture that is both domestic and national (and international), a culture that is at once private and public' (1990: 32). As a concrete starting point, Morley and Silverstone have decided to focus on two contextual concerns: on the one hand, television's place in the domestic context; on the other hand, television's status as a technology. However, when these contextual concerns are pushed to their logical extremes, they inevitably lead to a fundamental shattering of the possibility of studying the television audience as a stable and meaningful psychological or sociological category.

First of all, the mundane fact that television is generally consumed at home (and not in a laboratory or a classroom) calls for the by no means new but still sobering observation that 'the use of television cannot be separated from everything else that is going on around it' (Morley and Silverstone 1990: 35). That is, the activity so often simplistically described as 'watching TV' only takes shape within the broader contextual horizon of a heterogeneous and indefinite range of domestic practices. As a result, the very notion of 'watching TV' undergoes a dispersal: what the activity is, what it entails and what it means cannot be predetermined, but depends on the influence of a plurality of interacting contexts. 'Watching TV' is no more than a shorthand label for a wide variety of multidimensional behaviours and experiences implicated in the practice of television consumption. If this is the case, however, it becomes difficult to demarcate when we are and when we are not part of the television audience. In a sense we are, as citizens living in television-saturated modern societies, always inevitably incorporated in that category, even when we personally don't actually watch it very often. For example, even when we have never seen *Dallas* or *Murphy Brown* or have missed Saddam Hussein's television performance, we can hardly avoid being implicated in such television events through their general diffusion in the intricate networks of day-to-day social discourse.

Considering television as a *technology* – rather than merely as a set of

distinct messages or texts – only enhances the dispersal of 'television audience' as a coherent category. The emphasis on television as technology enlarges the scope of what is generally known as the premise of the 'active' audience. As a communications technology, television has what Morley and Silverstone call a double articulation: since it is both a set of hardware objects (i.e. the TV set and connected technological items such as the VCR, the video camera, the computer, the remote control device, the satellite dish, the telephone, and so on) and a vehicle for symbolic material, television creates an enormous open space for the ways in which it becomes integrated in the domestic flow of everyday life. This leads to a rather dizzying accumulation of the audience's meaning-producing capacity. As Silverstone has put it:

> Television is potentially meaningful and therefore open to the con-structive work of the consumer-viewer, both in terms of how it is used, or placed, in the household – in what rooms, where, associated with what other furniture or machines, the subject of what kinds of discourses inside and outside the home and in terms of how the meanings it makes available through the content of its programmes are in turn worked with by individuals and household groups who receive them.
>
> (Silverstone 1990: 179)

Here, the scope of reception theory (which posits the indeterminacy of the meaning of the text outside of concrete viewer readings of it) is extended by applying the metaphor of textuality to the realm of technologies as well: technologies too, hardware, material objects, only take on meaning in and through their consumers' 'readings' and uses of them. Television con-sumption, in short, is a meaning-producing cultural practice at two inter-dependent levels. Looking at television as a domestic technology implies for Morley and Silverstone a look at the television audience as 'multiply embedded in a consumer culture in which technologies and messages are juxtaposed, both implicated in the creation of meaning, in the creative possibilities of everyday life' (1990: 51).

It is precisely the idea of profound embeddedness of television con-sumption (and of media consumption in general) in everyday life, and therefore its irreducible heterogeneity and dynamic complexity, that has been a central emphasis within culturalist audience studies, although the epistemological bearings of this emphasis, which amount to a form of *radical contextualism*, are not always thoroughly understood.

Of course it is true that the recognition of diversity in audience activity has been a major strand in the development of social-scientific audience research, ranging from uses and gratifications research to reception analysis to observational work on television's social uses within the family. But many of these studies still seem to start out from a conceptualization of television

itself as a given phenomenon with fixed features and intrinsic potentials, which can then be used or interpreted in different ways by different audience groups. From a radical contextualist perspective, however, television's meanings for audiences – textual, technological, psychological, social – cannot be decided upon outside of the multidimensional intersubjective networks in which the object is inserted and made to mean in concrete contextual settings.

For example, many research projects have been set up on the basis of the uninterrogated commonsense assumption that television is an 'entertainment medium', implying that 'entertainment' is not only an institutional or textual category but also a psychological need or preference, and that the two are more or less correlated in some functional fashion. If we take up the stance of radical contextualism however, we must let go of such an ahistorical assumption of pregiven fixity of what television is, in the recognition that the meanings of television within the domestic realm only emerge within contextualized audience practices. That is, the precise 'entertainment function' of television can only be determined *post facto*: outside of specific articulations of television–audience relationships we cannot meaningfully decide about 'the entertainment value' of television. After all, the term 'entertainment' itself can encompass a whole array of differential and shifting idiosyncratic meanings, depending upon the culturally specific ways in which social subjects experience 'entertaining' in any particular situation or setting. What is entertaining for some (say, horror movies) may not be entertaining for others at all, and what we find entertaining under some circumstances (say, an episode of a sitcom after a hard day's work) may fail to entertain us at other times.

To put it more generally, both 'television' and 'audience' are fundamentally indeterminate categories: it is impossible to list *a priori* which possible meanings and characteristics each category acquires in any specific situation in which people engage in television consumption. As a result of this contingency of meaning, the range of potential variety in audience practices and experiences becomes exponentially multiplied, indefinite if not infinite. Which meanings are concretely actualized, however, remains undecided until we have caught the full, multicontextually determined situation in which historical instances of television consumption take place. From this perspective, what the audience researcher needs to do is to secure the 'catch'.

As already discussed in chapter 2, this epistemological move towards radical contextualism in cultural studies has been accompanied by a growing interest in *ethnography* as a mode of empirical inquiry. Ethnographically oriented research is arguably the most suitable to unravel the minutiae of difference and variation as they manifest themselves in concrete, everyday instances of media consumption. What ethnographic work entails is a form of 'methodological situationalism', underscoring the thoroughly situated, always context-bound ways in which people encounter, use, interpret, enjoy,

think and talk about television and other media in everyday life. The understanding emerging from this kind of inquiry favours interpretive particularization over explanatory generalization, historical and local concreteness rather than formal abstraction, 'thick' description of details rather than extensive but 'thin' survey. But this ethnographic interest within audience studies is neither uncontroversial nor unproblematic. There is no need to go into the details of the controversy about ethnography here – many others have already done this – suffice it to observe at this point that what is at stake in the problem of ethnography is not just its supposed lack of systematicity and generalizability (which is the conventional critique levelled against it), but also its potential political and theoretical relevance as a form of knowledge. In short, what's the point of the ethnographic rendering of media audiences? What is its politics?

THE AMBIGUOUS POLITICS OF ETHNOGRAPHY

That the drift towards 'the ethnographic' is not merely a marginal academic matter but is also traceable in the belly of the beast itself, namely the commercial cultural and media industries, is exemplified by the crisis around ratings research, which is the most important and entrenched form of audience research circulating within the television industry. This crisis gained momentum in the latter half of the 1980s. Leaving aside the economic and institutional sides of the crisis, the controversy revolves around the alleged lack of 'accuracy' of the ratings figures produced by ratings companies such as A. C. Nielsen, resulting in major discontent and antagonism in network and advertisers' circles. In response, a solution is being sought in the development of ever more 'perfect' measurement instruments.

As I have already discussed in chapter 3, Nielsen is currently experimenting with the so-called 'passive people meter', a technology which can identify the faces of those in the living room through an electronic image recognition system (which has a memory where images of all household members are stored). Using tracking and artificial intelligence devices, the passive people meter can follow the movement of persons in the room, and fill in the blanks when people momentarily go out of the meter's field of vision. As Nielsen media research president John Dimling claims, this system will be able to generate audience reports that say: 'John started watching television at this minute and second and stopped at this minute and second' (1994: 23). Clearly, this method approaches the utopian dream of perfect monitoring, by creating a simulacrum of unobtrusive naturalistic observation, of what's happening in the living room, so that there will no longer be any doubt about who is watching which channel, which programme, which commercial, at any minute of the day (see Ang 1991 for a full account of these developments).

There is certainly an 'ethnographic' flavour to this corporate initiative, in

71

so far as being more empirically microscopic is envisaged as presenting an opportunity to improve measurement accuracy. More generally, marketing and advertising research circles are exhibiting increasing interest in qualitative and interpretive methods of gauging consumer behaviour, in the conviction that more detailed and local knowledge is needed in order to make their strategies to attract, reach and seduce the consumer more effective. In other words, even within market research the tenets of radical contextualism can be heard ever more frequently.

But this industry flirtation with the particular and the qualitative that is also characteristic of the ethnographic moment in culturalist audience studies is intrinsically contradictory. Despite its increasing interest in more detailed information about consumers and audiences, market research must always stop short of fully embracing the theoretical consequences of the consistent radical contextualism which underpins the culturalist turn within academic communication theory and research. As I have pointed out earlier, a radical contextualist perspective tends to lead to an unstoppable dispersal of the notion of 'audience', to the point that it may become pointless to measure 'it' (which is nevertheless an indispensable enterprise for an industry dependent for its functioning on determining the value of the audience commodity). For example, the recognition of the fact that the consumption and use of television is a multicontextually articulated, indeterminate and overdetermined set of co-occurring, competing, mutually interfering activities at once, makes equating 'watching' with 'directing the face towards the screen' a rather nonsensical operationalization indeed, never mind practically hazardous to determine in spaces where viewers are free to move about. It is hard to see how the quantity of the activity can ever be determined other than in an arbitrary, that is, discursively constructed way, implied in the very method being in use. 'Size' of the audience is a discursive construction rather than an objective fact, accomplished by containing rather than recognizing irreducible difference and variation (see also Sepstrup 1986).

Since market research is supposed to deliver informational products that can serve as the common symbolic currency for industry negotiations and decision-making, a too detailed familiarity with the radically contextual ways in which people consume and use media would only be counterproductive. It would not fit with the requirements of prediction and control to be fulfilled by the research function within the industry. In other words, if market research selectively derives certain *methods and techniques* from ethnography, it certainly does not allow itself to adopt an ethnographic *mode of understanding*, in the sense of striving toward clarifying what it means, or *what it is like*, to live in a media-saturated world. It is towards the latter, I would argue, that we should proceed if the assumptions of radical contextualism are to make a critical difference in the way in which

we comprehend and evaluate the quandaries of media audiencehood in contemporary society.

However, this vastly complicates our task as researchers. Since the premise of radical contextualism in principle involves the impossibility of determining any social or textual meaning outside of the complex situation in which it is produced, it is difficult to imagine where to begin and where to end the analysis. First of all, theoretically every situation is uniquely characterized by an indefinite multiplicity of contexts that cannot be known in advance. Furthermore, contexts are not mutually exclusive but inter-locking and interacting, superimposed upon one another as well as indefinitely proliferating in time and space. A project that would strive to take into consideration the whole contextual horizon in which heterogeneous instances of media consumption acquire particular shape, significance and effectivity would be quite unwieldy and exhausting indeed, if not over-ambitiously megalomaniac. This may be a reason why it seems easier to *talk about* ethnography than doing actual ethnographic work with audiences. This is also why the CRICT work is so significant, although not without its own problems and dilemmas. Let me sketch what I see as their main gist.

As we have seen, Morley and Silverstone have singled out two contextual frameworks for television consumption, namely the domestic and the technological. But at the same time they (rightly) state these contextual frameworks cannot be separated from 'the wider context of social, political and economic realities' (1990: 32). The confusing consequence is that they seem to be somewhat unclear as to how to articulate the plethora of other contexts they theoretically envisage. Those of nation and gender are mentioned explicitly, but we could easily imagine a virtually endless, varied list of other contexts: race, class, ethnicity, regional location, generation, religion, economic conjuncture, political climate, family history, the weather, and so on and so on – into the main thrust of the project. If not held in check, awareness of the infinity of intercontextuality could lead to contextualization gone mad!

To put it differently, imagining the radical, that is, eternally expanding contextuality of the particular meanings produced through media consumption would imply the taking up of an *impossible* position by the researcher, namely the position of being 'everywhere',[2] ceaselessly trying to capture a relentlessly expanding field of contextually overdetermined, particular realities. Although such a position may be epistemologically logical, it is, in the end, untenable ontologically, let alone pragmatically. No excursion into the real, no matter how ethnographic, can ever encompass such all-embracing knowing. As Jonathan Culler observes:

[C]ontext is boundless, so accounts of context never provide full determinations of meaning. Against any set of formulations, one can imagine further possibilities of context, including the expansion of

context produced by the reinscription within a context of the description of it.

<div align="right">(Culler 1983: 128)</div>

How then to get out of this dead-end? How can we come to terms with the inherently contradictory nature of the radical contextualist claim, without succumbing to what Clifford Geertz has called 'epistemological hypochondria' (1988: 71)? The answer, I would suggest, following Geertz, should be sought not in wanting to be epistemologically perfect, but in the uncertain trajectories of the politics of narrative and narration, of story and discourse. That is, by admitting that the ethnographer cannot be 'everywhere' but must always speak and write from 'somewhere', we can leave the remnants of logico-scientific thinking (as embodied in the epistemology of radical contextualism) for what it is in favour of narrative modes of reasoning and representation, in which not only the contexts of media consumption, but also the contexts of ethnographic knowledge production itself are taken into account (see, e.g., Richardson 1990).

It may be illuminating, in this regard, to turn briefly to some (meta-) anthropological literature, where the status of ethnography has recently been discussed more extensively (see, e.g., Clifford and Marcus 1986; Marcus and Fischer 1986; Fox 1991). In practice, ethnographic studies of media consumption tend to take communities of audiences – such as family audiences, specific audience subcultures or fan groups – as an empirical starting point, treating them as sense-making cultural formations, just as anthropologists have for decades taken up the task of describing and interpreting other cultures as meaningful wholes. However, the very project of documenting a 'culture' is being increasingly problematized within contemporary cultural anthropology. 'Culture' as such can no longer, if ever, be considered as a transparent object of empirical inquiry, a finished entity that can be discovered and documented as such by the ethnographer. On the contrary, documenting a 'culture' is a question of discursive construction which necessarily implicates the always (doubly) partial point of view of the researcher, no matter how accurate or careful s/he is in data gathering and inference making. As James Clifford has remarked:

> 'Cultures' do not hold still for their portraits. Attempts to make them do so always involve simplification and exclusion, selection of a temporal focus, the construction of a self–other relationship, and the imposition or negotiation of a power relationship.

<div align="right">(Clifford 1986: 10)</div>

We do not need to succumb to the far-reaching but rather disabling poststructuralist postulate of the impossibility of description emanating from this insight (as Culler gestured towards) to nevertheless accept the assertion that all descriptions we make are by definition constitutive, and

not merely evocative of the very object we describe (cf. Tyler 1987). Portraying a 'culture' implies the discursive knocking-up of a unitary picture out of bits and pieces of carefully selected and combined observations, a picture that makes sense within the framework of a set of preconceived problematics and sensitizing concepts which the researcher employs as cognitive and linguistic tools to make her or his descriptions in the first place.

However, while it might not have been too hard to hold such a picture romantically for a full and complete representation of a self-contained reality when the 'culture' concerned is apparently some clearly limited and finite other culture – as in the classic case of anthropology's remote and primitive, small and exotic island in the middle of the vast ocean, inhabited by people whose daily practices were relatively untouched and uninfluenced by the inexorably transformative forces of capitalist modernity – it has become quite impossible in today's modern world- system to even imagine a full and comprehensive portrait of any such cultural formation.[3] Contemporary culture has become an enormously complex and thoroughly entangled maze of interrelated and interdependent social and cultural practices, ceaselessly proliferating in time and taking place in global space. In other words, there simply are no pristine, isolated, wholesome 'cultures' any more that can be cut out from their surroundings in order to be pictured as such (see Marcus and Fischer 1986: chapter 4; Hannerz 1992). Today, all 'cultures' are interconnected to a greater or lesser degree, and mobile people are simultaneously engaged in many cultural practices at once, constantly moving across multidimensional, transnational space. In Geertz's words: 'The world has its compartments still, but the passages between them are much more numerous and much less well secured' (1988: 132).

This contemporary cultural condition – postcolonial, postindustrial, postmodern, postcommunist – forms the historical backdrop for the urgency of rethinking the significance of ethnography, away from its status as realist knowledge in the direction of its quality as a form of storytelling, as narrative. This does not mean that descriptions cease to be more or less true; criteria such as accurate data gathering and careful inference making remain applicable, even if their meaning and importance may become both more relative and more complicated, not just a question of technique but also perhaps one of ethics. It does mean that our deeply partial position as storytellers – a doubly partial position, as I have claimed earlier – should more than ever be seriously confronted and thought through in its consequences. Any cultural description is not only constructive (or, as some might say, 'fictive'), but also of a provisional nature, creating the discursive objectification and sedimentation of 'culture' through the singling out and highlighting of a series of discontinuous occurrences from an ongoing, neverending flux, and therefore by definition always-already falling short and falling behind. The point is not to see this as a regrettable shortcoming to be eradicated as much as possible, but as an inevitable state of affairs

which circumscribes the implicatedness and responsibility of the researcher/writer as a producer of descriptions which, as soon as they enter the uneven, power-laden field of social discourse, play their political roles as particular ways of seeing and organizing an ever elusive reality. This is what Geertz has called the 'discourse problem' in anthropology (1988: 83). For Geertz, this is ultimately a problem of authorship:

> The basic problem is neither the moral uncertainty involved in telling stories about how other people live nor the epistemological one involved in casting those stories in scholarly genres [. . .]. The problem is that now that such matters are coming to be discussed in the open, rather than covered with a professional mystique, the burden of authorship seems suddenly heavier.
>
> (Geertz 1988: 138)

This burden of authorship is all the heavier, I would suggest, as soon as we do not conceptualize it as an individual predicament, but as a deeply social and political one. This implies two things. First, it is important not to reduce the anthropologist-as-author to a literary figure, engaged in writing ethnography as a self-indulgent, purely aesthetic practice. If ethnography is not science, it is not literature either.[4] Ethnographic discourse should retain its primarily hermeneutic ambition to provide representations that allow us to better *understand* other people's as well as our own lives. The choice for this or that literary style of writing, this or that form of storytelling, though essential considerations, should be explicitly related to this ambition.

Second, let us not forget that the burden of authorship does not only convey a problem of writing, but also one of reading; it is not only a question of producing texts, but also of their reception. In short, the social context in which ethnographies are written, published, read and used is to be taken into consideration. Which stories to tell, in which form, to whom, where and when, and with what intention, are questions which academic scholars are not used to asking themselves, but they are central to the politics of intellectual work. In this respect, I agree with Talal Asad's argument that a 'politics of poetics' should not be pursued at the expense of a 'politics of politics':

> The crucial issue for anthropological practice is not whether ethnographies are fiction or fact – or how far realist forms of cultural representation can be replaced by others. What matters more are the kinds of political project cultural inscriptions are embedded in. Not experiments in ethnographic representation for their own sake, but modalities of political intervention should be our primary object of concern.
>
> (Asad 1990: 260)

CONSTRUCTING POSITIONED TRUTHS

How, then, can culturalist audience studies benefit from this self-reflexive rethinking of ethnography within contemporary anthropology? First of all, we should recognize that just as representations of 'culture' are, in a manner of speaking, inventions of anthropologists (Wagner 1981), so too are representations of 'audience' invented by audience researchers, in the sense that it is only in and through the descriptions conjured within the discourses produced by researchers that certain profiles of certain audiences take shape – profiles that do not exist outside or beyond those descriptions but are created by them. In this respect, academic audience researchers do not differ from market researchers: they are both in the business of creating audience profiles. But their politics, and therefore their rhetorical strategies and epistemological legitimizations – in short, the stories they tell – differ, given the disparate institutional conditions in which both groups have to operate.

Once again, this does not mean that people's involvements with media as audience members in everyday situations are not real or non-existent; it only means that our representations of those involvements and their inter-relationships in terms of 'uses', 'gratifications', 'decodings', 'readings', 'effects', 'negotiations', 'interpretive communities' or 'symbolic resistance' (to name but some of the most current concepts that have guided audience research) should be seen as ever so many discursive devices to confer a kind of order and coherence onto the otherwise chaotic outlook of the empirical landscape of dispersed and heterogeneous audience practices and experiences. The question, then, is what kind of representational order we should establish in our stories about media consumption. And in my view, culturalist audience studies, especially, should be in an excellent position to tell stories which avoid the objectification of 'audience' for which market researchers inevitably strive in their attempts to make the chaos of media audiencehood manageable for the cultural industries. The latter is clear, for example, in the constant search for new strategies of 'audience segmentation' within market research. At the same time, the very difficulty of producing satisfactory ways of segmenting the audience in clearcut, mutually exclusive categories suggests that market researchers too are confronted with the ultimate intransigence of audience chaos (see, e.g., Diamond 1993).

In a sense, radical contextualism is born of a creeping awareness of this chaos, and a welcome attempt to do more justice to it in our representations of audience practices and experiences. It is, in the words of Janice Radway, one way of grappling with 'the endlessly shifting, ever-evolving kaleidoscope of daily life and the way in which the media are integrated and implicated within it' (1988: 366). But as I have indicated before, the very desire for epistemological conquest implied in the will 'to do justice' to endless contextualization could easily lead to a sense of paralysis, leading to the

dictum: 'Don't do ethnography, just think about it.' Of course, the opposite extreme, 'Don't think about ethnography, just do it' is equally short-sighted (cf. Geertz 1988: 139). For the moment, the middle ground can be held by doing the thinking with the radical contextualist horizon always in mind, but at the same time translating our limitations (i.e. our incapability to be everywhere at the same time) into an opportunity and a responsibility to make consciously *political* choices for which position to take, which contextual frameworks to take on board in our forays into the world of media audiences. Epistemological considerations alone are bound to be insufficient or even counterproductive as guiding principles for making those choices, as Morley and Silverstone's project suggests, because from an epistemological perspective all contexts relate to each other, even though one could theorize that not all contexts are alike and not equally important. It is here that the 'modalities of political intervention', to use Asad's phrase, gain their pragmatic relevance. It is within the framework of a particular *cultural politics* that we can meaningfully decide which contexts we wish to foreground as particularly relevant, and which other ones could, for the moment, within this particular political conjuncture, be left unexplored. Radical contextualism can then act as a stance governed not by a wish to build an ever more 'comprehensive theory of the audience', which would by definition be an unfinishable task, but by an intellectual commitment to make the stories we end up telling about media consumption as compelling and persuasive as possible in the context of specific problematics which arise from particular branches of cultural politics. This is what Stuart Hall means when he argues that 'potentially, discourse is endless: the infinite semiosis of meaning. But to say anything at all in particular, you do have to stop talking. [. . .] The politics of infinite dispersal is the politics of no action at all' (1987: 45). Therefore, it is crucial to construct what Hall calls 'arbitrary closures' in our storytelling practice (i.e. epistemologically arbitrary), even though 'every full stop is provisional' (ibid.). Anthropologist Marilyn Strathern has succinctly put it this way: 'I must know on whose behalf and to what end I write' (1987: 269). That is, our stories cannot just tell 'partial truths', they are also, consciously or not, 'positioned truths' (Abu-Lughold 1991: 142).

In this respect, Strathern points to the success of contemporary feminist scholarship, a success which, in her view, 'lies firmly in the relationship as it is represented between scholarship (genre) and the feminist movement (life)' (1987: 268). And indeed, in much feminist scholarship the burden of authorship effectively transcends the tenets of liberal individualism which pervade conventional academic culture:

> Purposes may be diversely perceived; yet the scholarship is in the end
> represented as framed off by a special set of social interests. Feminists
> may argue with one another, in their many voices, because they also

78

know themselves as an interest group. There is certainty about that
context.

<div align="right">(Strathern 1987: 268)</div>

This is not the place to enter into a debate about Strathern's confident
assertion that feminism can provide a certainty of political context for
academic work; after all, feminism itself is increasingly questioned in terms
of its status as a general political roof for women's interests. (On this theme,
see further the essays in part II of this book.) Nevertheless, what matters
here is the self-conception of feminism as an imagined community that
manages to construct a commonality of interests, which enables feminist
scholars to develop and entertain a sense of commonality of worldly
purpose. For the academic and professional community of audience re-
searchers, of course, determining the political context of their work is much
more difficult, for they do not form, and cannot possibly form, a special
interest group. They do not, in any sense, form an imagined community
bound together by a unifying set of extra-academic social or political aims
and purposes. But this is precisely the reason why it is all the more important
for us to *construct* such aims and purposes, to define the modalities of
political intervention which can energize our interest in knowing audiences,
to actively create the 'arbitrary closures' that can give audience studies a
sense of direction and relevance in an ever more uncertain, complicated
world. This is another way of saying, quite simply, that what we need more
than ever is a renewed agenda for audience studies, one that is drawn up by
considerations of the *worldly* purposes of our scholarship.

This brings me back, finally, to the conjuncture of change in our
contemporary mediascape, which arguably poses the most pressing global
context for audience studies in the years to come. It is clear that the
initiatives of the transnational media industries are bringing about signific-
ant and confusing transformations in the multicontextual conditions of
audience practices and experiences. At the same time, these large-scale
structural developments have made the predicaments of postmodern
audiencehood ever more complex, indeterminate and difficult to assess, not
least because of the ubiquitousness of these developments. There no longer
is a position outside, as it were, from which we can have a total, transcending
overview of all that's happening. Our minimal task, in such a world, is to
explicate that world, make sense of it by using our scholarly competencies
to tell stories about the social and cultural implications of living in such a
world. Such stories cannot be comprehensive, but they can at least make us
comprehend some of the peculiarities of that world; they should, in the
listing of Geertz, 'analyze, explain, disconcert, celebrate, edify, excuse,
astonish, subvert' (1988: 143–4). To be sure, these are very liberal aims, but
they form the basis for Abu-Lughold's (1991) more radical claim that our
writing can either sustain or work against the grain of the tremendous

<div align="center">79</div>

discursive and economic powers of, in this instance, the global media corporations. How can we give substance to such claims by mobilizing the radical contextualism of ethnography? I can only give a partial, doubly partial, answer to this question, in the form of some proposals that reflect my own concerns and interests.

One political problematic which is barely addressed in audience work relates to the problem of public policy in an age of so-called consumer sovereignty. In their search for viable antidotes to the hegemonic logic of commercialism, media policy makers – and I am thinking here especially of the European tradition of public service broadcasting – have, for better or worse, often resorted to a discourse of 'quality' and 'minority programming'. But in doing this, public broadcasters still have not always managed to overcome paternalistic or elitist attitudes towards the television audience that pervade classic public service broadcasting ideology. In my view, this is the result of broadcasters' real and symbolic *distance* towards their audiences, a distance that tends to be intensified not closed by the now common use of quantitative market research surveys in these circles. In this policy context ethnographic understanding can be extremely useful; for example, it could potentially improve programming for ethnic minorities, now often suffering from lack of insight into the diverse and contradictory social experiences of its 'target audience'. In other words, only by an understanding of what it is like to live as non-European migrants in Europe can professional broadcasters hope to develop media provisions that these people find truly relevant. This is not to say that ethnography can save public service broadcasting as an institution; what I do suggest, however, is that ethnographic sensitivity to contextualized audience practices and experiences can enhance media production practices whose aim is more than the singleminded pursuit of profit (see Ang 1991: part III).

Of course, the construction of 'positioned truths' (or the politics of politics) in audience studies does not always have to have such direct practical bearings. In a sense, understanding audiences is of universal relevance today because increasingly the whole world population has now become hooked up to all sorts of mass media, both local and global. Media audiencehood has become an intrinsic part of our everyday reality. However, even though we do indeed increasingly inhabit the same media-dominated world, entire worlds of concrete practice and experience do remain alien to us, precisely because we cannot be 'everywhere', neither literally nor symbolically. In ignoring this, we would risk succumbing to sweeping generalizations which could only slight the scope of difference and variation that still exist. The media are increasingly everywhere, but not everywhere in the same way. I am referring here of course to the continuing concern over issues of cultural imperialism and globalization, issues that are likely to become more not less pronounced in the coming decades. Ethnography can help us locate and understand the 'gradual spectrum of mixed-

up differences' (Geertz 1988: 148) which comes with the progressive transnationalization of media audiencehood: what we study then is the articulation of world capitalism with the situations of people living in particular communities. As Abu-Lughold has remarked, 'the effects of extra-local and long-term processes are only manifested locally and specifically, produced in the actions of individuals living particular lives, inscribed in their bodies and their words' (1991: 150). Ethnography's radical con-textualism can in this respect usefully be pitted against the generalizing sweeps of much work on the effects of media transnationalization, moti-vated either by an improper romanticism of consumer freedoms, or by a paranoid fear of global control. To construct more nuanced accounts, I would suggest that the prime contextual factor to be highlighted here would be that of centre–periphery relationships, especially important for North Americans and West Europeans who live and work in relative comfort in the centres of what Ulf Hannerz calls the 'global ecumene' (1989). Hannerz is right to point of that from the point of the view of the centres, the periphery often looks lacking in creativity, activity and particularity. The essays in part III of this book address these issues further.

It is in telling stories about 'a diversity in motion, one of coexistence as well as creative interaction between the transnational and the indigenous' (Hannerz 1989: 72) that ethnography can, in Geertz's words,

> enlarge the possibility of intelligible discourse between people quite different from one another in interest, outlook, wealth, and power, and yet contained in a world where, tumbled as they are into endless connection, it is increasingly difficult to get out of each other's way.
>
> (Geertz 1988: 147)

Part II

GENDERED AUDIENCES

5

Melodramatic identifications: television fiction and women's fantasy

During the 1980s, American popular television fiction offered an array of strong and independent female heroines who seemed to defy – not without conflicts and contradictions, to be sure – stereotypical definitions of femininity. Heroines such as Maddie Hayes (*Moonlighting*) and Christine Cagney (*Cagney and Lacey*) did not fit into the traditional ways in which female characters have generally been represented in prime-time television fiction: passive and powerless, on the one hand, and sexual objects for men, on the other.

Christine Cagney, especially, and her partner Mary-Beth Lacey, are the kind of heroines who have mobilized approval from feminists (see D'Acci 1987; Clark 1990). *Cagney and Lacey* can be called a 'social realist' series, in which the personal and professional dilemmas of modern working women are dealt with in a serious and 'realistic' way. Cagney explicitly resists sexual objectification by her male colleagues, forcefully challenges the male hierarchy at work, and entertains an adult, respectful and caring friendship with her 'buddy' Lacey.

Maddie Hayes is a little more difficult to evaluate in straightforward feminist terms. However, while she often has to cope with the all-but-abusive, but ever-so-magnetic machismo of her recalcitrant partner David Addison, *Moonlighting*, as a typical example of postmodernist television, self-consciously addresses, enacts and acknowledges metonymically the pleasures and pains of the ongoing 'battle between the sexes' in the context of the series' characteristic penchant for hilarious absurdism and teasing parody (see Olsen 1987). In that battle, Maddie is neither passive nor always the loser: she fights and gains respect (and love) in the process.

Many women have enjoyed watching series such as *Cagney and Lacey* and *Moonlighting*, and it is likely that at least part of their pleasure was related to the 'positive' representations of women that both series offer. But this does not mean that other, more 'traditional' television fictions are less pleasurable for large numbers of women. On the contrary, as is well known, soap operas have traditionally been *the* female television genre, while

prime-time soaps such as *Dallas* and *Dynasty* have always had a significantly larger female audience than a male one.

Personally, I have often been moved by Sue Ellen of *Dallas* as much as I am at times by Christine Cagney. And yet, Sue Ellen is a radically different heroine from Cagney: she displays very little (will for) independence, she derives her identity almost entirely from being the wife of the unscrupulous and power-obsessed J.R. Ewing, whom she detests because he is never faithful, but whom she does not have the strength to leave.[1] As a consequence, Sue Ellen's life is dominated by constant frustration and suffering – apparently a very negative representation of 'woman' indeed. Despite this, the Sue Ellen character seems to be a source of identification and pleasure for many women viewers of *Dallas*: they seem not so much to love to hate J.R. but to suffer with Sue Ellen.

An indication of this can be derived from the research I reported on in *Watching Dallas* (Ang 1985). Through an advertisement in a Dutch weekly magazine, I asked people to send me their views about *Dallas*. From the letters, it was clear that Sue Ellen stood out as a character whom many women viewers were emotionally involved with. One of the respondents wrote:

> ... I can sit very happy and fascinated watching someone like Sue Ellen. That woman can really get round us, with her problems and troubles. She is really human. I could be someone like her too. In a manner of speaking.
>
> (quoted in Ang 1985: 44)

Another wrote:

> Sue Ellen is definitely my favourite. She has a psychologically believable character. As she is, I am myself to a lesser degree ('knocking one's head against a wall once too often') and I want to be (attractive).
>
> (quoted in Ang 1985: 124)

It is interesting to note that another *Dallas* character whose structural position in the narrative is similar to Sue Ellen's has not elicited such committed responses at all. Pamela Ewing (married to J.R.'s brother, Bobby) is described rather blandly as 'a nice girl', or is seen as 'too sweet'. In fact, the difference of appeal between the two characters becomes even more pronounced in the light of the findings of a representative Dutch survey conducted in 1982 (around the time that the popularity of *Dallas* was at its height). While 21.7 per cent of female viewers between 15 and 39 years mentioned Sue Ellen as their favourite *Dallas* character (as against only 5.9 per cent of the men), only 5.1 per cent named Pamela as their favourite (and 4.2 per cent of the men).[2]

Clearly Sue Ellen has had a special significance for a large number of women viewers. Two things stand out in the quotes above. Not only did

these viewers assert that the appeal of Sue Ellen is related to a form of realism (in the sense of psychological believability and recognizability); more importantly, this realism is connected with a somewhat tragic reading of Sue Ellen's life, emphasizing her problems and troubles. In other words, the position from which Sue Ellen fans seemed to give meaning to, and derive pleasure from, their favourite *Dallas* character seems to be a rather melancholic and sentimental structure of feeling which stresses the down-side of life rather than its happy highlights: frustration, desperation and anger rather than euphoria and cheerfulness.

To interpret this seemingly rather despondent form of female pleasure, I shall examine the position which the Sue Ellen character occupies in the *Dallas* narrative, and unravel the meaning of that position in the context of the specific fictional genre to which *Dallas* belongs: the melodramatic soap opera. The tragic structure of feeling embodied by Sue Ellen as a fictional figure must be understood in the context of the genre characteristics of the *Dallas* drama: just as Christine Cagney is a social-realist heroine and Maddie Hayes a postmodern one, so is Sue Ellen a melodramatic heroine. In other words, articulated and materialized in Sue Ellen's identity is what American critic Peter Brooks (1976) called the melodramatic imagination.

Of course, fictional characters may be polysemic just as they can take on a plurality of meanings depending on the ways in which diverse viewers read them. Thus, Sue Ellen's melodramatic persona can be interpreted and evaluated in several ways. Whilst her fans tended to empathize with her and live through her problems and troubles vicariously, others stress her bitchiness and take a stance against her. In the words of one *Dallas* viewer:

Sue Ellen has had bad luck with J.R., but she makes up for it by being a flirt. I don't like her much. And she's too sharp-tongued.

(quoted in Ang 1985: 32)

Others have called her 'a frustrated lady'. One of my respondents was especially harsh in her critique:

Take Sue Ellen. She acts as though she's very brave and can put up a fight, but she daren't make the step of divorce. What I mean is that in spite of her good intentions she lets people walk over her, because (as J.R. wants) for the outside world they have to form a perfect family.

(quoted in Ang 1985: 90)

According to Herta Herzog, who interviewed German viewers about *Dallas* in 1987, older viewers tend to see in Sue Ellen the woman ruined by her husband, while younger ones tend to see her as a somewhat unstable person who is her own problem (see Herzog 1987). However, despite the variation in emphasis in the different readings of Sue Ellen, a basic agreement seems to exist that her situation is an extremely contentious and frustrating one, and her personality is rather tormented. This is the core of the melodramatic

heroine. But while many viewers are put off by this type of character, some are fascinated, a response evoked not only by the dramatic content of the role, but also by the melodramatic style of the actress, Linda Gray. As one fan disclosed:

> Sue Ellen [is] *just fantastic*, tremendous how that woman acts, the movements of her mouth, hands, etc. That woman really enters into her role, looking for love, snobbish, in short a real woman.
>
> (quoted in Ang 1985: 32)

As a contrast, the same viewer describes Pamela as 'a Barbie doll with no feelings'!

It is not my intention to offer an exhaustive analysis of the Sue Ellen character as melodramatic heroine. Nor do I want to make a sociological examination of which segment of the audience is attracted to characters like her. Rather, I use her as a point of departure to explore women's pleasure in popular fiction in general, and melodramatic fiction in particular. Women who use Sue Ellen as a source of identification while watching *Dallas* do that by taking up, in fantasy, a subject position which inhabits the melodramatic imagination.[3] The pleasure of such imaginary identification can be seen as a form of excess in some women's mode of experiencing everyday life in our culture: the act of surrendering to the melodramatic imagination may signify a recognition of the complexity and conflict fundamental to living in the modern world.

SOAP OPERA AND THE MELODRAMATIC IMAGINATION

I now move to summing up some of the structural soap opera characteristics of *Dallas* which contributed to its melodramatic meanings (see Allen 1985). It should first be noted, however, that because *Dallas* is a prime-time programme, some of its features were different from those of the traditional daytime soaps. Most importantly, because the programme must attract a heterogeneous audience, it included a wider range of themes, scenes and plots. For example, male characters, as well as themes, scenes and plots which traditionally are mainly appreciated by male audiences, such as the wheelings and dealings of the oil business, and the cowboy/Western elements of the show, occupied a much more prominent place in the fictional world of *Dallas* than in regular daytime soap. Nevertheless, the general formal characteristics of *Dallas* did remain true to the soap opera genre, and are very important for the construction of melodramatic meanings and feelings in the text (see Feuer 1984; Ang 1985; also for melodrama in general see Brooks 1976; Gledhill 1987).

First of all, as in all melodrama, personal life is the core problematic of the narrative. Personal life must be understood here as constituted by its

everyday realization through personal relationships. In soap operas, the evolution of personal relationships is marked out through the representation of significant family rituals and events such as births, romances, engagements, marriages, divorces, deaths, and so on. It is the experience of these rituals and events (and all the attendant complications and disputes) on which soap opera narratives centre. This does not imply that non-personal issues are not addressed. However, the way in which they are treated and take on meaning is always from the standpoint of personal life:

> [T]he action of soap opera is not restricted to the familial, or quasi-familial institutions, but everything is told from the point of view of the personal.
>
> (Brunsdon 1981: 34)

Thus, while J.R.'s business intrigues formed a focal narrative concern in *Dallas*, they were always shown with an eye to their consequences for the well-being of the Ewing family members, not least his wife, Sue Ellen.

A second major melodramatic feature of soap opera is its excessive plot structure. If family life was the main focus of the *Dallas* narrative, the life of the Ewings was presented as one replete with extraordinary conflicts and catastrophes To the critical outsider this may appear as a purely sensationalist tendency to cliché and exaggeration – a common objection levelled at melodrama since the late nineteenth century. It is important to note, however, that *within* the fictional world of the soap opera all those extreme story lines such as kidnappings, bribery, extramarital affairs, obscure illnesses, and so on, which succeed each other at such a breathtaking pace, are not treated in a sensational manner, but are taken entirely seriously.[4] The parameters of melodrama require that such clichés be regarded and assessed not for their literal, referential value – i.e. their realism – but as meaningful in so far as they solicit a highly charged, emotional impact. Their role is metaphorical, and their appeal stems from the enlarged emotional impact they evoke: it is the feelings being mobilized here that matter. An excess of events and intensity of emotions are inextricably intertwined in the melodramatic imagination.

Sue Ellen's recurrent alcoholism is a case in point. Even though she has stayed away from alcohol for a long time loyal viewers are reminded of this dark side of her past every time she is shown refusing a drink. Do we detect a slight moment of hesitation there? Alcoholism is a very effective narrative motif that, in a condensed way, enables the devoted viewer to empathize with her feelings of desperation. She is married to a man she loathes but who has her almost completely in his power. In other words, Sue Ellen's propensity for alcoholism functioned as a metaphor for her enduring state of crisis.

Such a state of crisis is not at all exceptional or uncommon in the context of the soap opera genre. On the contrary, crisis can be said to be endemic

to it. As a result, Sue Ellen's predicament, as it is constructed, is basically unsolvable unless she leaves the *Dallas* community and disappears from the serial altogether. Here, a third structural characteristic of the soap opera makes its impact: its lack of narrative progress. *Dallas*, like all soap operas, is a neverending story: contrary to classic narratives, which are typically structured according to the logic of order/disorder/restoration of order, soap opera narratives never reach completion. They represent process without progression and as such do not offer the prospect of a conclusion or final denouement, in which all problems are solved. Thus, soap operas are fundamentally anti-utopian: an ending, happy or unhappy, is unimaginable. (And when *Dallas* eventually *did* end, mainly for commercial reasons, it was in an absurdistic fashion which did not provide any clearcut resolution to the narrative.) This does not mean, of course, that there are no moments of climax in soap operas. But, as Tania Modleski has observed, 'the "mini-climaxes" of soap opera function to introduce difficulties and to complicate rather than simplify the characters' lives' (1982: 107). Here, a basic melodramatic idea is conveyed: the sense that life is marked by eternal contradiction, by unsolvable emotional and moral conflicts, by the ultimate impossibility, as it were, of reconciling desire and reality. As Laura Mulvey has put it:

> The melodrama recognises this gap by raising problems, known and recognisable, and offering a personal escape similar to that of a daydream: a chance to work through inescapable frustrations by positing an alternative ideal never seen as more than a momentary illusion.
>
> (Mulvey 1978: 30)

The life of the Sue Ellen character in *Dallas* exemplified and dramatized this melodramatic scenario. She even expressed an awareness of its painfully contradictory nature. In one dialogue with Pamela, for example, she states:

> The difference [between you and me] is that you're a strong woman, Pam. I used to think I was, but I know differently now. I need Southfork. On my own, I don't amount to much. As much as I hate J.R., I really need to be Mrs J.R. Ewing. And I need him to be the father of John Ross [her son]. So I guess I just have to lead a married life without a husband.

In general, then, it could be said that the soap operatic structure of *Dallas* opens up a narrative space in which melodramatic characters can come to life symbolically – characters who ultimately are constructed as victims of forces that lie beyond their control. A heroine like Sue Ellen will never be able to make her own history: no matter how hard she tries, eventually the force of circumstances will be too overwhelming. She lives in the prison of an eternally conflictual present. No wonder that she reacts with frustration,

bitterness, resignation and cynical ruthlessness on the rebound. As she neatly summarized her own life philosophy:

> If J.R. seeks sex and affection somewhere else, so why shouldn't I? All Ewing men are the same. And for you to survive you have two choices. You can either get out, or you can play by their rules!

In fact, this frame of mind has led her to give up all attempts to find true happiness for herself: although she had her occasional moments of joy (a new lover, for example), they were futile in the face of her biggest self-imposed passion – to use all the power she had to undermine J.R.'s projects, to ruin his life just as he had ruined hers. She even refused him a divorce once to keep him from marrying another woman (by which he expected to win an extremely advantageous business deal). It is such small victories which made her feel strong at times. But they were ultimately self-destructive and never allowed her to break out of her cage.

Against this background, identifying with Sue Ellen – as with many other melodramatic heroines – implies a recognition of the fact that Sue Ellen's crisis is a permanent one: there seems to be no real way out. She may experience happy moments, but as viewers we know that those moments are bound to be merely temporary and inevitably followed by new problems and difficulties. At stake, then, must be a rather curious form of pleasure for these viewers. Whereas in other narratives pleasure comes from the assurance and confirmation of a happy end – as with the romantic union of a man and a woman in the formulaic 'they live happily ever after' – involvement with a character like Sue Ellen is conditioned by the prior knowledge that no such happy ending will ever occur. Instead, pleasure must come from living through and negotiating with the crisis itself. To put it more precisely, many female Sue Ellen fans tended to identify with a subject position characterized by a sense of entrapment: a sense in which survival is, in the words of television critic Horace Newcomb, 'complicated by ambiguity and blurred with pain even in its most sought-after moments' (1974: 178).

If this is true – and I have already given some indications that this may indeed be the case – how do we interpret this kind of identification, this form of pleasure in popular fiction?

PLEASURE, FANTASY AND THE NEGOTIATION OF FEMININITY

One could assert that melodramatic heroines like Sue Ellen should be evaluated negatively because they attest to an outlook on life that stresses resignation and despair. Isn't the melodramatic imagination a particularly damaging way of making sense of life because it affirms tendencies of individualistic fatalism and pessimism? And isn't such an impact especially

harmful for women as it reinforces and legitimizes masochistic feelings of powerlessness? Wouldn't it be much better for women and girls to choose identification figures that represent strong, powerful and independent women who are able and determined to change and improve their lives, such as Christine Cagney?

Such concerns are, of course, often heard in feminist accounts of popular fiction, but it is important to note here that they are often based upon a theoretical approach – what could be called a role/ image approach, or, more conventionally, 'images of women' approach – which analyses images of women in the media and in fiction by setting them against 'real' women. Fictional female heroines are then seen as images of women functioning as role models for female audiences (Moi 1985; Rakow 1986). From such a perspective, it is only logical to claim that one should strive to offer positive role models by supplying positive images of women. And from this perspective, feminist commonsense would undoubtedly ascribe the Sue Ellen character to the realm of negative images, reflecting a traditional, stereotyped or trivialized model of womanhood.

However, this approach contains both theoretical and political problems. Most importantly here, because it implies a rationalistic view of the relationship between image and viewer (whereby it is assumed that the image is seen by the viewer as a more or less adequate model of reality), it can only account for the popularity of soap operas among women as something irrational. In other words, what the role/image approach tends to overlook is the large *emotional involvement* which is invested in identification with characters of popular fiction.

To counteract this attitude, we first of all need to acknowledge that these characters are products of *fiction*, and that fiction is not a mere set of images to be read referentially, but an ensemble of textual devices for engaging the viewer at the level of fantasy (Walkerdine 1983; see also Cowie 1984; Kaplan 1986). As a result, female fictional characters such as Sue Ellen Ewing or Christine Cagney cannot be conceptualized as 'realistic' images of women, but must be approached as textual constructions of possible *modes of femininity*: as embodying versions of gendered subjectivity endowed with specific forms of psychical and emotional satisfaction and dissatisfaction, and specific ways of dealing with conflicts and dilemmas. In relation to this, they do not function as role models but are symbolic realizations of feminine subject positions with which viewers can identify *in fantasy*.

Fantasy is central here. In line with psychoanalytic theory, fantasy should not be seen as mere illusion, an unreality, but as a reality in itself, a fundamental aspect of human existence: a necessary and unerasable dimension of psychical reality. Fantasy is an imagined scene in which the fantasizing subject is the protagonist, and in which alternative, imaginary scenarios for the subject's real life are evoked. Fantasizing obviously affords the subject pleasure, which, according to the psychoanalysts, has to do with

the fulfilment of a conscious or unconscious wish. More generally, I want to suggest that the pleasure of fantasy lies in its offering the subject an opportunity to take up positions which she could not assume in real life: through fantasy she can move beyond the structural constraints of everyday life and explore other, more desirable situations, identities, lives. In this respect, it is unimportant whether these imaginary scenarios are 'realistic' or not: the appeal of fantasy lies precisely in that it can create imagined worlds which can take us beyond what is possible or acceptable in the 'real' world. As Lesley Stern has remarked, 'gratification is to be achieved not through acting out the fantasies, but through the activity of fantasising itself' (1982: 56).

Fantasies, and the act of fantasizing, are usually a private practice in which we can engage at any time and the content of which we generally keep to ourselves. Fictions, on the other hand, are collective and public fantasies; they are textual elaborations, in narrative form, of fantastic scenarios which, being mass-produced, are offered ready-made to audiences. We are not the originators of the public fantasies offered to us in fiction. This explains, of course, why we are not attracted to all the fictions available to us: most of them are irrelevant to our personal concerns and therefore not appealing. Despite this, the pleasure of consuming fictions that do attract us may still relate to that of fantasy: that is, it still involves the imaginary occupation of other subject positions which are outside the scope of our everyday social and cultural identities.

Implicit in the theoretical perspective I have outlined so far is a post-structuralist theory on subjectivity (see Weedon 1987). Central to this is the idea that subjectivity is not the essence or the source from which the individual acts and thinks and feels; on the contrary, subjectivity should be seen as a product of the society and culture in which we live: it is through the meaning systems or discourses circulating in society and culture that subjectivity is constituted and individual identities are formed. Each individual is the site of a multiplicity of subject positions proposed to her by the discourses with which she is confronted; her identity is the precarious and contradictory result of the specific set of subject positions she inhabits at any moment in history.

Just as the fictional character is not a unitary image of womanhood, then, so is the individual viewer not a person whose identity is something static and coherent. If a woman is a social subject whose identity is at least partially marked out by her being a person of a certain sex, it is by no means certain that she will always inhabit the same mode of feminine subjectivity. On the contrary, many different and sometimes contradictory sets of femininities or feminine subject positions (ways of being a woman) are in principle available to her, although it is likely that she will be drawn to adopt some of those more than others. Certain modes of femininity are culturally more legitimate than others; and every woman knows subject positions she

is best able to handle. This does not mean, however, that her identity as a woman is something determined once and for all in the process of social-ization. On the contrary, the adoption of a feminine subjectivity is never definitive but always partial and shaky: in other words, being a woman implies a neverending *process* of becoming a feminine subject – no one subject position can ever cover satisfactorily all the problems and desires an individual woman encounters.

All too often women (and men too, of course, but their relationship to constructions of masculinity is not at issue here) have to negotiate in all sorts of situations in their lives – home, at work, in relationships, in larger social settings. In this women are constantly confronted with the cultural task of finding out what it means to be a woman, of marking out the boundaries between the feminine and the unfeminine. This task is not a simple one, especially in the case of modern societies where cultural rules and roles are no longer imposed authoritatively, but allow individualistic notions such as autonomy, personal choice, will, responsibility and rationality. In this context, a framework of living has been created in which every individual woman is faced with the task of actively reinventing and redefining her femininity as required. The emergence of the modern feminist movement has intensified this situation: now women have become much more conscious about their position in society, and consequently are encouraged to take control over their own lives by rejecting the traditional dictum that anatomy is destiny. Being a woman, in other words, can now mean the adoption of many different identities, composed of a whole range of subject positions, not predetermined by immutable definitions of femininity. It would stretch beyond the purpose of this chapter to explore and explain in more detail how women construct and reconstruct their feminine identities in everyday life. What is important to conclude at this point, then, is that being a woman involves *work*, work of constant self-(re)construction. (The ever-growing range of different women's magazines is a case in point: in all of them the central problematic is 'how to be a true woman', while the meanings of 'true' are subject to constant negotiation.) At the same time, however, the energy women must put in this fundamental work of self-(re)construction is suppressed: women are expected to find the right identity effortlessly. (Women's magazines usually assume an enthusiastic, 'you-can do-it!' mode of address: work is represented as pleasure.)

It is in this constellation that fantasy and fiction can play a distinctive role. They offer a private and unconstrained space in which socially impossible or unacceptable subject positions, or those which are in some way too dangerous or too risky to be acted out in real life, can be adopted. In real life, the choice for this or that subject position is never without con-sequences. Contrary to what women's magazines tell us, it is often *not* easy to know what it means to be a 'true' woman. For example, the social display of forms of traditional femininity – dependence, passivity, submissiveness –

can have quite detrimental and self-destructive consequences for women when strength, independence or decisiveness are called for. In fantasy and fiction, however, there is no punishment for whatever identity one takes up, no matter how headstrong or destructive: there will be no retribution, no defeat will ensue. Fantasy and fiction, then, are the safe spaces of excess in the interstices of ordered social life where one has to keep oneself strategically under control.

From this perspective identification with melodramatic heroines can be viewed in a new way. The position ascribed to Sue Ellen by those identifying with her is one of masochism and powerlessness: a self-destructive mode of femininity which, in social and political terms, could only be rejected as regressive and unproductive. But rather than condemn this identification, it is possible to observe the gratification such imaginary subject positions provide for the women concerned. What can be so pleasurable in imagining a fantastic scenario in which one is a self-destructive and frustrated bitch?

In the context of the discussion above, I can suggest two meanings of melodramatic identifications. On the one hand, sentimental and melancholic feelings of masochism and powerlessness, which are the core of the melodramatic imagination, are an implicit recognition, in their surrender to some power outside the subject, of the fact that one can never have everything under control all the time, and that consequently identity is not a question of free and conscious choice but always acquires its shape under circumstances not of one's own making. Identification with these feelings is connected with a basic, if not articulated, awareness of the weighty pressure of social reality on one's subjectivity, one's wishes, one's desires. On the other hand, identification with a melodramatic character like Sue Ellen also validates those feelings by offering women some room to indulge in them, to let go as it were, in a moment of intense, self-centred abandon, a moment of giving up to the force of circumstances, just like Sue Ellen has done, so that the work of self-(re)construction is no longer needed. I would argue that such moments, however fleeting, can be experienced as moments of peace, of truth, of redemption, moments in which the complexity of the task of being a woman is fully realized and accepted. In short, whilst indulgence in a melodramatic identity in real life will generally only signify pathetic weakness and may have paralysing effects, fantasy and fiction constitute a secure space in which one can be excessively melodramatic without suffering the consequences. No wonder melodrama is so often accompanied with tears.

FINAL REMARKS

This interpretation of the appeal of melodramatic characters among women must, of course, be contextualized and refined in several ways. First of all, by trying to explain what it means for women to identify with a melo-

dramatic fictional character, I have by no means intended to justify or endorse it. I have tried to make it understandable, in the face of the ridicule and rejection that crying over melodramatic fiction (as if it were irrational) continues to receive. However, my analysis does not extend to any further impact upon the subjects concerned. Whether the release of melodramatic feelings through fantasy or fiction has an empowering or paralysing effect upon the subject is an open question and can probably not be answered without analysing the context of the fantasizing.

Second, we should not overlook the fact that not all women are attracted to melodrama, or not always, and that some men can be moved by melodrama too. If anything, this fact suggests that femininity and masculinity are not enduring subject positions inhabited inevitably by biological women and men, but that identity is transitory, the temporary result of dynamic identifications. Further research and analysis could give us more insight into the conditions, social, cultural, psychological, under which a surrender to the melodramatic imagination exerts its greatest appeal to particular subjects. Melodrama has been consistently popular among women in the modern period, but this does not have to be explained exclusively in terms of constants. The fundamental chasm between desire and reality, which forms the deepest 'truth' of the melodramatic imagination, may be an eternal aspect of female experience, but how that chasm is bridged symbolically and in practice is historically variable. In fact, there is a fundamentally melodramatic edge to feminism too. After all, are not the suffering and frustration so eminently materialized in melodramatic heroines the basis for the anger conveyed in feminism? And does not feminism stand for the overwhelming desire to transcend reality – which is bound to be a struggle, full of frustrations and moments of despair?

While the melodramatic heroine is someone who is forced to give up, leaving a yawning gap between desire and reality, the feminist is someone who refuses to give up, no matter how hard the struggle to close that gap might be.

Christine Cagney too shares more with Sue Ellen than we might expect. Of course, the manifest dramatic content of *Cagney and Lacey* is more in line with feminist ideals and concerns, and as such the Cagney and Lacey characters can provide an outlet for identification with fantasies of liberation for women viewers (G. Dyer 1987: 10). Despite the fact that Christine Cagney is an independent career woman who knows where she stands, she too must at times face the unsolvable dilemmas inherent in the lives of modern women: how to combine love and work; how to compete with the boys; how to deal with growing older . . . Often enough, she encounters frustration and displays a kind of cynical bitchiness not unlike Sue Ellen's. I would argue that some of the most moving moments of *Cagney and Lacey* are those in which Cagney gives in to the sense of powerlessness so characteristic of the melodramatic heroine.

POSTSCRIPT

Who are the melodramatic heroines of the 1990s? It is clear that suffering characters such as Sue Ellen no longer loom large on Hollywood television: actress Linda Gray now plays a very different character in the series *Models Inc.*, where she is the successful director-matriarch of a models firm. Any intertextual connection between *Models Inc.* and *Dallas* would certainly not fail to notice the disjunctures between the two characters (although Sue Ellen too became much more 'independent' towards the end of *Dallas*). It might be a sign of post-feminist times that the most popular female heroines today are bitchy and devious but enormously seductive characters such as Amanda (Heather Locklear) in *Melrose Place*, one of the most popular series among young women in the early 1990s, and her redoubtable predecessor Alexis (Joan Collins) in *Dynasty*. In some ways, these characters embody – like pop singer Madonna – enlarged, excessive representations of the liberal feminist ideal, but with a post-political twist: the dilemmas of the melodramatic heroine – i.e. the pains and frustrations that come from having to live in a still ultimately partriarchal world – no longer seem to bother these new women. The imaginary power they represent is further articulated in their ironic, camp sensibility, which tends to downplay any 'serious' emotional engagement and privileges an aestheticizing, theatrical appeal. One effect of this has been that both Amanda and Alexis seem to have enjoyed a relatively large gay following. All well and good, but does this mean that 'we' don't need melodramatic heroines anymore?

6

Feminist desire and female pleasure: on Janice Radway's *Reading the Romance*

Janice Radway's *Reading the Romance* (1984), one of the most influential studies within the so-called 'new audience research', does not exactly read like a romance. In contrast to the typically engrossing reading experience of the romance novel, it is difficult to go through *Reading the Romance* at one stretch. The text contains too many fragments which compel its reader to stop, to reread, to put the book aside in order to gauge and digest the assertions made – in short, to adopt an *analytical* position vis-à-vis the text. Contrary to what happens, as Radway sees it, in the case of romance novels, the value and pleasure of this reading experience does not primarily lie in its creation of a general sense of emotional well-being and visceral content-ment (ibid.: 70). Rather, *Reading the Romance* has left me, as one of its enthusiastic readers, with a feeling of tension that forces me to problematize its project, to ask questions about the kind of intervention Radway has tried to make in writing the book. Such questions generally do not present themselves to romance readers when they have just finished a particularly satisfying version of the romance genre. Radway has argued convincingly that it is precisely a *release* of tension that makes romance reading a particularly pleasurable activity for female readers. This release of tension is accomplished, on the one hand, by a temporary, literal escape from the demands of the social role of housewife and mother which is assured by the private act of picking up a book and reading a romance, and, on the other hand, by a symbolic gratification of the psychological need for nurturance and care that the romance genre offers these women – needs that, given their entrapment in the arrangements of 'patriarchal marriage', cannot be satisfied in 'real life'. This is elaborated by Radway in her characterization of romantic fiction as compensatory literature (ibid.: 89–95). In other words, the value of romance reading for women is, in Radway's analysis, primarily of a *therapeutic* nature.

But this opposition – between the analytical and the therapeutic – invites a somewhat oversimplified view of the relationship between *Reading the Romance* and women reading romances. To be sure, in Radway's book, we can distinguish an overtly therapeutic thrust. For what is at stake for

98

Radway is not just the academic will to offer a neat and sophisticated explanation of the whys and hows of romance reading, but also a feminist desire to come to terms, politically speaking, with this popular type of female pleasure.

The enormous popularity of romantic fiction with women has always presented a problem for feminism. It is an empirical given that pre-eminently signifies some of the limits of feminist understanding and effectivity. One of the essential aims of *Reading the Romance*, then, is to find a new feminist way to 'cope' with this 'problem'. And I would suggest that it is precisely this therapeutic momentum of *Reading the Romance* that, paradoxically enough, produces the deep sense of tension I felt after having read the book. At stake in the therapy, as I will try to show, is the restoration of feminist authority. The result, however, is not an altogether happy ending in the romance tradition. This is not to say that the book should *have* a happy ending, for *Reading the Romance* belongs to a completely different genre than the genre it is trying to understand. But because all feminist inquiry is by definition a politically motivated theoretical engagement, it always seems to present a certain articulation of the analytical with the therapeutic, both substantially and rhetorically. What I will try to do in this chapter, then, is to explore some of the ways in which this articulation materializes in *Reading the Romance*.[1]

What sets Radway's book apart in a 'technical' sense from earlier feminist attempts to grasp and evaluate the meaning of female romance reading is her methodology. In contrast, for example, to Tania Modleski's well-known *Loving with a Vengeance* (1982)[2] Radway has chosen to base her analysis upon oral interviews with a group of actual romance readers. Drawing on the insights of reader-response critics like Stanley Fish (1980) and Jane Tompkins (1980), she rejects the method of immanent textual analysis, which she criticizes as 'a process that is hermetically sealed off from the very people they [the romance critics concerned] aim to understand' (Radway 1984: 7). According to Radway, 'the analytic focus must shift from the text itself, taken in isolation, to the complex social event of reading where a woman actively attributes sense to lexical signs in a silent process carried on in the context of her ordinary life' (ibid.: 8). By leaving the ivory tower of textual analysis and mixing with actual readers, she pursues a strategy that aims at 'taking real readers seriously'. She thereby rejects the practice of treating them as mere subject positions constructed by the text, or as abstract 'ideal readers' entirely defined in terms of textual mechanisms and operations.

In her introduction to *Studies in Entertainment*, Tania Modleski has fiercely warded off Radway's criticism by arguing that conducting 'ethnographic studies' of subcultural groups may lead to a dangerous 'collusion between mass culture critic and consumer society' (1986: xii). In her view, it is virtually impossible for critical scholars to retain a 'proper critical

distance' when they submit themselves to the empirical analysis of audience response. While I share Modleski's concern about the dangers and pitfalls of empiricism, I do not believe that the project of ethnography is necessarily at odds with a critical stance, both in relation to consumer society, and with respect to the process of doing research itself. On the contrary, ethnographic fieldwork among audiences – in the broad sense of engaging oneself with the unruly and heterogeneous practices and accounts of real historical viewers or readers – helps to keep our critical discourses from becoming closed texts of Truth, because it forces the researcher to come to terms with perspectives that may not be easily integrated in a smooth, finished and coherent Theory. If anything, then, *Reading the Romance* is inspired by a deep sense of the contradictions and ambivalences posed by mass culture, and by a recognition of the profoundly unresolved nature of critical theory's dealings with it.

This does not mean, however, that ethnography is an unproblematic project. In every ethnographic study the researcher has to confront very specific problems of access and interpretation, which will have a decisive impact on the shape of the eventual account that is presented by the ethnographer: the text of the written book. In this chapter, then, I would like to examine the political motifs and strategies that are laid out in *Reading the Romance*. For Radway, ethnography is more than just a method of inquiry, it is an explicitly political way of staging a new feminist 'reconcili- ation' with 'the problem' of romantic fiction's popularity. For one thing, *Reading the Romance* is a report on the quite difficult, but apparently very rewarding, encounter between a feminist academic and (non-feminist) romance readers. Its broader significance thus lies in its dramatization of the relationship between 'feminism' and 'women'. It is the recognition that this relationship is a problematic one, not one of simple identity, that makes Janice Radway's book so important. Yet at the same time it is Radway's proposals for the resolution of the problem that make the tension I described above so painfully felt.

In the early chapters of the book, Radway's self-chosen vulnerability as an ethnographer is made quite apparent. In these chapters, the dialogic nature of the ethnographic project, which according to Radway is one of its central tenets, is more or less actualized. Of course, the narrative voice speaking to us is Radway's, but the limits of academic writing practice seem to make a more heterologic mode of textuality as yet almost unrealizable (see Clifford and Marcus 1986). She describes her initial trepidation upon first contacting and then meeting 'Dorothy Evans', or 'Dot', her main informant and the impassioned editor of a small fanzine for romance readers, living and working in a small Pennsylvania community fictionalized by Radway into 'Smithton'. The gap between researcher and informants is apparently quickly surmounted, however:

My concern about whether I could persuade Dot's customers to elaborate honestly about their motives for reading was unwarranted, for after an initial period of mutually felt awkwardness, we conversed frankly and with enthusiasm.

(Radway 1984: 47)

From this point on, Radway ceases to reflect on the nature of her own relationship to the 'Smithton women', and offers instead an often fascinating account of what she has learned from them. She quotes them extensively and is at times genuinely 'taken by surprise' by the unexpected turns of her conversations with Dot and the Smithton women. However, precisely because she does not seem to feel any real strain about the way in which she and her informants are positioned towards each other, she represents the encounter as one that is strictly confined to the terms of a relationship between two parties with fixed identities: that of a researcher/feminist and that of interviewees/romance fans. This ontological and epistemological separation between subject and object allows her to present the Smithton readers as a pre-existent 'interpretive community', a sociological entity whose characteristics and peculiarities were already there when the researcher set out to investigate it. It may well be, however, that this group of women only constituted itself as a 'community' in the research process itself – in a very literal sense indeed: at the moment that they were brought together for the collective interviews Radway conducted with them; at the moment that they were invited to think of themselves as a group that shares something, namely their fondness for romance reading, and the fact that they are all Dot's customers. An indication of this is offered by Radway herself:

In the beginning, timidity seemed to hamper the responses as each reader took turns answering each question. When everyone relaxed, however, the conversation flowed more naturally as the participants disagreed among themselves, contradicted one another, and *delightedly* discovered that they still agreed about many things
(Radway 1984: 48, emphasis added)

In relying on a realist epistemology, then, Radway tends to overlook the constructivist aspect of her own enterprise. In a sense, doing ethnography is itself a political intervention in that it helps to *construct* the culture it seeks to describe and understand, rather than merely reflect it. The concrete political benefit, in this specific case, could be that Radway's temporary presence in Smithton, and the lengthy conversations she had with the women, had an empowering effect on them, in that they were given the rare opportunity to come to a collective understanding and validation of their own reading experiences. Such an effect might be regarded as utterly limited by feminists with grander aims, and it is certainly not without its contra-

101

dictions (after all, how can we ever be sure how such temporary, cultural empowerment relates to the larger stakes of the more structural struggles over power in which these women lead their lives?), but it is worth noticing, nevertheless, if we are to consider the value and predicaments of doing feminist research in its most material aspects (see McRobbie 1982).

For Radway, however, other concerns prevail. The separation between her world and that of her informants becomes progressively more absolute towards the end of the book. In the last few chapters the mode of writing becomes almost completely monologic, and the Smithton women are definitively relegated to the position of 'them', a romance reading community towards which Radway is emphatically sympathetic, but from which she remains fundamentally distant. Radway's analysis first recognizes the 'rationality' of romance reading by interpreting it as an act of symbolic resistance, but ends up constructing a deep chasm between the ideological world inhabited by the Smithton women and the convictions of feminism:

> [W]hen the act of romance reading is viewed as it is by the readers themselves, from within the belief system that accepts as given the institutions of heterosexuality and monogamous marriage, it can be conceived as an activity of mild protest and longing for reform necessitated by those institutions' failure to satisfy the emotional needs of women. Reading therefore functions for them as an act of recognition and contestation whereby that failure is first admitted and then partially reversed.[. . .] At the same time, however, when viewed from the vantage point of a feminism that would like to see the women's oppositional impulse lead to real social change, romance reading can also be seen as an activity that could potentially disarm that impulse. It might do so because it supplies vicariously those very needs and requirements that might otherwise be formulated as demands in the real world and lead to the potential restructuring of sexual relations.
>
> (Radway 1984: 213)

These are the theoretical terms in which Radway conceives the troubled relationship between feminism and romance reading. A common ground – the perceived sharing of the experiential pains and costs of patriarchy – is analytically secured, but from a point of view that assumes the mutual exteriority of the two positions. The distribution of identities is clearcut: Radway, the researcher, is a feminist and *not* a romance fan; the Smithton women, the researched, are romance readers and *not* feminists. From such a perspective, the political aim of the project becomes envisaged as one of bridging this profound separation between 'us' and 'them'. Elsewhere, Radway has formulated the task as follows:

> I am troubled by the fact that it is all too easy for us, as academic feminists and Marxists who are preoccupied with the *analysis* of

ideological formations that produce consciousness, to forget that our entailed and parallel project is the political one of convincing those very real people to see how their situation intersects with our own and why it will be fruitful for them to see it as we do. Unless we wish to tie this project to some new form of coercion, we must remain committed to the understanding that these individuals are capable of coming to recognize their set of beliefs as an ideology that limits their view of their situation.

(Radway 1986: 105)

Does this mean then that doing feminist research is a matter of pedagogy? The militant ending of *Reading the Romance* leaves no doubt about it:

I think it absolutely essential that we who are committed to social change learn not to overlook [the] minimal but nonetheless legitimate form of protest [expressed in romance reading]. We should seek it out not only to understand its origins and its utopian longing but also to learn how best to encourage it and bring it to fruition. If we do not, we have already conceded the fight and, in the case of the romance at least, admitted the impossibility of creating a world where the vicarious pleasure supplied by its reading would be unnecessary.

(Radway 1984: 222)

Here, Radway's feminist desire is expressed in its most dramatic form: its aim is directed at raising the consciousness of romance reading women, its mode is that of persuasion, conversion even. 'Real' social change can only be brought about, Radway seems to believe, if romance readers would stop reading romances and become feminist activists instead. In other words, underlying Radway's project is what Angela McRobbie has termed a 'recruitist' conception of the politics of feminist research (1982: 52). What makes me feel so uncomfortable about this move is the unquestioned certainty with which feminism is posed as the superior solution for all women's problems, as if feminism automatically possessed the relevant and effective formulas for all women to change their lives and acquire happiness. In the course of the book Radway has thus inverted the pertinent relations: whereas in the beginning the ethnographer's position entails a vulnerable stance that puts her assumptions at risk, what is achieved in the end is an all but complete restoration of the authority of feminist discourse. This, then, is the therapeutic effect of *Reading the Romance*: it reassures where certainties threaten to dissolve, it comforts where divisions among women, so distressing and irritating to feminism, seem almost despairingly in-surmountable – by holding the promise that, with hard work for sure, unity *would* be reached if we could only rechannel the energy that is now put in romance reading in the direction of 'real' political action. In short, what is therapeutic (for feminism) about *Reading the Romance* is its construction of romance readers as embryonic feminists.

I do agree with Radway that the relationship between 'feminism' and 'women' is one of the most troublesome issues for the women's movement. However, it seems untenable to me to maintain a vanguardist view of feminist politics, to see feminist consciousness as the linear culmination of political radicality. With McRobbie (1982), I think that we should not underestimate the struggles for self-empowerment engaged in by 'ordinary women' outside the political and ideological frameworks of the self-professed women's movement. I am afraid therefore that Radway's radical intent is drawing dangerously near a form of political moralism, propelled by a desire to make 'them' more like 'us'. Indeed, what Radway's conception of political intervention tends to arrive at is the deromanticization of the romance in favour of a romanticized feminism!

This is not the place to elaborate on the practical implications of this political predicament. What I do want to point out, however, is how the therapeutic upshot of *Reading the Romance* is prepared for in the very analysis Radway has made of the meaning of romance reading for the Smithton women, that is, how the analytical and the therapeutic are inextricably entwined with one another.

Strangely missing in Radway's interpretive framework, I would say, is any careful account of the *pleasurableness* of the pleasure of romance reading. The absence of pleasure *as* pleasure in *Reading the Romance* is made apparent in Radway's frequent, downplaying qualifications of the enjoyment that the Smithton women have claimed to derive from their favourite genre: that it is a form of *vicarious* pleasure, that it is *only temporarily* satisfying because it is *compensatory* literature; that even though it does create 'a kind of female community', through it 'women join forces only symbolically and in a mediated way in the privacy of their homes and in the devalued sphere of leisure activity' (Radway 1984: 212). Revealed in such qualifications is a sense that the pleasure of romance reading is somehow not really real, as though there were other forms of pleasure that could be considered 'more real' because they are more 'authentic', more enduring, more veritable, or whatever.

Radway's explanation of repetitive romance reading is a case in point. She analyses this in terms of romance reading's ultimate inadequacy when it comes to the satisfaction of psychic needs for which the readers cannot find an outlet in their actual social lives. In her view, romance reading is inadequate precisely because it gives these women the *illusion* of pleasure while it leaves their 'real' situation unchanged. In line with the way in which members of the Birmingham Centre for Contemporary Cultural Studies have interpreted youth subcultures (see Hall and Jefferson 1976; Hebdige 1979), then, Radway comes to the conclusion that romance reading is a sort of 'imaginary solution' to real, structural problems and contradictions produced by patriarchy. (The real solution, one could guess, lies in the bounds of feminism.) All this amounts to a quite functionalist explanation of

romance reading, one that is preoccupied with its effects rather than its mechanisms. Consequently, pleasure as such cannot possibly be taken seriously in this theoretical framework, because the whole explanatory movement is directed towards the *ideological function* of pleasure.

Are the Smithton women ultimately only fooling themselves then? At times Radway seems to think so. For example, when the Smithton women state that it is impossible to describe the 'typical romantic heroine' because in their view, the heroines 'are all different', Radway is drawn to conclude that 'they refuse to admit that the books they read have a standard plot' (ibid.: 199). In imposing such a hasty interpretation, however, she forgets to take the statement seriously, as if it were only the result of the women's being lured by the realistic illusion of the narrative text.[3] But perhaps the statement that all heroines are different says more about the reading experience than Radway assumes. Perhaps it could be seen as an index of the pleasure that is solicited by what may be termed 'the grain of the story': the subtle, differentiated texture of each book's staging of the romantic tale that makes its reading a 'new' experience even though the plot is standard. In fact, Radway's own findings seem to testify to this when she reports that 'although the women almost never remembered the names of the principal characters, they could recite in surprising detail not only what had happened to them but also how they managed to cope with particularly troublesome situations' (ibid.: 201).

Attention to this pleasure of detail could also give us a fresh perspective on another thing often asserted by many of the Smithton women that puzzled Radway, namely that they always want to ascertain in advance that a book finishes with a happy ending. Radway sees this peculiar behaviour as an indication that these women cannot bear 'the threat of the unknown as it opens out before them and demand continual reassurance that the events they suspect will happen [i.e. the happy ending], in fact, will finally happen' (1984: 205). But isn't it possible to develop a more positive interpretation here? When the reader is sure *that* the heroine and the hero will finally get each other, she can concentrate all the more on *how* they will get each other. Finding out about the happy ending in advance could then be seen as a clever reading strategy aimed at obtaining maximum pleasure: a pleasure that is oriented towards the *scenario* of romance, rather than its outcome. If the outcome is predictable in the romance genre, the variety of the ways in which two lovers can find one another is endless. Cora Kaplan's succinct specification of what in her view is central to the pleasure of romance reading for women is particularly illuminating here, suggesting 'that the reader identifies with both terms in the seduction scenario, but most of all with *the process of seduction*' (1986: 162, emphasis added).

This emphasis on the staging of the romantic encounter, on the details of the moments of seducing and being seduced as the characteristic elements of pleasure in romance reading, suggests another absence in the interpretive

framework of *Reading the Romance*: the meaning of fantasy, or, for that matter, of romantic fantasy. In Radway's account, fantasy is too easily equated with the unreal, with the world of illusions, that is, false ideas about how life 'really' is. It is this pitting of reality against fantasy that brings her to the sad conclusion that repetitive romance reading 'would enable a reader to tell herself again and again that a love like the heroine's might indeed occur in a world such as hers. She thus teaches herself to believe that men *are able* to satisfy women's needs fully' (1984: 201). In other words, it is Radway's reductionist conception of phantasmatic scenarios as incorrect models of reality – in Radway's feminist conception of social reality, there is not much room for men's potential capacity to satisfy women – that drives her to a more or less straightforward 'harmful effects' theory.

If, however, as I have already suggested in chapter 5, we were to take fantasy seriously as a reality in itself, as a necessary dimension of our psychical reality, we could conceptualize the world of fantasy as the place of excess, where the unimaginable can be imagined. Fiction could then be seen as the social materialization and elaboration of fantasies, and thus, in the words of Allison Light, 'as the explorations and productions of desires which may be in excess of the socially possible or acceptable' (1984: 7).

This insight may lead to another interpretation of the repetitiveness of romance reading as an activity among women (some critics would speak of 'addiction'), which does not accentuate their ultimate psychic subordination to patriarchal relations, but rather emphasizes the rewarding quality of the fantasizing activity itself. As Radway would have it, romance fans pick up a book again and again because romantic fiction does *not satisfy them enough*, as it is only a poor, illusory and transitory satisfaction of needs unmet in 'real life'. But couldn't the repeated readings be caused by the fact that the romance novel *satisfies them too much*, because it constitutes a secure space in which an imaginary perpetuation of an emphatically utopian state of affairs (something that is an improbability in 'real life' in the first place) is possible?

After all, it is more than striking that romance novels always abruptly *end* at the moment that the two lovers have finally found each other, and thus never go beyond the point of no return: romantic fiction generally is exclusively about the titillating period *before* the wedding! This could well indicate that what repetitious reading of romantic fiction offers is the opportunity to continue to enjoy the excitement of romance and romantic scenes without being interrupted by the dark side of sexual relationships. In the symbolic world of the romance novel, the struggle between the sexes (while being one of the ongoing central themes of melodramatic soap operas; see Ang 1985: esp. chapter 4), will always be overcome in the end, precisely because that is what the romantic imagination self-consciously tries to make representable. Seen this way, the politics of romance reading is a politics of fantasy in which women engage precisely because it does *not* have

'reality value'. Thus, the romance reader can luxuriate in never having to enter the conflictual world that comes after the 'happy ending'. Instead, she leaves the newly formed happy couple behind and joins another heroine, another hero, who are to meet each other in a new book, in a new romantic setting.

What is achieved by this deliberate fictional bracketing of life after the wedding, it seems to me, is the phantasmatic perpetuation of the romantic state of affairs. Whatever the concrete reasons for women taking pleasure in this – here some further ethnographic inquiry could provide us with new answers – it seems clear to me that what is fundamentally involved is a certain determination to maintain the *feeling* of romance, or a refusal to give it up, even though it may be temporarily or permanently absent in 'real life,' against all odds. And it is this enduring emotional quest that, I would suggest, should be taken seriously as a psychical strategy by which women empower themselves in everyday life, leaving apart what its ideological consequences in social reality are.

If this interpretation is at all valid, then I am not sure how feminism should respond to it. Radway's rationalist proposal – that romance readers should be convinced to see that their reading habits are ultimately working against their own 'real' interests – will not do, for it slights the fact that what is above all at stake in the energy invested in romance reading is the actualization of romantic feelings, which are by definition 'unrealistic', excessive, utopian, inclined towards the sensational and the adventurous. That the daring quality of romanticism tends to be tamed by the security of the happy ending in the standard romance novel is not so important in this respect. What is important is the tenacity of the desire to feel romantically.

This is not to say that romantic fiction should be considered above all criticism. The ideological consequences of its mass production and consumption should be a continuing object of reflection and critique for feminism. Questions of sexual politics, definitions of femininity and masculinity, and the cultural meanings of the romance in general will remain important issues. However, all this should not invalidate the significance of the craving for and pleasure in romantic feelings that so many women have in common and share. In fact, I am drawn to conclude that it might be this common experience that could serve as the basis for overcoming the paralysing opposition between 'feminism' and 'romance reading'. While feminists, as Elizabeth Wilson (1986: 17) has noted, have often dismissed romanticism, it has a psychic reality that cannot simply be banished. However, by taking the love for romantic feelings seriously as a starting point for engagement with 'non-feminist' women, the feminist researcher might begin to establish a 'comprehension of self by the detour of the comprehension of the other' (Rabinow 1977: 5), in a confrontation with other women who may have more expertise and experience in the meanings, pleasures and dangers of romanticism than herself. What could change as a

result of such an ethnographic encounter – and to my mind it is this process-oriented, fundamentally dialogic and dialectical character of knowledge acquisition that marks the distinctive critical edge of ethnography – is not only 'their' understanding of what 'we', as self-proclaimed feminists, are struggling for, but, more importantly, the sense of identity that is constructed by feminism itself.

7

Gender and/in media consumption

(with Joke Hermes)

In the evening [Mr Meier] gets involved in conversation, otherwise he would at least have watched the regional news; so he does not see the results again until after the news. In a way he wanted to go to bed early, and that is what he told his wife. But now he has a faint hope of being able to see the Mueller goal on the Second Channel sports programme. However he would have to switch channels. He tells his wife she looks tired. She is surprised he cares, but she does go up to bed. He fetches a beer from the kitchen. Unfortunately his wife comes back to get a drink. Suddenly the penny drops. 'My God! The sports programme! That's why you sent me to bed!' He doesn't want to get involved, and quickly goes to the toilet. In the meantime it happens. His wife shouts, 'Hey Max Schmeling is on!' He doesn't react. He can't stand Schmeling because he has something to do with Coca-Cola. He deliberately doesn't hurry. When he comes back United's game is in progress. He is just in time to see the second, rather third-rate, goal. [. . .] In the afternoon (the next day) a neighbour tells him that his club has lost again, which is what he thought anyway, because when there is no wind he can hear the crowd in the stadium from the balcony and there has been no shouting. He goes for a walk with his wife and their younger children; some acquaintances delay him. When he comes home his elder son is watching the sports review after having slept till midday. Meier gets angry because he has wasted the day, and even more so when his son asks, 'Have you heard, United won 2–0!' As if he was an idiot! He gives his son the *Bild*, and the son says, 'I thought you didn't read that.' Offended, the father goes to his room, while the mother sits down next to her eldest son and watches the sports programme with him. It does not interest her, but it is an attempt at making contact.

(Bausinger 1984: 348–9)

This fascinating ethnographic account of the Meier family's dealings with the weekend sports coverage clarifies the thoroughly convoluted and

circumstantial way in which concrete practices of media consumption are related to gender. Mr Meier, the male football fan, ends up not watching his favourite team's game on television, while his wife, who doesn't care for sports, finds herself seating herself in front of the TV set the very moment the sports programme is on. Gender is obviously not a reliable predictor of viewing behaviour here. The scene illuminates the fact that media consumption is a thoroughly precarious practice, structured not by psychological or sociological predispositions of individual audience members but by the dynamic and contradictory goings-on of everyday life. The way gender is implicated in this practice is consequently equally undecided, at least outside of the context in which the practice takes concrete shape.

How gender is related to media consumption is one of the most under-theorized questions in mass communication research. In this chapter, we hope to offer some theoretical clarification about this important question. As Liesbet van Zoonen (1991) has pointed out, work in this area has until now almost exclusively concentrated on women, not men, and media consumption. This bias unwittingly reflects a more general bias in society, in which women are defined as the problematic sex (Coward 1983). This is a pity, since not femininity but also masculinity has recently been the subject of increasing critical inquiry (Kaufman 1987; Seidler 1989). More import-antly, we will argue here that limiting ourselves to women audiences as the empirical starting point for analysis would risk reproducing static and essentialist conceptions of gender identity. While much work in this area, most of it feministically inspired, has provided us with extremely useful insights into women's media uses and interpretations, we would argue that it is now time to develop a mode of understanding that does more justice to variability and precariousness in the ways in which gender identities – feminine and masculine subjectivities – are constructed in the practices of everyday life in which media consumption is subsumed. In our view, recent poststructuralist feminist theory can help us conceptualize more properly how gender might be articulated in practices of media consumption. In other words, this chapter's main argument is that the subject of gender *and* media consumption should be rephrased as gender *in* media consumption.

THE ACADEMIC EMANCIPATION OF WOMEN AUDIENCES

Feminist critics have displayed continuous concern about the relation of gender and media consumption. The concern has often focused upon the supposedly detrimental effects of popular media forms on women's consciousness. More specifically, the popularity among women of specifically 'feminine' genres such as soap operas and romance novels has often been explained in terms of their 'fit' with women's subordinate position in society. Early feminist accounts of women's media consumption are full of rendi-

tions reminiscent of the crude hypodermic needle model of media effects.[1] In *The Female Eunuch*, for example, Germaine Greer bitingly criticizes romance novels for reinforcing a kind of 'false consciousness' among their women readers:

It is a male commonplace that women love rotters but in fact women are hypnotized by the successful man who appears to master his fate; they long to give their responsibility for themselves into the keeping of one who can administer it in their best interests. Such creatures do not exist, but very young women in the astigmatism of sexual fantasy are apt to recognize them where they do not exist [. . .] Although romance is essentially vicarious the potency of the actual fantasy distorts actual behaviour. The strength of the belief that a man should be stronger and older than his woman can hardly be exaggerated.

(Greer 1971: 180)

In a similar but more earnest fashion, Sue Sharpe (1976) and Gaye Tuchman *et al.* (1978) see the mass-media as a major cause of the general reproduction of patriarchal sexual relationships. Sharpe posits that '[t]hroughout the media, girls are presented in ways which are consistent with aspects of their stereotyped images, and which are as equally unrealistic and unsatisfactory' (1974: 119); while Tuchman proposes that since mass-media images are full of traditionalist and outmoded sex-role stereotypes, they will inevitably socialize girls into becoming mothers and housewives, because 'girls in the television audience "model" their behavior on that of "television women"' (1978: 6). Sustaining such early accounts are two related, unwarranted assumptions: first, that mass-media imagery consists of transparent, unrealistic messages about women whose meanings are clearcut and straightforward; second, that girls and women passively and indiscriminately absorb these messages and meanings as (wrong) lessons about 'real life'. These assumptions have been considerably surmounted in later work, whose development can be characterized as gradually eroding the linear and monolithic view of women as unconditional victims of sexist media. This happened first of all through more theoretically sophisticated forms of textual analysis. Rather than seeing media images as reflecting 'unrealistic' pictures of women, feminist scholars working within structuralist, semiotic and psychoanalytic frameworks have begun to emphasize the ways in which media representations and narratives *construct* a multiplicity of sometimes contradicting cultural definitions of femininity and masculinity, which serve as subject positions that spectators might take up in order to enter into a meaningful relationship with the texts concerned (see, e.g., Mulvey 1975 and 1990; Kuhn 1982; Modleski 1982; Coward 1984; de Lauretis 1984; Moi 1985; Baehr and Dyer 1987; Doane 1987; Gamman and Marshment 1988; Pribram 1988; and many others). These studies are important because they pay more detailed attention to the particular *textual mechanisms* that

are responsible for engendering spectator identifications. For example, in her influential analysis of American daytime soap operas, Tania Modleski concludes that the soap opera's narrative characteristics construct a textual position for viewers that can be described as follows:

> The subject/spectator of soap operas [. . .] is constituted as a sort of ideal mother, a person who possesses greater wisdom than all her children, whose sympathy is large enough to encompass the conflicting claims of her family (she identifies with them all), and who has no demands or claims of her own (she identifies with no one character exclusively). [. . .] The spectator/mother, identifying with each character in turn, is made to see 'the large picture' and extend her sympathy to both the sinner and the victim. [. . .] By constantly presenting her with the many-sidedness of any question, by never reaching a permanent conclusion, soap operas undermine her capacity to form unambiguous judgments.
>
> (Modleski 1982: 92–3)

Here, a much more intricate and complex analysis is given of the textual operations of a popular genre such as the soap opera. Soap operas do not simply reflect already existing stereotypical images of women, but actively produce a symbolic form of feminine identity by inscribing a specific subject position – that of the 'ideal mother' – in its textual fabric. However, while such analyses of gendered spectatorship have provided us with better insight into the way in which media texts address and interpellate their viewers/readers, they generally do not problematize the way in which concrete viewers actually confront such interpellations. In fact, Modleski seems to imply that the 'ideal mother' position is an inescapable point of identification for soap opera viewers in their sensemaking of the genre. Indeed as Robert C. Allen has suggested, 'although Modleski seems to present the mother/reader as a textually inscribed position to be taken up by whoever the actual reader happens to be, she comes close at times to conflating the two' (1985: 94). In other words, text-oriented feminist analyses have often run the risk of being reductionist in their theoretical generalizations about gender and media consumption, a reductionism that stems from insufficiently distinguishing semiological and sociological levels of analysis. In the useful terminology of Annette Kuhn (1984), what is conflated here is the analysis of *spectatorship*, conceived as a set of subject positions constructed in and through texts, and the analysis of *social audiences*, understood as the empirical social subjects actually engaged in watching television, filmgoing, reading novels and magazines, and so on.

Janice Radway (1984) has been one of the first to recognize the pitfalls of textual reductionism. In her well-known study *Reading the Romance*, she claims that 'the analytic focus must shift from the text itself, taken in isolation, to the complex social event of reading [. . .] in the context of [. . .]

ordinary life' (1984: 8). In her view, then, textual analysis needs to be complemented by inquiry into how female audiences 'read' texts. In such a perspective, socially situated women are given some room for manoeuvre in their dealings with media texts; their responses cannot be deduced from textual positionings. 'Reading' is itself an active, though not free, process of construction of meanings and pleasures, a 'negotiation' between texts and readers whose outcome cannot be dictated by the text (Hall 1982; Gledhill 1988). This line of argument foregrounds the relevance of 'ethnographic' work with and among empirical audiences.

A more extensive review of this ethnographic move in the study of media audiences is given elsewhere in this book. In this context, it is sufficient to highlight the value of what is now commonly called 'reception analysis' by pointing at a study by Ellen Seiter *et al.* (1989). Through extensive interviews with female soap opera viewers in Oregon, Seiter *et al.* have unearthed a much more ambiguous relationship of viewers with the position of the 'ideal mother' which Modleski deems essential to the soap opera's textual operations. While the taking up of this position could indeed be recognized in the responses of some of Seiter *et al.*'s middle-class, college-educated informants, it was consciously resisted and vehemently rejected by most of the working-class women interviewees. Their findings have led Seiter *et al.* to draw the following conclusion:

> The 'successful' production of the (abstract and 'ideal') feminine subject is restricted and altered by the contradictions of women's own experiences. Class, among other factors, plays a major role in how our respondents make sense of the text. The experience of working-class women clearly conflicts in substantial ways with the soap opera's representation of a woman's problems, problems some women identified as upper or middle-class. [. . .] One of the problems with the spectator position described by Modleski is that the 'ideal mother' implies a specific social identity – that of a middle-class woman, most likely with a husband who earns a family wage. This textual position is not easily accessible to working-class women, who often formulate criticism of the soap opera on these grounds.
>
> (Seiter *et al.* 1989: 241)

This insightful juxtaposition of textual analysis and reception analysis makes clear that textually inscribed feminine subject positions are not uniformly and mechanistically adopted by socially situated women viewers/ readers. Textual generalizations about 'the female spectator' turn out to foreclose prematurely the possibility of empirical variation and heterogeneity within actual women's responses. Reception analysis makes clear, however, that women audiences do indeed actively negotiate with textual constructions and interpellations in such a way that the meanings given to texts – and consequently the positions eventually taken up by viewers/

readers – are brought in accordance with the women's social and subjective experiences. As a result, differences in readings between women with different social positions are brought to the surface.

In summary, then, feminist work addressing issues of gender and media consumption has evolved considerably from the early emphasis on 'un-realistic' images of women and their inevitably conservative effects on women audiences. The assumption of an *a priori*, monolithic reproduction of sexism and patriarchy has gradually made way for a view in which the media's effectivity is seen as much more conditional, contingent upon specific – and often contradictory – textual mechanisms and operations, on the one hand,[2] and upon the active and productive part played by female audiences in constructing textual meanings and pleasures, on the other. The latter trend, especially, has solicited a more optimistic stance towards women's role as media consumers: they are no longer seen as 'cultural dupes', as passive victims of inexorably sexist media; on the contrary, media consumption can even be considered as empowering (although never unproblematically), in so far as it offers audiences an opportunity for symbolic resistance to dominant meanings and discourses and for implicit acknowledgement of their own social subordination (cf. Brown 1990).

If early feminist criticism felt comfortable to speak authoritatively for the 'silent majority' of women, the more recent work is characterized by an awareness of the necessity to let 'other' women speak. If anything, this development signals a growing awareness among feminists of the problematic relationship between feminism and women (see chapter 6; also Brunsdon 1991). As a political discourse, feminism has generally postulated an ideal of the feminist subject, fully committed to the cause of social change and 'women's liberation'. However, in the face of the tenacious resistance displayed by large groups of women against feminist politics (think only of the pro-life movement in the United States) it is clear that feminism cannot presume to possess the one and only truth about women. Indeed, as Angela McRobbie has pointed out, 'to make such a claim is to uncritically overload the potential of the women's movement and to underestimate the resources and capacities of "ordinary" women [. . .] to participate in their own struggles as women but quite autonomously' (1982: 52). It is recognition of this that has led to the increasing popularity of validating – and sometimes celebrating – 'ordinary' women's experiences through research, including their experiences as audiences for media and popular culture.

We do not wish to enter into the debate over whether this move towards emphasis on audience creativity, which has been a more general recent trend within contemporary cultural studies, should be seen as 'encouraging cultural democracy at work' (Fiske 1987b: 286) or as researchers' wish fulfilment (Gitlin 1991; see also Morris 1988a). Instead, we would like to take a step back and look more dispassionately at some of the theoretical absences in the trajectory that work on gender and media consumption has

taken so far. In doing this, we do not aim to retreat from politics; rather, we intend to complicate the political dilemma invoked here – a dilemma framed by van Zoonen (1991) in terms of the dangers of relativism and populism – through a radical denaturalization of the ways that 'gender' and 'media consumption' have commonly been coupled together in research practice. We will come back to the political issue in our postscript, in which we will defend our commitment to a radically postmodern approach to (feminist) politics, and the role of particularistic ethnographic work therein.

THE DISPERSION OF 'WOMEN'

Let us return, for the sake of argument, to Seiter *et al.*'s project on women soap opera viewers. In this project, working-class women emerge as being more critical or resistant to the preferred meanings proposed by soap opera narratives than middle-class women (although they were found to express their criticisms in limited and apologetic ways, e.g. in terms of lack of realism and escapism) (Seiter *et al.* 1989: 241–2). In other words, the project shows that at the empirical level, women cannot be considered as a homogeneous category: class makes a difference.

However, one could cast doubt on the interpretive validity of the differentiations made by Seiter *et al.*, based as they are on macro-structural, sociological criteria (i.e. social class). Although these authors are careful in not over-generalizing their data, there are problems with their correlating different types of reading with the different class backgrounds of their informants. For example, in another account of differences between working-class and middle-class women watching soap operas, Andrea Press (1990) seems to contradict Seiter *et al.*'s interpretations. Drawing her conclusions from interviews with female viewers of the prime-time soap opera *Dynasty*, Press finds that it is middle-class women who are the more critical viewers. While working-class women speak very little of differences between the *Dynasty* characters and themselves – which in Press's view indicates their acceptance of the realism of the *Dynasty* text – middle-class viewers 'consciously refuse to be taken in by the conventions of realism which characterize this, like virtually all, prime-time television shows' (ibid.: 178). Although Press too is reluctant to over-generalize, she does in her conclusions emphasize 'the difference between middle-class women, who invoke [ideologies of femininity and the family] in order to criticize the show's characters in their discussions, and working-class women, who invoke them only to affirm the depictions they view' (ibid.: 179–80). This conclusion is at odds with Seiter *et al.*'s, who, on the contrary, found their working-class informants to be very critical of the discrepancy between textual representation and their personal experience.

In this context, it is impossible to explain satisfactorily the apparently contradictory conclusions of these two research projects, although several

considerations present themselves as possible factors: differences in operationalization of social class; differences in locality (Press conducted her interviews in the San Francisco Bay Area), representational differences between day-time and prime-time soap operas, differences in interview guidelines, differences in theoretical preoccupations in interpreting the transcripts, and so on.

At the very least, however, the contradiction highlights the liability of too easily connecting particular instances of meaning attribution to texts with socio-demographic background variables. Particular accounts as dug up in reception analysis are typically produced through researchers' staged conversations with a limited number of informants, each of them marked by idiosyncratic life histories and personal experiences. Filtering their responses – the transcripts of what they said during the interviews – through the pregiven categories of 'working-class' or 'middle-class' would necessarily mean a reductionist abstraction from the undoubtedly much more complex and contradictory nature of these women's reception of soap operas. An abstraction which is produced by the sociologizing perspective of the researchers, for whom sociological categorizations such as working-class and middle-class serve as facilitating devices for handling the enormous amount of interview material this kind of research generally generates.

What we are objecting to here is not the lack of generalizability that is so often levelled at qualitative empirical research conducted with small samples. If anything, the richness of data produced in this kind of research only clarifies the difficulty, if not senselessness, of the search for generalizations that has long been an absolute dogma in positivist social research.[3] Nor do we object to these researchers' endeavours to understand the way in which class position inflects women's reception of media texts. On the contrary, we greatly welcome such attempts to place practices of media consumption firmly within their complex and contradictory social contexts (we will return to this issue below).

What we do want to point to, however, is the creeping essentialism that lurks behind the classificatory move in interpreting certain types of response as originating from either working-class or middle-class experience. Such a move runs the danger of reifying and absolutizing the differences found, resulting – in the long run – in the construction of a simple opposition between two discrete class and cultural formations. Consequently, as John Frow (1987) has commented in relation to Pierre Bourdieu's (1984) important contribution to the sociology of taste distinctions, class experience comes to be considered as 'inevitably and inexorably entrapped within the cultural limits imposed on it' (Frow 1987: 71).[4] Pushed to its logical extreme, this would lead not only to the positing of fixed differences between working-class women and middle-class women, but also to the projection of unity and coherence in the responses of the two groups (although neither Seiter *et al.* nor Press makes any explicit gestures in this direction). In our view,

this form of social determinism implies a premature explanatory closure, which precludes recognition of multiplicity and transgression in the way women belonging to both groups can make sense of media. Thus, inconsistencies and variances within informants' accounts – familiar to *any* researcher who has worked with depth-interview transcripts – remain unaccounted for, or are even actively repressed.[5] But differences between women are not so neatly categorizable as the sociological picture would suggest. On the contrary, the closer we look, the more likely are we going to find complexity and contradiction in any one response.

Again, our critique is not meant to imply a denial of the existence of class differences. What we do want to question, however, is 'our ability to decide ahead of time the pertinence of such differences within the study of the effectivity of cultural practices' (Grossberg 1988b: 388). Thus, rather than treating class position as an isolatable 'independent variable' predetermining cultural responses, it could best be seen as a factor (or vector) whose impact as a structuring principle for experience can only be conceptualized within the concrete historical context in which it is articulated. Class never fully contains a social subject's identity. Otherwise we can never account for either variety or change and disruption in the social experience and consciousness of people, as well as for the possibility of experiences that cut across class-specific lines, in which class is of secondary, if not negligible, relevance.

As for class (or, for that matter, race or ethnicity), so for gender. As we have noted earlier, most research that sets out to examine gender and media consumption has concentrated exclusively on *women* audiences. What is implicitly taken for granted here is that gender is a given category, that people are always-already fully in possession of an obvious gender identity: women are women and men are men. Even the tentative but laudable attempts to do justice to differences between women (as in terms of class) do not go as far as problematizing the category of 'women' itself. As a result, as Virginia Nightingale has remarked, studies of women as audiences are undergirded by the basic assumption of women as

> objectifiable, somehow a unified whole, a group. The qualities that divide women, like class, ethnicity, age, education, are always of less significance than the unifying qualities attributed to women, such as the inability to know or say what they want, the preoccupation with romance and relationships, the ability to care for, to nurture, others.
>
> (Nightingale 1990: 25)

Or as Annette Kuhn has put it, 'the notion of a female social audience [. . .] presupposes a group of individuals already formed as female' (1984: 24).

Such a presumption is troublesome for both political and theoretical reasons. Not only does exclusive concentration on women as audiences unwittingly reproduce the patriarchal treatment of Woman as the defined

(and thus deviant) sex and Man as the invisible (and thus normal) sex – in this sense Andrew Ross's (1989) call for a properly audience-oriented study of pornography as a traditional 'men's genre' is long overdue;[6] more fundamentally, the *a priori* assumption that there is a continuous field of experience shared by all women and only by women tends to naturalize sexual difference and to universalize culturally constructed and historically specific definitions of femininity and masculinity.

The commonsense equation that women are women because they are women is in fact an empiricist illusion. As Denise Riley has forcefully argued:

> '[W]omen' is historically, discursively constructed, and always rela-
> tively to other categories which themselves change; 'women' is a
> volatile collection in which female persons can be very differently
> positioned, so that the apparent continuity of the subject of 'women'
> isn't to be relied on; 'women' is both synchronically and diachronically
> erratic as a collectivity, while for the individual, 'being a woman' is
> also inconstant, and can't provide an ontological foundation.
>
> (Riley 1988: 1–2)

The pertinence of this argument asserts itself rather exemplarily in the continuing trouble posed by the category of 'women' for marketers, those whose business it is to address, reach and 'catch' women as consumers. It is well known that any marketing strategy aimed at women is less than perfect; marketers have learned to live with the fact that the dream of guaranteed successful communication – which amounts to knowing exactly how to identify 'women' – can never be fulfilled. Indeed, as one commentator has observed, 'marketers lurch from one stereotype to another as they try to focus in on the elusive female consumer' (Canape 1984: 38). Market researchers' ongoing attempts notwithstanding to come up with new categorial typifications of women – happy housewife, superwoman, romantic feminist – 'women' remains a 'moving target' for marketers and advertisers (cf. Bartos 1982).

What we can learn from the pragmatic wisdom of marketers is that we cannot afford taking 'women' as a straightforward, natural collectivity with a constant identity, its meaning inherent in the (biological) category of the female sex. In social and cultural terms, 'women', as much as 'class', is not an immutable fact, but an inescapably indeterminate, ever-shifting category (Haraway 1985; Riley 1988; J. K. Scott 1988; Butler 1990).

Against this background, we would argue against a continued research emphasis on women's experience, women's culture, women's media consumption as if these were self-contained entities, no matter how internally differentiated. This is not to deny that there are gender differences or gender-specific experiences and practices; it is, however, to suggest that their meanings are always relative to particular constructions in specified contexts. For example, in examining the consumption of a ubiquitous genre

such as women's magazines, we should not only attend to both female and male self-identified readers (and arguably non-readers as well), but also pay attention to the multiple feminine and masculine identifications involved. We would argue, then, that the theoretical question that should guide our research practice is how gender – along with other major social axes such as class and ethnicity – is *articulated* in concrete practices of media consumption. We will elaborate on this question in the next section.

THE PRISON HOUSE OF GENDER AND BEYOND

Recent poststructuralist feminist theory has powerfully questioned the essentialist and reductionist view of sexual difference underlying the assumption of fixity of gender identity (male or female).[7] Poststructuralism asserts first of all that subjectivity is non-unitary, produced in and through the intersection of a multitude of social discourses and practices which position the individual subject in heterogeneous, overlaying and competing ways. A person's subjectivity can thus be described in terms of the multiplicity of subject positions taken up by the person in question. Moreover, post-structuralism claims that an individual's subjectivity is never finished, constantly in reproduction as it were, as s/he lives out her/his day-to-day life and engages herself/himself with a variety of discourses and practices encountering and positioning her/him. In this sense, a female person cannot be presumed to have a pregiven and fixed gender identity as a woman. Rather, an individual's gendered subjectivity is constantly in process of reproduction and transformation. Being a woman can mean many different things, at different times and in different circumstances. The en-gendering of the subject, in other words, goes on continuously through what Teresa de Lauretis has called 'the various technologies of gender [. . .] and institutional discourses [. . .] with power to control the field of social meaning and thus produce, promote, and "implant" representations of gender' (1987: 18).

To describe this process more concretely, we can make a distinction between gender definitions, gender positionings and gender identifications. Gender definitions, produced within specific social discourses and practices in which gender is made into a meaningful category (what de Lauretis calls 'technologies of gender'), articulate what is considered to be feminine or masculine in culture and society. Different discourses produce different definitions within specific contexts. For instance, Catholic religious discourse defines woman as virgin, mother or whore. It is contradicted by radical feminist discourse that defines women as oppressed human beings, victims of male exploitation. Such discourses, and the gender definitions they produce, are never innocent; nor are they all equally powerful, coexisting in a happy plurality. Rather, they often contradict and compete with each other. In our societies, dominant gender discourses work to maintain

119

relations of power between males and females in that they assign different roles, opportunities, ideals, duties and vulnerabilities to 'men' and 'women' that are classified as normal and are very difficult to break out of. This, of course, relates to the concept of gender positionings. It is at this level that work in textual analysis, as described in the first section of this chapter, has made its valuable contribution. How and to what extent discursively constructed gender-differentiated positions are taken up by concrete females and males, however, depends on the gender identifications made by actual subjects. It should be pointed out that this is not a mechanical and passive process: assuming this would imply a discourse determinism analogous to the textual determinism criticized above. How processes of gender identifications should be theorized and examined, however, is one of the underdeveloped aspects of the poststructuralist theory of subjectivity. When, how and why, in other words, do male and female persons keep identifying with positions that are defined as properly masculine or feminine in dominant discourses?

As must have become clear from our summary of developments in the field above, it is especially the passage from gender positionings to gender identifications that is theoretically relevant for work on gender and media consumption. To comprehend better the mechanisms of this process, it is useful to take up the suggestion made by Henriques *et al.* (1984; see also Hollway 1989) that there must be an 'investment', loosely speaking, an emotional commitment, involved in the taking up of certain subject positions by concrete subjects. As Henriques *et al.* put it:

> By claiming that people have investments [. . .] in taking up certain positions in discourses, and consequently in relation to each other, I mean that there will be some satisfaction or pay-off or reward (these terms involve the same problems) for that person. The satisfaction may well be in contradiction with other resultant feelings. It is not necessarily conscious or rational. But there is a reason. [. . .] I theorize the reason for this investment in terms of power and the way it is – historically inserted into individuals' subjectivity.
>
> (Henriques *et al.* 1984: 238)

The term 'investment', which Henriques *et al.* derived from the Freudian term *Besetzung* (cathexis), is adequate because it avoids both biological or psychological connotations such as 'motivation' or 'need', and rationalistic ones such as 'choice'.[8] The term also gives some depth to the notion of 'negotiation' that was put forward earlier to conceptualize text/reader relationships. Investment suggests that people have an – often unconscious – stake in identifying with certain subject positions, including gender positions, and that the stake in these investments, and it should be stressed that each individual subject makes many such, sometimes conflicting investments all the time, should be sought in the management of social relations. People

invest in positions which confer on them relative power, although an empowering position in one context (say, in the family) can be quite disempowering in another (say, in the workplace), while in any one context a person can take up both empowering and disempowering positions at the same time.

Furthermore, given the social dominance of gender discourses based upon the naturalness of sexual difference, there is considerable social and cultural pressure on female and male persons to invest in feminine and masculine subject positions, respectively. This leads to what Hollway (1989) calls the recursive production of social relations between men and women, which is not the same as mechanical reproduction because successful gender identifications are not automatic nor free of conflicts, dependent as they are on the life histories of individual people and the concrete practices they enter into, such as practices of media consumption. In other words, what this theoretical perspective suggests is that the construction of gender identity and gender relations is a constant achievement in which subjects themselves are complicit. In the words of de Lauretis '[t]he construction of gender is the product and the process of both representation and self-representation' (1987: 9).

A number of audience studies that have focused on the issue of gender and media consumption can usefully be recounted in the light of this theoretical perspective. For example, Radway's (1984) interpretation of romance reading provides a good example of how some female persons inadvertently reproduce their gendered subjectivity through all sorts of positions they take up and identify with in the course of their lives. Radway concluded that the women she interviewed used the act of reading romances as a 'declaration of independence' from one position accorded them by dominant patriarchal discourse: the position of ever-available and nurturing housewife and mother. At the same time, however, they submit to patriarchal discourse in their very reading, by investing so much energy in the imaginary (and wishful) reconstruction of masculinity as they interpret romances as stories about male transformation from hard and insensitive machos to loving and caring human beings. Such an analysis highlights how one and the same practice – reading romances – can contain contradictory positionings and investments, although ultimately ending up, in Radway's analysis, in reproducing a woman's gendered subjectivity.

However, there is still a sense of overgeneralization in Radway's interpretation, in that she has not sufficiently specified the social circumstances in which her informants performed their romance reading. (For a further discussion of Radway's interpretive strategies, see chapter 6.) In this sense James Curran is right in his observation that 'Radway's *tour de force* offers an account of romance addicts' relationship to patriarchy but not to their flesh and blood husbands' (1990: 154). This does not invalidate Radway's analysis, since patriarchal discourses are effective in more encompassing

ways than solely through direct face to face encounters, but her account does acquire a somewhat functionalist, adynamic quality the moment she transposes the analysis of how gender identifications are implicated in romance *reading* (a practice) to an explanation of individual romance *readers* (concrete historical subjects).

Ann Gray (1987, 1992), who studied how women relate to television and popular culture in the home, has pointed to similar contradictions in women's gender identifications, but she places them more concretely in their particular life histories. Not having had many opportunities in education and the job market, the women of Gray's study got married in order to leave their parents' homes and get settled on their own. By the time their children had grown up and they had a little more room to reflect on their lives, the patterns had been etched in. Marriage and motherhood seemed an escape at first but turned out to be a trap that was inescapable for most, despite their awareness of inequalities between men and women. The books and television programmes they prefer are tailored to female escapism and this, according to Gray, is how these women use them.[9] Gray's account makes clear how the apparent inevitability of the reproduction of femininity is in fact a result of the sedimented history of previous positionings and identifications in which these women find themselves caught, although they keep struggling against it through new investments that *are* available to them, such as consuming 'feminine' media genres and using the VCR to tape their favourite soap operas in order to be able to watch alone or with their women friends, thereby evading the derogatory comments of their husbands (Gray 1987).

One can also account for many women's gendered use of the telephone – for maintaining household activities, maintaining family relationships, for 'gossip' and 'chatter' – along these lines (Rakow 1988). Sherry Turkle's (1988) analysis of the 'masculinization' of the computer and the concomitant 'computer reticence' among some of the girls she studied provides another example. Although all these studies did limit themselves empirically to women's responses, they can most usefully be seen as illustrating that gender does not simply predetermine media consumption and use; on the contrary, what they illuminate is that it is in and through the very practices of media consumption – and the positionings and identifications they solicit – that gender identities are recursively shaped, while those practices themselves in turn undergo a process of gendering along the way.

This, then, is what we mean by the *articulation* of gender in practices of media consumption. The concept of articulation refers to the process of 'establishing a relation among elements such that their identity is modified as a result of the articulatory practice' (Laclau and Mouffe 1985: 105). In concrete terms, the concept can theorize how neither gender nor media consumption has a necessary or inherent meaning; only through their articulation or specific interlocking in particular situations do media con-

sumption practices acquire meanings that are gender-specific. Furthermore, the concept is more accurate than 'construction' or 'production' because it connotes a dynamic process of fixing or fitting together, which is, however, never total nor final. The concept of articulation emphasizes the impossibility of fixing ultimate meanings (Laclau and Mouffe 1985; see also Hall 1986b).

To clarify the importance of seeing gender and media consumption in terms of their articulations, let us give just one more example, derived from David Morley's study of the gendering of television viewing habits in a number of working-class families in London. What sets Morley's study apart from the examples above is that he takes as an empirical unit of analyis not individual women (and men), but a structured relational context, namely the modern nuclear family (see, also e.g., Lull 1988; Morley and Silverstone 1990). One of the observations he makes is that there is nothing inherently masculine about the wish to watch television with full concentration (as some of the men he interviewed reported), and that there is nothing inherently feminine in the tendency of the women in the study to watch distractedly. Instead, Morley interprets this empirical gender difference as resulting from 'the dominant model of gender relations within this society' which 'is one in which the home is

> primarily defined for men as a site of leisure – in distinction to the 'industrial time' of their employment – while the home is primarily defined for women as a sphere of work (whether or not they also work outside the home). [As a result] men are better placed to do [television viewing] wholeheartedly, and [. . .] women seem only to be able to do [it] distractedly and guiltily, because of their continuing sense of their domestic responsibilities.
>
> (Morley 1986: 147)

However, put this way Morley's argument still sounds too mechanical, in that he tends to collapse gender positionings and gender identifications together. After all, it is not likely that the gendered pattern will be found in all (London working-class) families all the time, despite the force of the dominant discourse. (To assume this would only reproduce the objectification of working-class culture that we criticized above.) Thus, the articulation of concentration/masculine and distraction/feminine in some family homes only comes about in concrete situations, in which personal investments, social circumstances and available discourses are interconnected in specific ways within the families concerned. Articulations, in other words, are inexorably contextual.

Moreover, such articulations have to be made again and again, day after day, and the fact that the same articulations are so often repeated – and thus lead to the successful reproduction of established gender meanings, gender relations and gender identities – is not a matter of course; it is, rather, a

matter of active re-production, continual re-articulation.[10] But in each family, there may be moments in which the woman becomes a much more involved television viewer, whereas her husband would lose interest in the set. No articulation is ever definitive or absolute. Under certain conditions, existing articulations can be disarticulated, leading to altered patterns of media consumption, in which women and men take up very different positions. For example, experiences such as illness, children leaving the home, extramarital affairs, political upheavals, and so on, may disrupt daily life in such a way to break down existing patterns. This is how change comes about.

The concept of articulation, then, can account for what Laclau and Mouffe call 'the presence of the contingent in the necessary' (1985: 114). Moreover, the unfinished and overdetermined nature of articulations also helps to explain what Riley calls 'the temporality and malleability of gendered existence' (1988: 103). She points out, rather ironically, that it's not possible to live twenty-four hours a day soaked in the immediate awareness of one's sex, which is another way of saying that women are only sometimes 'women', female persons steeped in an overwhelming feminine subjectivity. In other words, even though, according to de Lauretis, the social subject is 'constituted in gender' (1987: 2), in everyday life gender is not always relevant to what one experiences, how one feels, chooses to act or not to act. Since a subject is always multiply positioned in relation to a whole range of discourses, many of which do not concern gender, women do not always live in the prison house of gender.

Indeed, the currency of non-gendered or gender-neutral identifications should emphatically be kept in mind in our search for understanding the variability and diversity of media consumption practices, both among and within women and men. How, otherwise, is one to understand women who like watching the weekend sports programme, the news or hard-boiled detectives, men reading women's magazines or watching *Cagney and Lacey*, couples watching pornography or reading travel guides together, and so on? Indeed, it is questionable whether we should always foreground the articulation of masculinity and femininity in analysing media consumption practices.[11] For example, in his analysis of the cross-cultural reception of *Dynasty*, Kim Schrøder (1988) concludes that the pleasure of regularly watching *Dynasty*, for his male and female interviewees alike, has to do with the pleasure of solving narrative enigmas, what he calls 'the weekly reconstruction of self-confidence'. Similarly, we might ask whether the pleasure of watching sports is really in all its aspects that different for men and for women; we might consider that discourses of nation and nationalism may play a more significant role in sports viewing than discourses of gender (Poynton and Hartley 1990). Of course, this doesn't mean that gender positionings are totally absent from either *Dynasty* or sports programmes; what we do want to point out, however, is that non-gendered identifications

124

may sometimes take on a higher priority than gendered ones, allowing for a much more complex and dynamic theorization of the way media consumption is related to gender.

In this sense, we oppose Susan Bordo's dismissal of the idea of gender neutrality as purely ideological. 'In a culture that is in fact constituted by gender duality [. . .] one cannot simply be "human"', she states (Bordo 1990: 152). But if we acknowledge that culture is not a monolithic entity but a shifting set of diverse practices, we must assume the partiality (or non-absoluteness) of gender as a structuring principle in culture. Furthermore, the taking up of positions in which gender is not necessarily implicated – for example, that of professional, hostage, teacher or citizen – always transcends the 'simply human'; these are overdetermined social positions in which identities may – temporarily – be articulated in non-gendered ways, dependent upon context.[12] Indeed, given the dominant culture's insistence on the all-importance of sexual difference, we might arguably want to cherish those rare moments that women manage to escape the prison house of gender.

THE INSTABILITY OF GENDER IN MEDIA CONSUMPTION

Our theoretical explorations have led us to recognize the fundamental instability of the role of gender in media consumption practices. We cannot presume *a priori* that in any particular instance of media consumption gender will be a basic determining factor. In other words, media consumption is not always a gendered practice, and even if it is a gendered practice its modality and effectivity can only be understood by close examination of the meanings that 'male' and 'female' and their inter-relationships acquire within a particular context.

What we have tried to clarify, then, is the importance of recognizing that there is no prearticulated gender identity. Despite the force of hegemonic gender discourse, the actual content of being a woman or a man and the rigidity of the dichotomy itself are highly variable, not only across cultures and historical times, but also, at a more micro-social and even psychological level, amongst and within women and men themselves. Gender identity, in short, is both multiple and partial, ambiguous and incoherent, permanently in process of being articulated, disarticulated and rearticulated.

The consequences of this particularist perspective for research into gender and media consumption are not too difficult to spell out. In our view, the ethnographic turn in the study of media audiences is, given its spirit of radical contextualism and methodological situationalism (Ang 1991; see also chapter 4), well suited to take on board the challenge of problematizing and investigating in which concrete situations which gender positions are taken up by which men and women, with what identificatory investments

125

and as a result of which specific articulations. But in order to do this, the ethnographic project needs to be radicalized even more, since not only gender but also media consumption cannot be conceptualized in static terms. To be sure, with this claim we want to give this chapter a final destabilizing twist.

The current emphasis on the social experiences of audience subjects as a starting point for understanding practices of media consumption is ethnography's major contribution to audience studies. However, in their focus on women's reception of women's genres most existing studies of gender and/in media consumption have not pushed the ethnographic thrust far enough. Since the main interest of these studies, as we have seen, has been in text/reader relationship, they tend to decontextualize the reception process from the ongoing flow of everyday life. But in our media-saturated world media audiences can no longer be conceived as neatly demarcated categories of people, collectively set in relation to a single set of isolated texts and messages, each carrying a finite number of subject positions. This insight can only lead to a more radical 'anthropologization' of the study of media consumption, in which the text is radically decentred and the everyday contexts in which reception, consumption and use take place are more emphatically foregrounded (e.g. Radway 1988; Moores 1993; Drotner 1994; Silverstone 1994; Hermes 1995).

To do justice to such a perspective, then, we need to go beyond the boundaries of reception analysis and develop new forms of 'consumption analysis'. In everyday life, media consumption cannot be equated with distinct and insulated activities such as 'watching television', 'reading a book', 'listening to a record', and so on. Since people living in (post)modern societies are surrounded by an ever-present and ever-evolving media-environment, they are always-already audiences of an abundance of media provisions, by choice or by force. Thus, media consumption should be conceptualized as an ever-proliferating set of heterogeneous and dispersed, intersecting and contradicting cultural practices, involving an indefinite number of multiply positioned subjects: '[E]veryone is constantly exposed to a variety of media and forms, and participates in a range of events and activities' (Grossberg 1988a: 20–1).

Hermann Bausinger (1984) has summed up a list of phenomenological considerations which illuminates the enormous complexity of the field opened up here, although the list is also helpful in beginning to map the terrain. To understand day-to-day media use in contemporary society, Bausinger states, it is necessary to take the whole 'ensemble' of intersecting and overlapping media provisions into consideration. Audiences piece together the contents of radio, television, newspapers, and so on. As a rule, media texts and messages are not used completely or with full concentration. We read parts of sports reviews, skim through magazines and zap from channel to channel when we don't like what's on TV. Furthermore, media

use, being an integral part of the routines and rituals of everyday life, is constantly interrelated with other activities such as talking, eating or doing housework. In other words, 'mass' communication and 'interpersonal' communication cannot be separated. Finally, according to Bausinger, media use is not a private, individual process, but a collective, social process. Even when reading the newspaper one is often not truly alone, but interacting with family, friends or colleagues. In short, comprised within the deceptively simple term 'media consumption' is an extremely multifarious and differentiated conglomerate of activities and experiences.

Against this background, we need to perform an even further particularization in our research and interpretive endeavour. Since media consumption takes place in the 'the complex and contradictory terrain, the multi-dimensional context, within which people live out their everyday lives' (Grossberg 1988a: 25), no two women (or men) will have exactly the same experiences in 'the ever-shifting kaleidoscope of cultural circulation and consumption' (Radway 1988: 361), although of course specific overlapping interests and commonalities in past and present circumstances are not ruled out. In such a context, we must accept contingency as posing the utter limit for our understanding, and historical and local specificity as the only ground on which continuities and discontinuities in the ongoing but unpredictable articulation of gender in media consumption can be traced. In other words, such continuities and discontinuities only emerge *post facto*. Within this horizon, ethnography's task would be the production of accounts that make these historically specific continuities and discontinuities explicit, thereby lifting them out of their naturalized day-do-day flow.[13]

This brings us back to the hazardous episode of daily life in the Meier family with which we opened this chapter. In unexpectedly ending up watching the sports programme, Mrs Meier simultaneously places herself outside the gendered discourse of 'televised football is for men', and reproduces the traditional definition of femininity in terms of emotional caretaking by using the viewing of the game as a means of making contact with her son. It is not impossible that such accidental events will lead Mrs Meier to eventually like football on television, thereby creating a gender-neutral zone within the family's life with the media. After having finished doing the dishes while watching a favourite soap opera on a small black and white TV set in the kitchen, she might watch the sports programme in the sitting room because she and her husband have become involved in a debate over the technical qualities of United's new goalkeeper (thereby developing a 'masculine' interest in sports). Or else, she might watch the game for human interest reasons (which would be a 'feminine' subject position). At the same time, whether she takes up a masculine, feminine or gender-neutral position in relation to TV football, this very development would only reinforce Mr Meier's investment in a discourse which sees masculine preferences as natural.

POSTSCRIPT: ON FEMINIST CRITIQUE

It is clear that our exposition of the instability of gender/media consumption articulations draws a great deal from postmodern theory, energized as it is by a wariness of generalized absolutes and its observance of the irreducible complexity and relentless heterogeneity of social life (see also Corner 1991). However, doesn't this stance make theory and politics impossible? Doesn't postmodern particularism inevitably lead to the resignation that all there is left viable are descriptions of particular events at particular points in time? And doesn't radical endorsement of particularity and difference only serve to intensify an escalating individualism? If we declare 'women' to be an indeterminate category, how can a feminist politics still assert itself?

These questions are certainly valid and understandable, although we think they need not have to remain unanswered. For one thing, we believe that the dangers of easy categorization and generalization, so characteristic of mainstream traditions in the social sciences (including mass communication theory and research), are greater than the benefits of a consistent particularism. The earlier feminist tendency to speak for and behalf of 'women' as if this were a unified category with a uniform identity has already been eroded by a gradual acknowledgement of differences between different sorts of women, positioned in different relations of class, ethnicity, generation, sexual orientation and regionality. But postmodern feminism, building up a poststructuralist theory of subjectivity, goes further than this sociological differentiating move by adopting a more profound sense of gender scepticism, thereby eradicating any pregiven guarantee for female unity. In this sense, postmodern feminism is itself a critical reaction to the normative and moralist absolutism in earlier feminisms: '[A] critical vision consequent upon a critical positioning in un-homogeneous gendered social space' (Haraway 1988: 589).[14]

As Jane Flax has noted, '[f]eminist theories, like other forms of postmodernism, should encourage us to tolerate and interpret ambivalence, ambiguity, and multiplicity' (1990: 56). She even adds to this that '[i]f we do our work well, reality will appear even more unstable, complex, and disorderly than it does now' (ibid.: 56–7). In political terms, this means that we can no longer afford to found a feminist practice upon the postulation of some fixed figure of 'women' without risking being totalizing and excluding the experiences and realities of some. Arguably, such unifying feminist politics will only be ultimately unproductive: the fact that many women today refuse to call themselves feminists is symptomatic of this. Another example would be the sharp contrast between the critical feminist condemnation of Steven Spielberg's film *The Color Purple* as a white middle-class cooptation of Alice Walker's novel, and the impressive positive responses to the film from black women viewers (Bobo 1988; Stuart 1988). This example also clarifies the political importance of local, contextualized

ethnographic studies: the production of 'situated knowledges' whose critical value lies in their enabling of power-sensitive conversation and contestation through comparison rather than in epistemological truth (Haraway 1988).

Indeed, any feminist standpoint will necessarily have to present itself as partial, based upon the knowledge that while some women sometimes share some common interests and face some common enemies, such commonalities are by no means universal. Asserting that there can be no fixed and universal standards for 'political correctness' does not mean relativist political reticence nor submission to a pluralist free-for-all. On the contrary, it is an acknowledgement of the fact that in order to confront 'sexism in all its endless variety and monotonous similarity' (Fraser and Nicholson 1990: 34), a flexible and pragmatic form of criticism might be more effective than one based upon predefined truths, feminist or otherwise. What is at stake here then is not relativism, but a politics of location:

> [L]ocation is about vulnerability; location resists the politics of closure, finality, or [. . .] 'simplification in the last instance'. [. . .] We seek [knowledges] ruled by partial sight and limited voice – not partiality for its own sake but, rather, for the sake of the connections and unexpected openings situated knowledges make possible. [. . .] The only way to find a larger vision is to be somewhere in particular [and through] the joining of partial views and halting voices into a collective subject position that promises a vision of the means of ongoing finite embodiment, of living within limits and contradictions – of views from somewhere.
>
> (Haraway 1988: 590)

Part III

AUDIENCES AND GLOBAL CULTURE

8

Cultural studies, media reception and the transnational media system

CULTURAL STUDIES AND CULTURAL CRITIQUE

An intense interest in culture is one of the most significant trends in contemporary communication studies. At the same time, the term 'culture' is so widely used and elusive that its current prominence could obscure the fact that its analysis is being undertaken from a diversity of perspectives and approaches. The emergence of a set of critical-cultural approaches to communication, generally called cultural studies, needs to be distinguished from the less encompassing social-scientific interest in cultural phenomena displayed within mainstream communication research. To be more precise, in my view the perceived convergence of disparate scholarly traditions that is hailed by some observers (e.g. Blumler *et al.* 1985; Schrøder 1987; Curran 1990) should be embraced with caution. Although culture may at first sight be a 'common object of study' (Rosengren 1988: 10) that can contribute to the further loosening up of unproductive divisions between 'mainstream' and 'critical' traditions, the theoretical and methodological, as well as epistemological and political differences between the two traditions, as I have already discussed in chapter 2, remain impressive and need to be acknowledged as such.

In brief, 'culture' in mainstream communication research is generally conceptualized in behavioural and functionalist terms, about which 'object-ive' knowledge can be accumulated through the testing of generalizable hypotheses by way of conventional social-scientific methods. Such positivist interest in media culture is, in many respects, at odds with the concerns of cultural studies. In the latter, 'culture' is not simply treated as a discrete object of communication research. It is the contradictory, continuous and open-ended *social process* of the production, circulation and consumption of meaning that cultural studies is about, not 'culture' defined as a more or less static, bounded and objectified set of ideas, beliefs and behaviours. David Chaney has recently put it this way: 'The innovation of cultural studies has meant that the crisis of culture has been firmly placed within the social history of modernity' (1994: 13).

This implies a completely different set of working principles: cultural studies is interested in historical and particular meanings rather than in general types of behaviour, it is process-oriented rather than result-oriented, interpretive rather than explanatory. Most important, what fundamentally divides both traditions is their respective self-conceptions as intellectual discourse: the scientistic ambitions of social science are vehemently at odds with those of cultural studies. As an intellectual practice, cultural studies is positively and self-consciously eclectic, critical and deconstructive (see, e.g., Hall 1986b; Grossberg *et al.* 1992).[1] It does not seek paradigmatic status, nor does it obey established disciplinary boundaries. It is, as Angela McRobbie (1994) has put it, an 'undisciplined discipline'. Its intellectual loyalties reach beyond the walls of the academy to the critique of current cultural issues in the broadest sense. Cultural studies forms what Clifford Geertz (1983) has called a 'blurred genre' of intellectual work: it is at once cultural research and cultural criticism. Ultimately, doing cultural studies does not mean contributing to the accumulation of science for science's sake, the building of an ever more encompassing, solidly constructed, empirically validated stock of 'objective' knowledge, but participating in an ongoing, open-ended, politically motivated debate, aimed at evaluating and critiquing our contemporary cultural condition. In this context topicality, critical sensibility and sensitivity to local specificities are more important than theoretical professionalism, methodological purity and generalized 'truths'. French Marxist psychologist Michel Plon told me years ago, non-apologetically, 'I don't work hard enough because I read too many newspapers.' In my view, above all else it is this worldly attitude that is required for doing cultural studies.

MEDIA RECEPTION AS FOCUS OF CULTURAL CRITIQUE

Cultural studies has gained an enormous popularity in the past decade or so. It has become a preferred intellectual 'meeting point' for scholars who are searching for alternatives, not only to the worn-out paths of the 'dominant paradigm', but also to the increasingly sterile reiterations of classical critical theory (e.g. Hardt 1989). The work of the Birmingham Centre for Contemporary Cultural Studies (e.g. Hall *et al.* 1980) is generally seen as the source of the emerging tradition, but its influence has spread to many critical-intellectual corners in advanced capitalist societies, although paradoxically enough less so in continental Europe than in Canada, Australia and, particularly, the United States (see, e.g., Ang and Morley 1989; Blundell *et al.* 1993; Frow and Morris 1993; Stratton and Ang 1995).

What I want to do here is give a short sketch of some of the central issues related to media and communication that have preoccupied cultural studies, and clarify the lines along which the formulation of cultural critique within

this tradition has developed. I will also suggest some themes which I find particularly pertinent for cultural studies to take up in the present period of massive economic, political and technological transformation of our media environment. In Europe and elsewhere, the question of 'national identity' has been particularly prominent in official responses to these changes. I will focus my discussion on this issue. The European case will only be rendered obliquely, however, because I think that European problems are hardly unique (although certainly historically specific and distinctive) in a world that moves progressively towards global integration, at least at the structural level of political economy. Finally, to pick up a central theme of this book, I will highlight the importance of an ethnographic approach in assessing the cultural impact of these current developments.[1]

These concerns reflect a personal point of view – a perspective coloured by the politics of my own work, which has centred on ways of conceptualizing and understanding television audiences. Watching Dallas (Ang 1985), in which I analysed letters from viewers about the infamous American prime-time soap opera, was ostensibly an attempt to probe the ways in which audiences interpret and give meaning to a popular television text, but its broader political context was the then rampant public outrage about the 'Americanization' of European public broadcasting. In showing how Dallas fans were silenced and thus disempowered by a dominant official discourse which categorically rejects such programmes as 'bad mass culture', I wanted to disarticulate the often taken-for-granted conflation between the logic of the commercial and the pleasure of the popular. I wanted to open up the possibility of a less deterministic thinking about these issues: a political stance against the increasing commercialization of broadcasting at the level of policy should not, as so often happens, preclude the recognition, at a cultural level, of the real enjoyment people take in commercially produced media material – a recognition that is sustained by making understandable the textual and socio-cultural parameters of that pleasure. In other words, I imagined my work to be, among many other things, a form of cultural critique that aimed at unsettling the prevailing and, in my view, counterproductive views on popular television and its audiences. (The original version of the book was published in Dutch in 1982, when the controversy about Dallas in the Netherlands was at its height.)

Of course, the way the book was received (and, as a result, its discursive effectivity) was beyond my control, and is something about which I can say very little here. What I think is important to emphasize, however, is that while the book came to be read as an exercise in what is now commonly called 'reception analysis' (see, e.g., Jensen and Rosengren 1990), the ideological and cultural climate in which the book was written played a decisive role in shaping the arguments and interpretations put forward in it. By 1990, a reception analysis of Dallas would have been inspired by very different political and socio-cultural problematics. For example, the very

success of *Dallas* has dramatically challenged European programming policies, to the point that it has become an accepted model for European productions of television drama, where Europeanized 'imitations' of *Dallas* – such as the French *Chateauvallon* and the German *Schwarzwaldklinik* – have become a regular provision (Silj 1988). I would suspect that this would have significantly altered the appeal of American mass television to European audiences.

It may seem immodest to propose my own work to illustrate the need for cultural studies to pursue a practice of analytical and theoretical 'conjuncturalism' – that is, the need to try 'writing at just the right moment in just the right way' (Rorty 1989: 174). The justification for it, however, is the fact that reception analysis (i.e. the study of audience interpretations and uses of media texts and technologies) has been one of the most prominent developments in recent communication studies, including cultural studies. To put it in more general terms, reception analysis has intensified our interest in the ways in which people actively and creatively make their own meanings and create their own culture, rather than passively absorb pregiven meanings imposed upon them. As a result, the question of audience has acquired a central place in cultural studies. The thrust of the interest has been ethnographic: while most reception studies were limited to analysing the specifics of certain text/audience encounters, the methods used were qualitative (depth-interviewing and/or participant observation), and the emphasis has overwhelmingly been on the detailed description of how audiences negotiate with media texts and technologies. Although, from an anthropological point of view, the ethnographic method has only been applied in a limited way in these studies (Hannerz 1992; Spitulnik 1993), reception analyses are an important step in the development of a more full-fledged ethnographic understanding of media consumption.

Numerous concrete studies have been carried out inspired by this trend. Australian critic Meaghan Morris even goes so far as having the impression that 'thousands of versions of the same article about pleasure, resistance, and the politics of consumption are being run off under different names with minor variation' (1988a: 20). She goes on to say that while the theses underlying the ethnography of audiences have been extremely enabling for cultural studies (e.g. that consumers are not 'cultural dopes', but critical users of mass culture), she is now worried about 'the sheer proliferation of the restatements', which threaten to lead to 'the emergence [. . .] of a *restrictive definition* of the ideal knowing subject of cultural studies' (ibid.).

Translated freely, the problem signalled by Morris is as follows. The ethnographic perspective on audiences has led to a boom in isolated studies of the ways in which this or that audience group actively produces specific meanings and pleasures out of this or that text, genre or medium. However, while the positivist would be pleased with such an accumulation of empirical verifications (and elaborations) of a central hypothesis, it is not adequate for

purposes of open-ended cultural critique. On the contrary, self-indulgent 'replications' of the same research 'design' would run the danger of merely producing an ever more absolute formal Truth, an empty, abstract, and ultimately impotent generalization that could run like this: '[P]eople in modern mediatised societies are complex and contradictory, mass cultural texts are complex and contradictory, therefore people using them produce complex and contradictory culture' (Morris 1988a: 22).

Although audience ethnographies have certainly enhanced and transformed our understanding of media audiences, I do take Morris's concerns to heart. For purposes of cultural critique, validating audience experience or 'taking the side of the audience' alone is not enough. In this sense, the term 'reception' itself bears some limitations because, stemming from the linear transmission model of communication (Carey 1989), it tempts us to foreground the spatial/temporal moment of direct contact between media and audience members, and thus to isolate and reify that moment as the instance that merits empirical examination. A more thoroughly *cultural* approach to reception, however, would not stop at this pseudo-intimate moment of the text/audience encounter, but address the differentiated meanings and significance of specific reception patterns in articulating more general cultural negotiations and contestations. The conflict-ridden reception of Salman Rushdie's novel *The Satanic Verses* would be a tragic case in point here. This case shows how the clash between different interpretive communities can form a nodal point where complicated political tensions, ideological dilemmas and economic pressures (e.g. relating to the publishing industry) find their expression in ways which have worldwide consequences (Asad 1990). This admittedly extraordinary example suggests the importance of not reducing reception to an individualized, essentially psychological process, but to conceptualize it as a deeply politicized, cultural one.[2]

To avoid the 'banality' in cultural studies that Morris points to, then, qualitative reception analysis needs to be placed in a broader theoretical framework, so that it ceases to be just a sophisticated form of empirical audience research, but becomes part of a more encompassing understanding, both structural and historical, of our contemporary cultural condition and the place of the media in it. In other words, what we need is more ethnographic work not on discrete audience groups, but on media consumption as an integral part of popular cultural practices, articulating both 'subjective' and 'objective', both 'micro' and 'macro' processes. That is to say, media consumption can be seen as one site of 'the complex and contradictory terrain, the multidimensional context, within which people live out their everyday lives' (Grossberg 1988a: 25). At the same time, it is in this very living out of their everyday lives that people are inscribed into large-scale structural and historical relations of force which are not of their own making. I will have this set of theoretical assumptions in mind in charting a conceptual terrain that can inform such a 'globalization' of the

137

ethnographic pursuit. First, however, I want to place the ethnographic turn within cultural studies in a more substantial historical and theoretical perspective.

THE POWER OF THE POPULAR: BEYOND IDEOLOGY AND HEGEMONY

The ethnographic turn in audience studies has functioned as a way of relativizing the gloomy tendency of an older perspective within cultural studies, namely ideological criticism. A distinctive assumption of cultural studies is that the social production and reproduction of sense and meaning involved in the cultural process is not only a matter of signification, but also a matter of power. The intimate connection of signifying practices and the exercise of power is a focal interest of cultural studies. As Grossberg notes, 'Once we recognize that all of culture refracts reality as well as reproducing it as meaningful, then we are committed as well to examining the interests implicated in particular refractions' (1983: 46). Consequently, ideology was logically foregrounded in cultural studies to the point that the cultural and the ideological tended to be collapsed into one another: cultural processes are by definition also ideological in so far as the way in which the world is made to mean in a society tends to coincide with the interests of the dominant or powerful classes and groups in that society. The Gramscian concept of hegemony is mostly used to indicate the cultural leadership of the dominant classes in the production of generalized meanings, of 'spontaneous' consent to the prevailing arrangement of social relations – a process, however, that is never finished because hegemony can never be complete. Since the communications media are assumed to play a pivotal role in the continuous struggle over hegemony, cultural studies became preoccupied with the question of how the media helped to produce consensus and manufacture consent (Hall 1982). This set of assumptions has enabled us to understand the precise textual and institutional mechanisms by which the media function ideologically; how, that is, in processes of institutionalized cultural production particular meanings are encoded into the structure of texts, 'preferred meanings' which tend to support existing economic, political and social power relations.

As a form of cultural critique, this kind of ideological analysis (of which I have only given a simplified description here) is ultimately propelled by a will to demystify, denounce, condemn; it is a deconstructive practice which presupposes that the researcher/critic take up the aloof position of critical outsider. However, this perspective was soon sided by a countercurrent, which emphasized not top–bottom power, but bottom–top resistance, itself a form of (informal, subordinate) power. The well-known work on youth subcultures (e.g. Hall and Jefferson 1976; Willis 1977; Hebdige 1979), but also the emergence of ethnographic approaches to reception are part of the

same trend. It is a populist reaction which stressed the vitality and energy with which those who are excluded from legitimate, institutional power create a meaningful and liveable world for themselves, using the very stuff offered them by the dominant culture as raw material and appropriating it in ways that suit their own interests. Hall's (1980a) encoding/decoding model opened up the space to examine the way in which the media's preferred meanings could be 'negotiated' or even occasionally subverted in recalcitrant audience readings. John Fiske, the most exuberant ambassador of this position, has pushed it to an extreme in several provocative publications by virtually declaring the audiences' independence in the cultural struggle over meaning and pleasure (e.g. 1987a, 1987b; see also L. A. Lewis 1990; Jenkins 1992). In this version of cultural studies the researcher/critic is no longer the critical outsider committed to condemn the oppressive world of mass culture, but a conscious fan, whose political engagement consists in 'encouraging cultural democracy at work' (Fiske 1987b: 286), by giving voice to and celebrating audience recalcitrance.

As Morris has remarked, what we have here is 'a humane and optimistic discourse, trying to derive its values from materials and conditions already available to people' (1988a: 23). However, what does it amount to as cultural critique? There is a romanticizing and romanticist tendency in much work that emphasizes (symbolic) resistance in audience reception, which, according to Morris, can all too easily lead to an apologetic 'yes, but . . .' discourse that downplays the realities of oppression in favour of the representation of a rosy world 'where there's always a way to redemption'. Similar criticisms have been voiced by other critical theorists (e.g. Modleski 1986; Schudson 1987; Gripsrud 1989; Budd *et al.* 1990).

But this kind of 'selling out', I would argue, is not the inevitable outcome of the ethnography of reception. In this respect, it is unfortunate that the politics of reception analysis has all too often been one-sidedly cast within the terms of the liberal defence of popular culture, just as uses and gratifications research could implicitly or explicitly, in theoretical and political terms, serve as a decontextualized defence of the media status quo by pointing at their 'functions' for the active audience (cf. Elliott 1974). Similarly, research into how audiences create meanings out of items of media culture has often been used as an empirical refutation of the elitist argument that mass culture stupefies, numbs the mind, reinforces passivity, and so on. There is something truly democratic about this discourse, and I would be the last to want to question the importance of attacking the damaging impact of the high/low culture divide, which still pervasively informs – and limits – national cultural and educational policies, for example. However, revalidating the popular alone – by pointing to the empirical fact that audiences are active meaning producers and imaginative pleasure seekers – can become a banal form of cultural critique if the popular itself is not seen in a thoroughly social and political context. In other words, audiences may

be active in a myriad of ways in using and interpreting media, but it would be utterly out of perspective to cheerfully equate 'active' with 'powerful', in the sense of 'taking control' at an enduring structural or institutional level. It is a perfectly reasonable starting point to consider people's active negotiations with media texts and technologies as empowering in the context of their everyday lives (which, of course, is *the* context of media reception), but we must not lose sight of the *marginality* of this power. As Michel de Certeau has remarked about the clandestine tactics by which ordinary women and men try to 'make do' in their everyday practices of consumption:

> [T]his cultural activity of the non-producers of culture, an activity that is unsigned, unreadable, and unsymbolized, remains *the only one possible* for all those who nevertheless buy and pay for the showy products through which a productivist economy articulates itself
> (de Certeau 1984: xvii, emphasis added)

To be sure, one of the important contributions made by ethnographic studies of reception is exactly the 'signing', 'reading' and 'symbolizing' – the documenting, the putting into tangible discourse – of the fragmented, invisible, marginal tactics by which media audiences symbolically appropriate a world not their own. This is no doubt what Fiske meant by encouraging cultural democracy, and he is right. However, if the ethnography of reception wants to elaborate its critical function, it cannot avoid confronting more fully what sociologists have dubbed the micro/macro problematic: the fact that there are structural limits to the possibilities of cultural democracy *à la* Fiske, that its expression takes place within specific parameters and concrete conditions of existence. In short, we need to return to the problematic of hegemony.

If the euphoria over the vitality of popular culture and its audiences has tended to make the question of hegemony rather unfashionable in some cultural studies circles, it is because the popular came to be seen as an autonomous, positive entity in itself, a repository of bold independence, strength and creativity, a happy space in which people can arguably stay outside the hegemonic field of force. The problem with this argument is that it conceives the relationship between the hegemonic and the popular in terms of mutual exteriority. However, in a culture where power is mostly exerted not through brute force but through 'soft' strategies of persuasion and seduction, incorporation and interpellation, it would make more sense to locate the hegemonic within the very texture of the popular. As Colombian communication theorist Martín-Barbero has noted, 'we need to recognize that the hegemonic does not dominate us from without but rather penetrates us, and therefore it is not just against it but from within it that we are waging war' (1988: 448). Therefore, he is wary of a 'political identification of the popular with an intrinsic, spontaneous resistance with which the subordin-

ate oppose the hegemonic' (ibid.). Instead, what should be emphasized is 'the thick texture of hegemony/subalternity, the interlacing of resistance and submission, and opposition and complicity' (ibid.: 462). The resulting forms of cultural resistance are not just ways to find redemption, but also a matter of capitulation; invested in them is not just pleasure, but also pain, anger, frustration – or sheer despair.

Martín-Barbero's Latin American perspective, informed as it is by the harsh and ugly realities spun off by the subcontinent's unequal economic development, profound political instability and day-to-day social disorder, especially in the explosive urban areas, can not only help to undermine the Euro- and Americocentrism of much cultural studies, but also, more positively, (re)sensitize us to the messy and deeply political contradictions which constitute and shape popular practices. In Latin America, the popular is often nostalgically equated with the indigenous, and this in turn with the primitive and the backward, the disappearing 'authentic popular' untouched by the forces of modernity. From this perspective, the unruly, crime-ridden, poverty-stricken culture of the urban popular, concentrated in the *favelas*, the *barrios*, and other slums, but diffusing its subversions from there right into the hearts of the modern city centres, could only be conceived of as contamination of indigenous purity, as an irreconcilable loss of authenticity. Against this vision, Martín-Barbero proposes to reconceptualize the indigenous as at once 'dominated and yet as the possessors of a positive existence, capable of development' (1988: 460). In this way, we can begin to see the urban popular not as inauthentic degeneration but as the truly contemporary site where powerless groups seek to take control of their own conditions of existence within the limits imposed by the pressures of modernity (see also Martín-Barbero 1993).

In the West, where everyday life is relatively comfortable even for the least privileged, the struggle for popular survival and self-affirmation seems to have lost its urgency. However, it is not true that, as Martín-Barbero would have it, 'in the United States and Europe [. . .] to talk of the popular is to refer solely to massness or to the folklore museum' (1988: 464). In the developed world too the popular remains invested with intense conflict: this is the case even in such a seemingly innocent terrain as cultural consumption and media reception. To be sure, Martín-Barbero's assumption that popular culture is a subordinate culture that stands in a contradictory relation to dominant culture is hardly unique and is well represented in British cultural studies too, particularly as a result of its Gramscian legacy (Bennett *et al*. 1986). However, this general theoretical assumption has not sufficiently succeeded in informing concrete analyses of media audiences. Instead, our understanding of media reception – one of the most prominent practices where the popular takes shape in today's 'consumer societies' – is still governed by the unhelpful dichotomies of passive/active, manipulative/ liberating, and so on. What a critical ethnography of reception needs to

141

ferret out, then, is the unrecognized, unconscious and contradictory effectivity of the hegemonic within the popular, the relations of power that are inscribed within the very texture of media reception practices. In this context, Sut Jhally and Justin Lewis's (1992) study on audience readings of the immensely popular *The Cosby Show* points to the extremely useful insight that hegemony can operate precisely through popularity, and that this in turn is enhanced by the polysemic nature of the text: 'The hegemonic power of *The Cosby Show*, it turns out, actually depends upon its ability to resonate with different audiences in different ways' (J. Lewis 1991: 205). To put it more generally, what we need to clarify is the complex and contradictory ways in which the popular is *implicated* in the hegemonic, and vice versa. In the following section, I will sketch one of the trajectories along which we can begin to stake out this terrain.

THE HEGEMONIC SPECIFIED: THE TRANSNATIONAL MEDIA SYSTEM

To begin with, it is important to develop a concrete sense of the hegemonic forces that rule the world today. In too much cultural studies work understanding of hegemony remains at an abstract theoretical level, evoked rather than analysed, by alluding to basic concepts such as 'class', 'gender' and 'race'. We need to go beyond these paradigmatic conceptualizations of hegemony and develop a more specific, concrete, contextual, in short, a more ethnographic sense of the hegemonic (Marcus 1986).

I can only make an extremely sketchy start here, and it seems to me that a good point to begin is the rather disturbing changes that the international media system – arguably an important locus of hegemonic forces – is undergoing at present. As we are moving towards the end of the century the communications industries, as part of the ever expanding capitalist system, have been in a process of profound economic and institutional restructuration and transformation, which can be characterized by accelerated transnationalization and globalization. We can see this in the emergence of truly global, decentred corporations in which diverse media products (film and television, press and publishing, music and video) are being combined and integrated into overarching communications empires such as Bertelsmann, Murdoch, Berlusconi and Time Warner. This process is accompanied by an increased pressure towards the creation of transnational markets and transnational distribution systems (made possible by new communication technologies such as satellite and cable), transgressing established boundaries and subverting existing territories – a process which, of course, has profound political and cultural consequences (Morley and Robins 1989; Robins 1989; Appadurai 1990; Jacka 1992). The currency of such notions as 'the information revolution' and 'postmodernity' are indicative of the perceived pervasiveness of the changes, and in our everyday lives we are

direct witness of these changes through the turbulent transformation of our media environment, in both technological (cable, satellite, video, computer games) and institutional (new TV channels, dismantling of public service broadcasting) terms.

These historical developments form, in very specific ways, the structural and global configurations of hegemony within which contemporary practices of media reception and consumption evolve. As we have seen, ethnographies of media audiences emphasize, and tend to celebrate, the capability of audience groups to construct their own meanings and thus their own local cultures and identities, even in the face of their virtually complete dependence on the image flows distributed by the transnational culture industries. However, this optimistic celebration of the local can easily be countered by a more pessimistic scenario, pictured by Manuel Castells, who foresees 'the coexistence both of the monopoly of messages by the big networks and of the increasingly narrow codes of local microcultures around their parochial cable TV's' (quoted in Robins 1989: 151). In other words, wouldn't the vitality and creativity of audiences in creating their own cultures merely amount to paltry manifestations of, in Castells' words, 'cultural tribalism' within an electronic global village?

It would be ludicrous, I would argue, to try to find a definitive and unambiguous, general theoretical answer to this question – as the theory of cultural imperialism has attempted to do (Tomlinson 1991) – precisely because there is no way to know in advance which strategies and tactics different peoples in the world will invent to negotiate with the intrusions of global forces in their lives. For the moment, then, we can only hope for provisional answers – answers informed by ethnographic sensitivity to how structural changes become integrated in specific cultural forms and practices, under specific historical circumstances. Only such a particularistic approach will allow us to avoid premature closures in our understanding, and keep us alert to contextual specificities and contradictions.

But an ethnographic perspective suitable for and sensitive to the peculiarities of our contemporary cultural condition needs to move beyond the restrictive scope delimited by the boundaries of the local, and develop an awareness for the pertinent asymmetries between production/distribution and consumption, the general and the particular, the global and the local. In other words, ethnography's critical edge should not just reside in romantically discovering and validating diversity and difference in an increasingly homogeneous world, as has been suggested by several authors (cf. van Maanen 1988); it can more ambitiously – and with a greater sense of unequal power relationships across the board – work towards an unravelling of the intricate intersections of the diverse and the homogeneous, the complicated interlockings of autonomy and dependency. Furthermore, the ethnographic perspective can help to detail and specify the abstracting, telescopic view invoked by structural analysis of the transnational media system:

The ethnographic task lies ahead of reshaping our dominant macro-frameworks for the understanding of historical political economy, such as capitalism, so that they can represent the actual diversity and complexity of local situations for which they try to account in general terms.

(Marcus and Fischer 1986: 88)

In short, one way to examine the ways in which the hegemonic and the popular interpenetrate one another is to trace the global in the local, and the local in the global. The next, last section of this chapter gives an illustration of this point.

WHERE THE GLOBAL AND THE LOCAL MEET: NATIONALITY AND THE STRUGGLE FOR CULTURAL IDENTITIES

One central issue in which a recognition of the intertwining of global and local developments has particularly strong theoretical and political consequences is the issue of cultural identity. In the struggles that are fought out around this issue in many parts of the world today, the structural changes brought about by the transnationalization of media flows are often assessed and officially defined in terms of a threat to the autonomy and integrity of 'national identity'. However, I would suggest that such a definition of the problem is a very limited and limiting one because it tends to subordinate other, more specific and differential sources for the construction of cultural identity (e.g. those based upon class, locality, gender, generation, race, ethnicity, religion, politics, and so on) to the hegemonic and seemingly natural one of *nationality*. The defence and preservation of national identity as a privileged foundation for cultural identity is far from a general, self-evidently legitimate political option. After all, nations are themselves artificial, historically constituted politico-cultural units; they are not the natural destiny of pregiven cultures, rather their existence is based upon the construction of a standardized 'national culture' that is a prerequisite to the functioning of a modern industrial state (Gellner 1983; Hobsbawm 1990). The desire to keep national identity and national culture wholesome and pristine is not only becoming increasingly unrealistic, but is also, at a more theoretical level, damagingly oblivious to the contradictions that are condensed in the very concept of national identity. Defining national identity in static, essentialist terms – by forging, in a manner of speaking, authoritative checklists of Britishness, Frenchness, Greekness, Japaneseness, Australianness, and so on – ignores the fact that what counts as part of a national identity is often a site of intense struggle between a plurality of cultural groupings and interests inside a nation, and that therefore national identity is, just like the popular identities in Latin America and elsewhere, fundamentally a dynamic, conflictual, unstable and impure phenomenon.

However, contrary to the subterranean tactics by which informal popular identities are created, the categories of national identity and national culture are invested with formal, discursive legitimacy and are at present still dominantly used as a central foundation for official cultural and media policies. It is this constellation that has been thrown into question by the electronic intrusions of the transnational media system, which does not care about national boundaries, only about boundaries of territory of transmission and of markets. It is not just a question of 'cultural imperialism', that older term that suggests the unambiguous domination of one dependent culture by a clearly demarcated other (Tomlinson 1991). The homogenizing tendencies brought about by the transnational era may be better characterized by the term 'cultural synchronization' (Hamelink 1983), and it poses quite a different problem as to the politics of national identity. The Mexican theorist García Canclini has formulated the problem as follows:

> To struggle to make onseself independent of a colonial power in a head-on combat with a geographically defined power is very different from struggling for one's own identity inside a transnational system which is diffuse, complexly interrelated and interpenetrated.
>
> (quoted in Martín-Barbero 1988: 452)

In other words, in the increasingly integrated world-system there is no such thing possible as an independent cultural identity: every identity must define and position itself in relation to the cultural frames affirmed by the world-system. Ignoring this, which is the case when national identity is treated as a sacrosanct given, not only can lead to undesirable unintended consequences, but is itself an act of symbolic power, both by defining an abstracted, unified identity for diverse social and cultural groups within a nation, and by fixing, in a rigid fashion, relationships between distinct national 'imagined communities' (Anderson 1983).

Two more Third World examples can illuminate how a politics of national identity, or one that is propelled in its name, always implies a rearrangement of relations of cultural power, both locally and globally. The examples also point to the kind of concrete situations that ethnographies of reception could take up while holding together both local specificity and global pressures.

In its attempt to foster Malaysian national identity, the Malaysian government ruled in 1989 that television commercials were no longer allowed to feature 'pan-Asian' models (and still less Caucasian models or ads 'suggesting Western superiority'). Instead, actors should represent Malaysia's main ethnic groups: Malays, Chinese and Indians. Ironically, however, the government had in the early 1980's taken precisely the opposite tack, directing advertising agencies to stop using racially identifiable models, reasoning that using mixed-race actors would be more adequate to promote a unitary Malaysian identity (Goldstein 1989). What

we see here is not only that national identity is a matter of selective construction, including some and excluding other elements from it (defining itself as much in terms of what it is not as in what it is), but also the very uncertainty and instability of what that identity is and should be. The inconsistency exemplified in this case glaringly elucidates the precariousness of a cultural politics that depends on the concept of national identity for its rhetorics and assumptions.

The second example describes a more spontaneously popular case of cultural nationalism. In the Philippines, English, brought by the American colonizers at the turn of the century, has been the official language for nearly thirty years after the nation's independence in 1946. English was the language that served to linguistically unify a country inhabited by peoples who speak more than seventy regional languages and dialects. After the downfall of President Marcos in 1986, however, the country has seen the spectacular and spontaneous (i.e. unplanned) emergence of one of the native languages, Tagalog, as a popular national language. Tagalog, not English, was the language of street rallies and demonstrations and it became an emblem of national self-esteem. Now, most popular TV shows and comic books are in Tagalog, TV newscasts in Tagalog are drawing far larger audiences than those in English, and there is even a 'serious' newspaper in Tagalog, breaking the previous English-language monopoly in this market. Politicians can no longer rely upon delivering their speeches in English only (President Aquino's command of the indigenous language was said to have improved tremendously) (Branegan 1989). If this turn of events would stir some optimism in the hearts of principled nationalists, it also has more contradictory consequences: it may lead, for example, to new, linguistically based inequalities and social divisions. It is not unlikely that the use and command of English will gradually decline among the less privileged, while the upper and middle classes will continue to speak both languages. After all, on a global scale English is the language that gives access to economic success and social mobility.

These two examples reinforce Schlesinger's claim that it is important for us communication researchers

> not to start with communication and its supposed effects on national identity and culture, but rather to begin by posing the problem of national identity itself, to ask how it might be analyzed and what importance communication practices might have in its constitution.
>
> (Schlesinger 1987: 234)

Furthermore, we can see how the cultural constitution of national identity, as articulated in both official policies and informal popular practices, is a precarious project that can never be isolated from the global, transnational relations in which it takes shape. At a more general level, these cases give

us a hint at the multiple contradictions that are at play in any local response to global forces.

There is also an opposite tack to take. While the transnational communications system tends to disrupt existing forms of national identification, it also offers opportunities of new forms of bonding and solidarity, new ways of forging cultural communities. The use of video by groups of migrants all over the world (Indians, Chinese, Turks, and so on) is a telling case. The circulation and consumption of ethnically specific information and entertainment on video serves to construct and maintain cross-national 'electronic communities' of geographically dispersed peoples who would otherwise lose their ties with tradition and its active perpetuation (Gillespie 1989; Naficy 1993; Kolar-Panov 1994) Thus, while official, national(ist) policies against further dissemination of the transnational media system seem to be more impossible and ineffectual than ever, social groups inside and between nations seem to have found informal ways to construct their own collective identities within the boundaries of the system that limits and binds us all.

I have not highlighted the cases above out of cross-cultural romanticism, but because things happening in distant places and among other peoples – often reified as an amorphous 'Third World' – may offer us lessons that are relevant in Europe as well. For example, recently European national identities have been thoroughly put under pressure by the growing importance of an integrated European media policy, as for example in the EU's directive for a *Television without Frontiers*. Culturally, this policy, which is an attempt to regulate the otherwise uncontrolled expansion of the transnational media system across Europe, is legitimated by pointing to the need to defend and promote some notional, supra-national 'European identity', in which the range of separate national identities in Europe will presumably be represented. However, this sweeping pan-Europeanism, which is increasingly becoming a hegemonic force at the level of official Euro-politics, contains many contradictions. For one thing, it is clear that there is no agreement about what such a European identity should look like. Thus, the smaller nations (such as the Netherlands, Denmark and Greece) are suspicious about the dominance of the larger nations (France, Germany, Italy), while there is also a clash of visions and interests between nations who define themselves as part of a 'Nordic' European culture and those that represent the 'Latin' culture. Of course, this is not to say that the separate national identities themselves should be seen as harmonious givens to which we could resort as a safe haven (after all, the nations themselves are repositories of conflicting cultural identifications), rather, it is to suggest that the politics of European identity is a matter of cultural power and resistance, not simply a question of cherishing some 'heritage', as much official policy discourse would have it.

Troubling in this respect is the way in which such a 'heritage' is artificially

forged by the formulation of what is included in and excluded from the configuration of 'Europeanness'. This implies symbolic strategies that are sustained by constructing the image of a unified European culture that needs to be protected from the supposed threat of external, alien cultural influences. In his book *Orientalism* Edward Said (1978) has already shown how the idea of 'Europe' has benefited from the colonial period onwards from its claimed superiority to the culture of the 'Orient'. This 'heritage' of latent and manifest racism still has troubling effects on ethnic relations in most European countries.

More recently, Europeanists have shown obsessive concern about the supposed threat of cultural 'Americanization' as a consequence of the transnationalization of the media system. However, this is to blatantly ignore the fact that American cultural symbols have become an integral part of the way in which millions of Europeans construct their cultural identities. Thus, official policies based upon a totalizing antagonism of 'Europe' against 'America' are necessarily out of touch with everyday life in contemporary Europe. If American popular culture seems so attractive to so many in the world, how do people incorporate it in their activities, fantasies, values, and so on? What multifarious and contradictory meanings are attached to images of the 'American way of life' in what specific circumstances? Surely, those meanings cannot be the same in different parts and among different groups and peoples living in Europe or, for that matter, in Latin America or Southeast Asia, but we know almost nothing about such differences. Against this background, pan-Europeanist discourse should not simply be seen as a counter-hegemonic response to the very real American hegemony in the field of cultural production and distribution, but as itself a hegemonic strategy that tends to marginalize the more elusive popular responses of ordinary Europeans. More specifically, I suggest that the official definition of 'Americanization' as an unambiguous threat should be relativized by looking at the contradictory losses *and* opportunities allowed by it. As Marcus and Fischer suggest,

> the apparent increasing global integration suggests not the elimination of cultural diversity, but rather opportunities for counterposing diverse alternatives that nonetheless share a common world, so that each can be understood better in the other's light.
>
> (Marcus and Fischer 1986: 136)

What I have tried to conjure up, then, is the broad range of creative practices which peoples in different parts of the world are inventing today in their everyday dealings with the changing media environment that surrounds them. The often hazardous and unpredictable nature of these practices make them difficult to examine with too formalized methods: it is an ethnographic approach that can best capture and respect them in their concrete multifacetedness. Here, then, lies the critical potential of an ethnography of

audiences that evinces global and historical consciousness as well as attention to local detail. In the words of Marcus and Fischer,

> since there are always multiple sides and multiple expressions of possibilities active in any situation, some accommodating, others resistant to dominant cultural trends or interpretations, ethnography as cultural criticism locates alternatives by unearthing these multiple possibilities as they exist in reality.
>
> (Marcus and Fischer 1986: 116)

Its emphasis on what *is* rather than on what could be makes ethnography a form of cultural critique that is devoid of utopianism. But then, we live in particularly non-utopian (or post-utopian) times – which is, of course, precisely one of the central features of the 'postmodern condition' (cf. Lyotard 1984; Ross 1988; Rorty 1989). The *de facto* dissemination of the transnational media system is an irreversible process that cannot be transcended, only negotiated. In such a situation, a critical perspective that combines a radical empiricism[3] with open-ended theorizing[4] may be one of the best stances we can take up in order to stay alert to the deeply conflictual nature of contemporary cultural relations across the globe. It is a form of cultural critique which is articulated by, and gives voice to, 'pained and disgruntled subjects, who are also joyous and inventive practitioners' (Morris 1988a: 25).

9

Global media/local meaning

Marshall McLuhan's idea of the global village, of the whole world united through long-distance communication technologies, has recently gained renewed popularity as a result of a number of heavily televised historic events such as the fall of the Berlin Wall, the Tiananmen Square Massacre, the Gulf War, the civil wars in Bosnia and Somalia. It is largely through the representational practices of Ted Turner's Cable News Network (CNN) that the Gulf War could be dubbed the 'Third World War' – a war in which the whole world presumably participated through the electronic collapsing of time and space induced by satellite television technology. Indeed, CNN's unprecedented triumph in catapulting the 'War in the Gulf' (as CNN's caption went) as a 'simultaneous happening' into billions of dispersed living rooms worldwide seems to confirm Turner's self-proclaimed ambition, in the name of world peace and harmony, to turn the world instantly into one big global audience. As Australian cultural critic McKenzie Wark has observed:

> The whole thing about the media vector is that its tendency is toward *implicating* the entire globe. Its historic tendency is toward making any and every point a possible connection – everyone and everything is a potential object and/or subject of a mediated relation, realized instantly. In the Gulf War, to see it [on CNN] was to be implicated in it. [. . .] We are all, always, already – there.
>
> (Wark 1994: 15)

However, this perception can be sustained only from a productivist view of the process of mass communications, which needs to be complemented with the specific productivities of the receiving end of the process. In other words, the idea of a unified and united global village imagines the global audience as an anonymous 'taxonomic collective' (Ang 1991: chapter 3), gathered together as one large diasporic community participating in 'the live broadcasting of history' (Dayan and Katz 1992). Indeed, as Wark says, 'we are all, always, already – there'. But at the same time we are also *not* there. As audiences of the Gulf War on CNN, we were present and absent at the same

150

time. To put it differently, at one level CNN is indeed a spectacular embodiment of the 'annihilation of space by time' brought about by what Harold Innis (1951) has called space-binding communication media. The emphasis on speed of delivery and immediacy of transmission does indeed produce a structure of temporal synchronicity which makes space irrelevant: a wide variety of dispersed locales are, at this structural level, and assuming that they are so 'fortunate' to be able to receive CNN directly, symbolically bound together by the simultaneous appearance of the same images on the TV screen. At another level, however, the spatial dimension cannot be discounted when it comes to what happens to those images once they arrive in specific locations. At this cultural level, at once more mundane and more fluid local realities can themselves present an unpredictable interpretive screen through which the intruding electronic screen images are filtered. At the level of the day-to-day, space cannot be annihilated because the social specificity of any locality is inevitably marked by its characteristics as a place. In other words, global media do affect, but cannot control local meanings.

Two weeks after the launch of Operation Desert Storm on 15 January 1991, I asked my students at the University of Amsterdam to write down how they experienced the event that seemed to preoccupy and usurp all public discourse in those cold winter days (winter, that is, in the Northern hemisphere only). It should be noted that CNN is available as a regular 24-hour-a-day cable channel to Dutch television audiences and that about 90 per cent of Dutch homes are cabled, making the American news network into a virtually omnipresent, ready service in that country, which is by no means the case in many other parts of the world – a reminder that the presumably 'global' is by no means 'universal'. From my students' responses, a rather consistent pattern emerged. During the first few days after the war broke out, there was an obsessive fascination with its minute-to-minute goings-on which CNN purported to inform us about. Any spare time was spent in front of the TV set, motivated by a haunting sense of involvement which was soon superseded by a desire to detach: after less than a week or so, fascination was replaced by indifference and, to some, resentment about the excessive nature of the media's coverage of the war. The initial interest gave way to a more routine form of (dis)engagement. In other words, what gradually but inevitably occurred was a kind of 'resistance' against the imposed complicity created by the news media, a quiet revolt against the position of well-informed powerlessness induced by the media's insistence on keeping us continuously posted. As one student exclaimed: 'It's as if nothing else happened anymore!' What these students articulated, then, was a clear determination to defy the global media's orchestrated colonization of their attention and interest. For most of them, the war remained a limited media reality which did not succeed in totally encroaching on the intimate texture of their local, everyday concerns.

I invoke this small case-study here in order to raise some questions about a particularly pressing cultural and political problematic on the verge of the twenty-first century: the consequences of the increasing scale and rapidity of global flows of media products and technologies as a result of the growing economic power of the transnational communications corporations, and the construction of global media markets that go with their activities. The case-study suggests that by considering the perspective of media audiences in our analysis, we can avoid mistaking 'world politics' as constructed by CNN and other news media for 'the whole story'. Media reality has not completely erased social reality, as is often claimed by radical postmodernists, counter-posed as it is by the centrifugal forces of the local micro-circumstances in which people live out their everyday lives, where different concerns take on priority. At the same time, Wark (1994) is right to stress that even if we get bored with the CNN coverage, we are still, willy-nilly, implicated in it. We can switch off the TV set, but as its images pervade the texture of our everyday worlds, the distinction between media reality and social reality becomes blurred. What needs to be addressed, then, is the complicated relationship between global media and local meanings, their intricate interconnections as well as disjunctions (Appadurai 1990; Morley 1992: chapter 13).

It is often said that emerging from the ever more comprehensive expansion of the capitalist culture industries is a 'global culture'. How should we conceptualize and analyse this monstrous beast? No doubt, the liberal discourse in which CNN's Ted Turner appropriated McLuhan's global village idea falls short here, incapable and unprepared as it is to see beyond the optimistic, happy pluralist rhetoric of 'free flow of information' and 'democratic participation'. This rhetoric was already criticized and discarded in the 1970s and 1980s by critical theorists who, mostly speaking in the name of Third World perspectives and interests, forcefully emphasized the deep imbalance of those flows and the 'cultural imperialism' that is implicated in that process (for a critical overview, see Tomlinson 1991). But the cultural imperialism thesis, on its part, provides an equally flawed account of 'global culture', evoking an unrelenting and all-absorbing, linear process of cultural homogenization seen as the result of unambiguous domination of subordinated peoples and cultures by a clearly demarcated powerful culture, usually designated as American or European, or, more generally, as 'Western' culture. It is not only the residual elements of hypodermic needle theories of 'media effects' that make such a view problematic. A more fundamental problem is its implicit assumption of 'culture' as an organic, self-contained entity with fixed boundaries, whose traditional wholesomeness is presumed to be crushed by the superimposition of another, equally self-contained, 'dominant culture'. As a result, talk about cultural imperialism often tends to collude with a defence of conservative positions of cultural puritanism and protectionism. To put it differently, this

perspective too easily equates the 'global' as the site of cultural erosion and destruction, and the 'local' as the site of pristine cultural 'authenticity'. It is such a dichotomized, binary counterposing of the 'global' and the 'local' that I wish to challenge here. As I have already suggested in chapter 8, the global and the local should not be conceived as two distinct, separate and opposing realities, but as complexly articulated, mutually constitutive. Global forces only display their effectivity in particular localities; local realities today can no longer be thought outside of the global sphere of influence, for better or for worse.

The transnational dissemination of mass-mediated culture is, given the hegemonic strength of global capitalism in today's world economy, an irreversible process that cannot be structurally transcended, at least not in the foreseeable future. But this does not mean that it is not actively and differentially responded to and negotiated with in concrete local contexts and conditions. These local responses and negotiations, culturally diverse and geographically dispersed, need to be taken into account if we are to understand the complex and contradictory dynamics of today's 'global culture'. In this respect, as Mike Featherstone (1990) has remarked, it is preferable to speak about globalization, to think in terms of complex *processes* of global integration rather than in terms of static and given polarities of 'global' and 'local'. Globalization – defined by Roland Robertson as 'the concrete structuration of the world as a whole' (1990: 20), the series of developments by which the world becomes a 'single place' – should not be thought of in simple, linear terms. It is not a sweeping, all-absorbing process; and, above all, it is an always unfinished, and necessarily unfinishable, process precisely because this single global place we live in is also a deeply fractured one.

The construction of a 'global culture', then, should not be conceived as a process of straightforward homogenization, in which all cultural difference and diversity is gradually eradicated and assimilated. Rather, globalization involves a checkered process of systemic desegregration in which local cultures lose their autonomous and separate existence and become thoroughly interdependent and interconnected. Nowadays, as I will indicate later, local cultures everywhere tend to reproduce themselves precisely, to a large extent, through the appropriation of global flows of mass-mediated forms and technologies.

In this sense, the integrative effects of globalization should be conceived in a conditional rather than a substantive sense. What becomes increasingly 'globalized' is not so much concrete cultural contents (although global distribution does bring, say, the same movies to many dispersed locals), but, more importantly and more structurally, the parameters and infrastructure which determine the conditions of existence for local cultures. It can be understood, for example, as the dissemination of a limited set of economic, political, ideological and pragmatic conventions and principles which

govern and mould the accepted ways in which media production, circulation and consumption are organized throughout the modern world. This is one sense in which the claim that 'the media are American' (Tunstall 1977) has a quintessential validity. After all, it is in the United States that many of these principles and conventions, now often taken for granted and fully routinized, were first explored and perfected. As the commercial principle of production of culture for profit becomes ever more dominant, for example, it brings with it a spread of concomitant practices such as marketing, advertising and audience research, all heavily institutionalized, specialized practices which were first developed in the United States in the early twentieth century. Furthermore, the commodification of media culture is an increasingly global phenomenon which brings with it the adoption of peculiarly modernist cultural arrangements such as the fashion system with its principle of planned obsolescence, framed within risk-reducing strategies of innovation through repetition. In television, for example, this takes the form of a continuous rehashing of relatively constant formats and genres (e.g. the cop show, the sitcom, the soap opera) and a standardization of scheduling routines. Again, it is in American commercial television that such profit-maximizing strategies have been most perfected, from where they have been increasingly globalized, that is, taken as the commonsense way of doing things.

However, it is in the particular appropriation and adaptation of such standardized rules and conventions within local contexts and according to local traditions, resources and preferences that the non-linear, fractured nature of cultural globalization displays itself. The evolution of the film and television industries in Hong Kong is a point in case. In the 1950s, Cantonese movies dominated the Hong Kong market, drawing on traditional Cantonese cultural forms such as opera, musicals and contemporary melodrama. Their popularity declined in the 1960s and early 1970s, when Hollywood films consistently outgrossed locally produced Chinese films. By the 1980s, however, the most popular film genres in Hong Kong were once again locally produced, in the Cantonese language, but evincing definite elements of 'indigenization' of the Western action adventure movie format. The contemporary genre of Cantonese Kung Fu movies, for example, appropriated and refracted James Bond-style film narratives by using fists and martial arts as weapons, as well as drawing on traditional Cantonese values such as vengeance for friends and kin, loyalty to close acquaintances and punishment to traitors (Lee 1991).

Culturally speaking, it is hard to distinguish here between the 'foreign' and the 'indigenous', the 'imperialist' and the 'authentic': what has emerged is a highly distinctive and economically viable hybrid cultural form in which the global and the local are inextricably intertwined, in turn leading to the modernized reinvigoration of a culture that continues to be labelled and widely experienced as 'Cantonese'. In other words, what counts as 'local'

and therefore 'authentic' is not a fixed content, but subject to change and modification as a result of the domestification of imported cultural goods. As Joseph Tobin observes in the context of Japanese consumer culture, '[w]hat was marked as foreign and exotic yesterday can become foreign but familiar today and traditionally Japanese tomorrow' (1992: 26). Tobin mentions the example of sukiyaki, now considered a 'traditional' Japanese food but actually a dish borrowed from the Europeans. The same is happening in Japan with the hamburger, where McDonald's Biggu Makku is becoming increasingly Japanized and where hybrids such as a 'riceburger' have been invented.

A similar, well-known story has been told about the telenovela, a genre which had its origins in the American daytime soap opera but soon evolved into a distinctively Latin American genre. Telenovelas became so popular in that part of the world that they gradually displaced American imports from the TV schedules and become an intrinsic part of local popular culture (Vink 1988; Mattelart and Mattelart 1990). A similar erosion of the hegemony of American imports has taken place wherever there is competition from local productions, which almost everywhere tend to be more popular than American programmes (McNeely and Soysal 1989).

Of course, all too euphoric evaluations of such developments as evidence of 'global pluralism' and 'local autonomy' should be countered and confronted with the remark that they still remain framed within the concerns of capitalist culture, now at the national level rather than the transnational one. Nevertheless, what such examples do indicate is that the apparent increasing global integration does not simply result in the elimination of cultural diversity, but, rather, provides the context for the production of new cultural forms which are marked by local specificity. If, in other words, the global is the site of the homogeneous (or the common) and the local the site of the diverse and the distinctive, then the latter can – in today's integrated world-system – only constitute and reconstitute itself in and through concrete reworkings and appropriations of the former. Diversity, then, is to be seen not in terms of local autonomy but in terms of local reworkings and appropriations. The diverse is not made up of fixed, originary differences, but is an ever-fluctuating, ever-evolving proliferation of 'expressions of possibilities active in any situation, some accommodating, others resistant to dominant cultural trends or interpretations' (Marcus and Fischer 1986: 116). Two things follow from this. First, we have to recognize the hybrid, syncretic and creolized, always-already 'contaminated' nature of diversity in today's global cultural order, a fluid diversity emanating from constant cultural traffic and interaction rather than from the persistence of original, rooted and traditional 'identities'. Second, we can agree with Ulf Hannerz (1992) that contemporary global culture, what he calls 'the global ecumene', is bounded not through a replication of uniformity, but through

an organization or orchestration of diversity; a diversity that never adds up to a perfectly coherent, unitary whole.

At a more fundamental level, this discussion leads me to explore the relationship of the globalization of culture and the predicament of modernity. After all, modernity has been presented as one of the most sweeping globalizing forces in history – if anything, as dominant ideology would have it, the whole world ought to 'modernize' itself, become 'modern'. But what does this mean in cultural terms? One of the most eloquent descriptions of the modern experience comes from Marshall Berman:

> There is a mode of vital experience – experience of space and time, of self and others, of life's possibilities and perils – that is shared by men and women all over the world today. I will call this body of experience 'modernity'. To be modern is to find ourselves in an environment that promises us adventure, power, joy, growth, transformation of ourselves and the world – and at the same time, that threatens to destroy everything we have, everything we know, everything we are. Modern environments and experiences cut across all boundaries of geography and ethnicity, of class and nationality, of religion and ideology: in this sense, modernity can be said to unite all mankind [sic]. But [and here comes an important qualification, I.A.] it is a paradoxical unity, a unity of disunity: it pours us all into a maelstrom of perpetual disintegration and renewal, of struggle and contradiction, of ambiguity and anguish. To be modern is to be part of a universe in which, as Marx said, 'all that is solid melts into air'.
>
> (Berman 1982: 1)

In this sweeping, totalizing generalization, Berman articulates the very central feature of modernist discourse – seeing modernity as a relentlessly universalizing force, imposing a singular type of hyper-individualized experience, destroying traditional connections and meanings on which old certainties were based. But he is only half right. When we look at what is actually happening in global culture today, we can see that not all that was solid has melted into air: on the contrary, the globalizing force of capitalist modernity has not dissolved the categorial solidities of geography, gender, ethnicity, class, nationality, religion, ideology, and so on, which still have crucial impacts on the ways in which people experience and interpret the world and create and recreate their cultural environments, although the way they do so has been reframed by and within the structuring moulds of the modern itself.

Moreover, at the mundane level of daily life people build new solidities on the ruins of the old ones. When old ties and bonds and systems of meaning were eroded by the dissemination of the modern, they were replaced by new ones: people form new senses of identity and belonging, new symbolic commodities. But these new solidities are of a different nature

than the old, traditional ones: they are less permanent, less total, less based on fixed territories, more dynamic, more provisional, and above all they are often based on the resources offered by global modern culture itself. To put it differently, it is not enough to define the modern as a singular, universal and abstract experience formally characterized by a constant revolutionizing impulse; instead, we should emphasize that there are many, historically particular and localized ways of being modern, shaped by and within particular conditions and power relations.

At issue here, of course, is the question, not of postmodernism, but of postmodernity. I would like to oppose the tendency of the discourse of postmodernism to speak about contemporary culture in purely or primarily aesthetic terms, emphasizing elements such as pastiche, collage, allegory and spectacle. Lash and Urry see this kind of postmodernist cultural forms as a more or less direct effect of what they call the 'disorganised capitalism' of today (1987: 286), while Fredric Jameson (1991) has, in a famous essay, dubbed postmodernism 'the cultural logic of late capitalism'. The importance here is not to reduce the postmodern to 'mere' style, but to see it much more broadly as describing some fundamental aspects of social formation and meaning production in life dominated by the forces of global capitalism. To be sure, the reduction of the postmodern to an artistic attitude, an -ism, a superstructural phenomenon, might be particularly biased to the situation in the developed West, where the epithets of modernity and modernism can arguably be attached to a 'real' and protracted historical period (say, 1789–1968) and where the *post*modern is often experienced as either a demystification or a betrayal of 'the project of modernity' and its modernist ideals (Habermas 1983). In the context of this discussion, however, I find it more useful to approach postmodernity not just as that which comes *after* the modern in a chronological sense, but more profoundly as those modes of social experience and practice which respond, synchronically as well as diachronically, to the cultural contradictions brought about by, and inherent in, modernity itself.

In this sense, it is worth asserting that the peripheries of the world, those at the receiving end of the forces of globalization, where capitalist modernization has been an imposed state of affairs rather than an internal development as was the case in Europe, have always been more truly postmodern than Europe itself, because in those contexts the eclectic juxtaposition and amalgamation of 'global' and 'local' cultural influences have always been a social necessity and therefore an integrated mode of survival rather than a question of aesthetics. Becoming modern, in these cases, has always been ridden with power and violence; it could never have been a matter of simply embracing the new, as Berman would have it – but then, he described a peculiarly romanticized way of becoming modern – but has been one of being *forced* to 'let all that is solid melt into air' by Western powers, and of becoming experienced in the creation of improvised and

makeshift forms of new solidities in order to negotiate the consequences of an imposed entry into the 'modern world-system'. As a result, being 'modern' here has always-already been a fractured experience, always a matter of negotiating with an Other which presents itself as both the site of power and object of desire. As Hannerz, a Swedish anthropologist, has astutely remarked:

> [T]he First World has been present in the consciousness of many Third World people a great deal longer than the Third World has been on the minds of most First World People. The notion of the sudden engagement between the cultures of center and periphery may thus in large part be an imaginative by-product of the late awakening to global realities of many of us inhabitants of the center.
>
> (Hannerz 1991: 110)

This is not to ignore the unequal power relations that continue to characterize the relentlessly globalizing tendencies of modern capitalism, which have only become more overwhelming in scale and scope in the late twentieth century. It is, however, to point to the unpredictable, often incongruous and highly creative (though not necessarily desired or desirable) cultural consequences of these power relations as they intervene in shaping particular local contexts, particularly those positioned at the relatively powerless receiving end of transnational cultural and media flows. It is here, in these peripheries, where the intricate intertwinings of global media and local meaning – not their binary counterposing – are most likely to be a taken-for-granted aspect of everyday experience, where postmodernity – in the sense of an always-already 'disintegrated' modernity, a modernity whose completion has failed from the start (see Ang and Stratton 1996) – is most manifestly palpable as a 'condition' of daily life.

Therefore, let me finish with three stories in order to illuminate the profound incoherence of the current global cultural (dis)order, that of the 'modern world-system', three stories located in three very differently positioned global peripheries (for not all peripheries are the same). What they do have in common is the fact that they all have to grapple with the unsolicited 'invasion' of global media from a centre which is undeniably American. But, as Hannerz observes: 'Anglo culture, the culture of the WASPs, may have provided the metropolis, the Standard, the mainstream, but as it reaches out toward every corner of society, it becomes creolized itself' (1992: 226).

This is certainly what happened when Hollywood videos first entered the lived reality of the Warlpiri people, an isolated Aboriginal community in the Australian Central Desert, in the early 1980s. There is a lot of concern about the ability of traditional cultures to survive this new electronic invasion but, as the late anthropologist Eric Michaels, who spent three years among the Warlpiri, notes, this concern is all too often cast within the long tradition

of a Western racist paternalism intent on 'protecting' these 'primitive', 'preliterate', 'prehistorical' people from the ravages of 'modernity'. Ironically, such a stance only serves to monopolize the 'modern' to the West, forever relegating indigenous Australians to the realm of an ahistorical 'nonmodern'. Such a stance also disavows the very historical fact that the current plight of Aboriginal people – dispossessed from their own land, living forever in a colonized state – was precipitated precisely by the globalizing force of European modernity. That many of these communities still survive after two hundred years of forced contact is an indication of their cultural strength, not their helplessness, in managing and accommodating the brute and powerful impositions from outside. Michaels noticed that electronic media were remarkably attractive and accessible to the Warlpiri, in contrast with print and literacy. This, according to Michaels, is not because audiovisual images do not need active interpretation and 'reading' to be made sense of; on the contrary:

> It could prove promising that the most popular genres appear to be action/adventure, soaps, musicals, and slapstick. [. . .] As the least character-motivated, most formulaic fictions, they may encourage active interpretation and cross-culturally varied readings [where] culture-specific references are either minimal or unnecessary for the viewer's enjoyment. From this perspective, it would seem difficult to see in the introduction of imported video and television programs the destruction of Aboriginal culture. Such a claim can only be made in ignorance of the strong traditions and preferences in graphics, the selectivity of media and contents, and the strength of interpretation of the Warlpiri.
>
> (Michaels 1994 [1987]: 96)

This is not to indiscriminately celebrate or congratulate the Warlpiri on their ingenious resilience, for what Michaels is interested in is not so much such a 'romanticism of the oppressed', but rather the more complicated idea that video might be relatively compatible with traditional Warlpiri culture (which Michaels contrasts with the great resistance against reading and literature within the community) only because it enables an evocative mode of interpretation which is congruous with the Warlpiri graphic system, the way writing does not (and which might thus be much more destructive to Aboriginal culture, as Michaels more or less suggests). In this sense, what might be called 'Aboriginal modernity' is an extremely precarious and fragile, perhaps transitory cultural formation.

Cut now to Trinidad, a place which is peripheral in the global scenario in a very different way than Aboriginal Australia. It is an independent nation-state with its own, formally 'sovereign' cultural apparatus and national media industry, but contrary to, for example, Hong Kong or India or even Nigeria, Trinidad cannot be, and will arguably never be, the primary

producer of the images and goods from which it constructs its own cultural modernity (Miller 1992). As such small postcolonial nations will generally depend heavily on Western products, it is, again, the transformative properties of local consumption which are crucial for an appreciation of their cultural distinctiveness.

When British anthropologist Daniel Miller went to Trinidad to document contemporary life on this South Caribbean island, he was soon confronted with the centrality of the American soap opera *The Young and the Restless* in the population's everyday cultural experience. Why? Miller interprets this popularity by associating it with the uniquely Trinidadian concept of bacchanal. If one asks Trinidadians to describe their country in one word, by far the commonest response is 'bacchanal', 'said with a smile which seemed to indicate affectionate pride triumphing over potential shame' (Miller 1992: 176). Bacchanal designates a way of experiencing the everyday world in terms of gossip, scandal, exposure, confusion and disorder, representing a local sense of truth for many Trinidadians, who are acutely aware of the fluidity and dynamism of their national reality precisely because of its location on the periphery, subject to uncontrollable external forces, past and present. *The Young and Restless*, says Miller, could become central to the Trinidadian imaginary because it 'reinforces bacchanal as the lesson of recession which insists that [. . .] the façade of stability is a flimsy construction which will be blown over in the first storm created by true nature' (ibid.: 179) The fact that it is an imported product of mass-mediated culture that could acquire this centrality, muses Miller, stems precisely from the fact that local TV productions cannot incorporate clear expressions of bacchanal, concerned as they are with the 'serious', official concerns of the nation-state. Instead, what the popular consumption of *The Young and the Restless* in Trinidad accomplishes is not only the indigenization of the soap opera as Trinidadian, but also 'the refinement of the concept of Trinidad as the culture of bacchanal' (ibid.). Miller provides a useful historical context for this apparently paradoxical state of affairs:

> It is hard to talk of a loss of tradition here, since Trinidad was born into modernity in its first breath, a slave colony constructed as producer of raw materials for the industrialising world. The result is an extremely fluid society which makes itself up as it goes along.
>
> (Miller 1992: 179)

The fact that, in the late 1980s, an American soap opera became a key instrument for forging a highly specific sense of Trinidadian culture reveals the way in which the local can construct its syncretic, postmodern brand of cultural identity through consumption of the global. As Miller usefully concludes, 'authenticity', if we still want to retain that word, 'has increasingly to be judged a posteriori not a priori, according to local consequences not local origins' (1992: 181).

As with the case of the popularity of Hollywood videos among the Warlpiri, however, this isn't to suggest that the power of the transnational media industry is in any sense diminished. It is, however, to at least entertain the possibility that at the level of culture, meaning and identity, 'the interplay of center and periphery could go on and on, never settling into a fixed form precisely because of the openness of the global whole' (Hannerz 1992: 266).

In the end, however, we do need to return to the persistent asymmetry between centre and periphery, and to the very substantial Americanness of much of 'global' media, not only in terms of corporate ownership and working principles, but also, more flagrantly, in terms of symbolic content: images, sounds, stories, names. No amount of transformative interpretation will change this. And even though CNN implicated all of us into vicarious participation in the supposedly global Gulf War, the experiential disjuncture between 'here' and 'there' remains, as McKenzie Wark narrates:

> It was difficult, as an Australian, not to experience the war as something that happened in America, performed, acted, and sponsored by Americans, for Americans. On television, most voices were American. All the images looked American. Even Saddam seemed to be an American. As American as Lon Chaney or Bela Lugosi. Iraq seemed to be a place in America. A place like Wounded Knee or Kent State or the Big Muddy.
>
> (Wark 1994: 13)

Australia – Wark's Australia, not that of the Warlpiri – can hardly be called a periphery in the same way as Trinidad; like the Netherlands or Sweden, it is better described as part of the 'semi-periphery', a part of 'the West' but relatively marginal within it. Nevertheless, as Wark astutely observes, every (white) Australian who grew up after the Second World War knows 'the feeling of growing up in a simulated America', resulting in 'a perverse intimacy with the language and cultural reference points which nevertheless takes place elsewhere' (1994: 14). And not only in Australia. Although this experience of decentredness in an imaginary geography – a paradox which might quite appropriately be called 'postmodern' – has become a rather common one throughout the globe, its cultural consequences in particular localities have hardly begun to be understood.

Perhaps it is precisely because of this paradox, this dominant Americanness which presents itself as global and universal, that my Dutch students quickly lost interest in CNN's representation of the 'War in the Gulf', and why this first truly 'living room war' did not become 'authenticized' in the local experience of those who, from a 'global' perspective, would be reduced to the status of 'silent majority' (Baudrillard 1983).

10

In the realm of uncertainty: the global village and capitalist postmodernity

Speaking about the present condition of the world, or 'today', has become a thoroughly messy and capricious matter. The collapse of official communism in Eastern Europe and the subsequent ending of the Cold War, the Gulf War, the gradual decline of American hegemony, the rise of Japan to world economic might, the spread of the AIDS virus, and the environmental crisis are only some of the major historical events which signal a reshuffling of geopolitical relations whose eventual outcomes remain deeply uncertain. Indeed, as Immanuel Wallerstein has noted, the capitalist world-system is in mutation now; we have arrived 'in the true realm of uncertainty' (1991: 15).

I cannot dissociate myself from this condition of uncertainty. Indeed, what I would like to do here is take this uncertainty on board – not only as to the state of the world 'today' but also regarding the current state (and status) of 'theory', let alone 'communication theory'. The very idea of a book on 'communication theory today' – in which this essay first appeared (Crowley and Mitchell 1994) – assumes that such an entity exists or should exist (despite its undoubtable internal plurality and diversity), that it can be proposed and formulated, and that it matters. But this assumption cannot go unquestioned. Of course 'communication' is, and should be, a crucial site of critical intellectual reflection if we are to understand contemporary social, political and cultural relations, although the very notion of 'communication' itself, encompassing such a mixed bag of events and processes, is hardly specific enough to be used as a starting point for theorizing the complicated entanglements between peoples, powers and cultures in the world 'today'.

At any rate, what I will try to explicate here is that if we are to understand Wallerstein's true realm of uncertainty, we have to go beyond the concerns of communication theory, however defined. This is because communication theory, founded as it is on the logic of reduction, if not elimination, of uncertainty, cannot deal with uncertainty as a *positive* force, and a necessary and inevitable condition in contemporary culture, the condition of *capitalist postmodernity*.

One of the most popular metaphors used to describe this condition has been McLuhan's 'global village'. However, this very popularity tends to

foreclose a closer engagement with exactly what it means when we say that today's world is a 'global village'. Often the unwarranted (but strangely reassuring) assumption is made that the creation of the 'global village' implies the progressive homogenization – through successful communication – of the world as a whole.[1] However, as George Marcus has noted, the fact 'that the globe generally and intimately is becoming more integrated [. . .] paradoxically is not leading to an easily comprehensible totality, but to an increasing diversity of connections among phenomena once thought disparate and worlds apart' (1992: 321). In other words, the global village, as the site of the culture of capitalist postmodernity, is a thoroughly paradoxical place, unified yet multiple, totalized yet deeply unstable, closed and open-ended at the same time. I will propose here a theorization of capitalist postmodernity as a *chaotic* system, where uncertainty is a built-in feature.

THE GLOBAL VILLAGE AND THE FALLACY OF COMMUNICATION

Communication theory has traditionally used metaphors of transport and flow to define its object. In the resulting transmission models of communication, as James Carey has remarked, 'communication is [seen as] a process whereby messages are transmitted and distributed in space for the control of distance and people' (1989: 15). In putting it this way, Carey foregrounds the deeply political nature of epistemological choices. In Carey's words, '[m]odels of communication are [. . .] not merely representations of communication but representations *for* communication: templates that guide, unavailing or not, concrete human interaction' (ibid.: 32). In historical and economic terms, the instances of human interaction Carey refers to pertain primarily to the geographical expansion of modern capitalism, with its voracious need to conquer ever more extensive and ever more distant markets. Such was the context for the creation and spread of a spatially biased system of communication, epitomized by the parallel growth of the railroad and the telegraph in the nineteenth century, which privileges speed and efficiency in the traversing of space. Spatial integration was the result of the deployment of these space-binding communication technologies, first at the level of the nation, then extending over increasingly large parts of the globe. Following Canadian theorist Harold Innis, Carey describes modern capitalist culture as a 'space-binding culture': 'a culture whose predominant interest was in space – land as real estate, voyage, discovery, movement, expansion, empire, control' (ibid.: 160). In this respect, McLuhan's 'global village', a world turned into a single community through the annihilation of space in time, represents nothing other than (the fantasy of) the universal culmination of capitalist modernity. In short, what I want to establish here is the intimate interconnection between the trans-

mission paradigm of communication, the installation of high communication systems and the logic of capitalist expansion.

But the control effected by communication-as-transmission does not only pertain to the conquest of markets for the benefit of economic gain; it is also a control over people. In social terms, then, communication-as-transmission has generally implied a concern with social order and social management; hence, for example, the longstanding interest in communication research, particularly in the United States, in the 'effects' of messages: persuasion, attitude change, behavioural modification. What is implicit in this social psychological bias in communication research is an (unstated) desire for a compliant population, and therefore a belief in the possibility of an ordered and stable 'society'. In this sense, communication research has evolved as a branch of functionalist sociology, for which the question of social integration (e.g. through the dissemination of a 'central value system' throughout the entire social fabric) is the main concern. The effects tradition was a specification of this concern in relation to the media: are the media (dys)functional for social integration? This concern did not remain restricted to the population *within* a society; it has also been envisaged beyond the societies that make up the core of modern capitalism, as in the information diffusion theories of Third World 'development' and 'modernization' of the 1950s and 1960s where mass communication processes were thought to play a vital role. Here, the making of the 'global village' can be rewritten as the transformation, or domestication, of non-Western others in the name of capitalist modernity, the civilization which was presumed to be the universal destiny of humankind: global spatial integration is equated with global social and cultural integration.

It should be clear that in theoretical terms transmission models of communication inherently privilege the position of the Sender as legitimate source and originator of meaning and action, the centre from which both spatial and social/cultural integration is effectuated. Communication is deemed successful if and when the intentions of the Sender, packaged in the Message, arrive unscathed at the Receiver, sorting the intended effects. But the hegemony of such linear and transparent conceptions of communication has been severely eroded in the last few decades. This erosion was simultaneously an epistemological and a political one. A telling case is Everett Rogers' declaration, in 1976, of the 'passing' of the 'dominant paradigm' of the diffusion model of development. As author of *The Diffusion of Innovations* (1962), Rogers had to submit almost fifteen years later that the model's weakness lie precisely in its emphasis on linearity of effect, in its reliance on hierarchy of status and expertise, and on rational (and presumably benevolent) manipulation from above (see Rogers 1976).

Not coincidentally, the same period saw the ascendancy of alternative, critical accounts of development, often framed within theories of cultural imperialism and dependency. The rise of such accounts can be understood

in the light of the growing force of anti-systemic, new social movements in the West which have challenged the unquestioned hegemony of capitalist modernity's 'central value system', as well as the increasing desire for self-determination in postcolonial, developing nations. As John Tomlinson has argued, 'the various critiques of cultural imperialism could be thought of as (in some cases inchoate) protests against the spread of (capitalist) modernity' (1991: 173). However, Tomlinson continues, 'these protests are often formulated in an inappropriate language of domination, a language of cultural imposition which draws its imagery from the age of high imperialism and colonialism' (ibid.). I would add here that this inappropriate language is symptomatic of the fact that most theories of cultural imperialism remain firmly couched within transmission models of communication. Indeed, the marked emphasis within the notion of cultural imperialism on the dimension of power operating in the relation between Sender and Receiver importantly exposes the illusion of neutrality of the transmission paradigm. But because it conceptualizes those relations in terms of more or less straightforward and deliberate imposition of dominant culture and ideology, they reproduce the mechanical linearity of the transmission model. Such a vision is not only theoretically, but also historically inadequate: in a world-system where capitalism is no longer sustained through coercive submission of colonized peoples (as in nineteenth-century high imperialism) but through the liberal institutions of democracy and the sovereign nation-state, equation of power with imposition simply will not do. The problem, rather, is to explain how capitalist modernity 'imposes' itself in a context of formal 'freedom' and 'independence'. In other words, how are power relations organized in a global village where everybody is free and yet bounded? It is in order to grasp the ramifications of this question that we need to develop new theoretical tools.

For the moment, I would like to stress how the crisis of the transmission paradigm was not just an internal, academic affair,[2] but ran parallel with developments in the 'real' world, where the spread of modern capitalism from core to periphery, which was very much undergirded by the increasingly global deployment of ever more sophisticated space-binding media, has been found to have led not to the creation of an ordered global village, but to the multiplication of points of conflict, antagonism and contradiction. Never has this been clearer than in today's new world (dis)order, Wallerstein's 'true realm of uncertainty'. In short, the crisis of the transmission paradigm takes the shape here of a deep uncertainty about the *effectiveness* of the Sender's power to control. For Sender, read (the media of) modern capitalism. In this context, it shouldn't surprise that the transmission paradigm was particularly hegemonic in communication theory during the high period of American hegemony as the superpower within the modern capitalist world. Neither is it surprising that the crisis of

the paradigm erupted when that hegemony started to display cracks and fissures.

Within communication theory, this crisis has led to a proliferation of *semiotic* models of communication, which foreground the ongoing construction of meaning as central to communicative practices. What such models reject is the assumption of transparency of meaning which underlies the idea of communication as transmission; instead, communication is conceived as a social practice of meaning production, circulation and exchange. James Carey's rich and important work epitomizes this shift by adopting such a semiotic model in his formulation of a ritual view of communication, which he defines as 'the production of a coherent world that is then presumed, for all practical purposes, to exist' (1989: 85). From this perspective, communication should be examined as 'a process by which reality is constituted, maintained, and transformed' (ibid.: 84), the site of 'symbolic production of reality' (ibid.: 23). In Carey's view, this social reality is a 'ritual order' made up by 'the sharing of aesthetic experience, religious ideas, personal values and sentiments, and intellectual notions' through which a 'common culture' is shaped (ibid.: 34–5).

The gist of Carey's theoretical argument is that communication *is* culture. Without communication, no culture, no meaningful social reality. However, there are problems with Carey's emphasis on ritual *order* and *common* culture, inasmuch as it evokes the suggestion that such an order of common meanings and meaningfulness can and should be securely created. Carey's proposal to build 'a model of and for communication of some restorative value in reshaping our common culture' (1989: 35) stems from a genuine critique of the instrumentalist values of capitalist modernity, but his longing for *re*storing and *re*shaping cultural sharing suggests a nostalgia for a past sense of 'community', for a local-bound, limited and harmonious *Gemeinschaft*. But it is difficult to see how such a (global?) common culture can be created in the ever-expanding and extremely differentiated social reality constructed by capitalist modernity. To put it differently, Carey's concern with the time-binding functions of communication – its role as social cement through the construction of continuity and commonality of meanings – seems ironically to perpetuate the concern with social integration which is implicit in the transmission paradigm. Carey's position implies that a global village which is integrated in both spatial and social/cultural terms can and should be brought about not through the dissemination of pregiven meanings from Sender to Receiver, but by enhancing rituals of mutual conversation and dialogue. In this sense, he unwittingly reproduces the assumption of capitalist modernity as a universal civilization, at least potentially. The (democratic) promotion of communication-as-ritual is the recipe for it.[3]

Carey's model, then, privileges the *success*, both theoretically and politically, of communication-as-ritual. In so doing, he tends to collapse communication and culture, as the title of his book, *Communication as Culture*,

suggests. For Carey, communication studies and cultural studies are one and the same thing. In this sense, Carey's solution to the crisis of the transmission paradigm is a conservative one in that it ends up securing 'communication', and thus communication theory, as a privileged theoretical object for cultural studies.

I would suggest, however, that it is the *failure* of communication that we should emphasize if we are to understand contemporary (postmodern) culture. That is to say, what needs to be stressed is the fundamental *uncertainty* that necessarily goes with the process of constructing a meaningful order, the fact that communicative practices do not necessarily have to arrive at common meanings at all. This is to take seriously the radical implications of semiotics as as theoretical starting point: if meaning is never given and natural but always constructed and arbitrary, then it doesn't make sense to prioritize meaningfulness over meaninglessness. Or, to put it in the terminology of communication theory: a radically semiotic perspective ultimately subverts the concern with (successful) communication by foregrounding the idea of 'no necessary correspondence' between the Sender's and the Receiver's meanings. That is to say, not success, but failure to communicate should be considered 'normal' in a cultural universe where commonality of meaning cannot be taken for granted.

If meaning is not an inherent property of the message, then the Sender is no longer the sole creator of meaning. If the Sender's intended message doesn't 'get across', this is not a 'failure in communications' resulting from unfortunate 'noise' or the Receiver's misinterpretation or misunderstanding, but because the Receiver's active participation in the construction of meaning doesn't take place in the same ritual order as the Sender's. And even when there is some correspondence in meanings constructed on both sides, such correspondence is not natural but is itself constructed, the product of a particular articulation, through the imposition of limits and constraints to the openness of semiosis in the form of 'preferred readings', between the moments of 'encoding' and 'decoding' (see Hall 1980a). That is to say, it is precisely the existence, if any, of correspondence and commonality of meaning, not its absence, which needs to be accounted for. Jean Baudrillard has stated the import of this inversion quite provocatively:

> [M]eaning [. . .] is only an ambiguous and inconsequential accident, an effect due to ideal convergence of a perspective space at any given moment (History, Power, etc.) and which, moreover, has only ever really concerned a tiny fraction and superficial layer of our 'societies'.
>
> (Baudrillard 1983: 11)

What we have here is a complete inversion of the preoccupations of communication theory, of meaningful human interaction as the basis for the social – or, for that matter, for the global village. As I will try to show below, this theoretical inversion, which is one of the fundamental tenets of

poststructuralist theorizing, allows us to understand the global village not as a representation of a finished, universalized capitalist modernity (characterized by certainty of order and meaning), but as a totalized yet fundamentally dispersed world-system of capitalist *post*modernity (characterized by radical uncertainty, radical *indeterminacy* of meaning).

NEW REVISIONISM?

Such a move is not merely a theoreticist game but is essential if we are to develop a *critical* theorizing of the new world (dis)order. I will clarify this by briefly looking at the presumptions at work in the recent controversy around what some authors have called the 'new revisionism' in mass communication research (Curran 1990; see also e.g., Schlesinger 1991).This so-called 'new revisionism', I should say at the outset, is a fiction, born of a rather conservative wish to retain 'mass communication' as a separate field of study, on the one hand, and a misrecognition of the radical potential of the idea of indeterminacy of meaning, on the other. Although I will not spend too much time deconstructing this fiction, I think it is important to counter some of its assertions in order to clarify precisely what that radical potential involves. What should be resisted, I think, is the theoretical and political closure which the fiction of the new revisionism imposes on our understanding of what 'mass communication' means in today's world.

According to James Curran, this so-called 'new revisionism' has fundamentally transformed what he calls 'the radical tradition' of mass communication scholarship. This transformation is exemplified, says Curran, in the well-known ethnographic studies of media audiences in cultural studies (about which you have been reading in this book). As Curran would have it, these studies revise the classic radical stance, which was informed by a (neo-)Marxist pessimism towards the all-powerful role of the mass media as transmitters of dominant ideology (and which also undergirds most theories of cultural imperialism). But now that audiences are conceived as active producers of meaning and produce a diversity of readings, that 'oppressive' role of the media has been considerably diminished, to the point that there might be no dominant ideology at all. Curran claims that 'radical researchers' now stress 'audience autonomy' and have implicitly concluded 'that the media [have] only limited influence' (1990: 145–6). In this sense, Curran concludes, previously radical critics have presumably moved towards a more moderate, pluralist position, so that 'the critical tradition in media research has imploded in response to internal debate' (1991: 8). But this is an utterly mistaken conclusion. Curran could only come to such a conclusion by adopting a narrow conceptualization of power, as if evidence of diversity in readings of media texts could be equated with audience freedom and independence from media power! In other words, while the semiotic notion that meaning is constructed rather than given is now widely

recognized throughout the discipline, Curran retains the mechanical, distributional notion of power of the transmission paradigm. This, however, is a rather truncated rendering of the radical scope of indeterminacy of meaning, made possible by objectifying 'communication', 'media' and 'audience', lifting them out of their larger social and historical contexts.

If anything, Curran's rendering of 'the new audience research' indicates that merely replacing a transmission model for a semiotic model of communication is not enough. The problem with communication models in general is that they describe the world in terms of closed circuits of senders, messages and receivers. That the unidirectionality of such circuits is complicated by feedback loops, processes of exchange and interaction, or intermediary moments of meaning construction doesn't make the circuit less closed: there is no 'outside' to the communication. As a result, it becomes impossible to think about the relation of power and meaning in more multidimensional terms, to recognize the operation of multiple forms of power at different points in the system of social networks in which both 'senders' (e.g. media) and 'receivers' (e.g. audiences) are complexly located and produce meanings. Instead, power becomes a fixed entity which simply changes hands from senders to receivers and vice versa. And since, again according to Curran, critical scholars now acknowledge that audiences are not passive absorbers of 'dominant ideology' transmitted by the media but actively produce their own meanings with the help of the predispositions they bring to texts, a paradigmatic consensus can now be declared which favours the liberal pluralist idea that '[t]here are no dominant discourses, merely a semiotic democracy of pluralist voices' (1990: 151). Here again is another invocation of a unified and integrated global village, now as a space in which power is so evenly diffused that everybody is happily living ever after in a harmonious plurality of juxtaposed meanings and identities.[4]

This is what I mean by the closure imposed by Curran's misappropriation of 'the new audience research' and invention of a 'new revisionism'. It is a closure which expels any sense of and for uncertainty, with no place for unresolved ambiguity and contradiction. It is also a closure which revels in a confidence of having repudiated any notion of cultural imperialism, any idea of unequal power relationships between 'core' and 'periphery' in the global village. And to be sure, certain tendencies within critical work on audiences have facilitated this misappropriation, precisely for their lack of clarity about the theoretical status of this work. Thus, John Fiske's (in)famous celebration of the semiotic power of audiences to create their own meanings and pleasures has been widely interpreted as a confirmation of the liberal pluralist paradise (e.g. Curran 1990: 140). What is more, Fiske's excessive romanticism and populism has been severely criticized *within* cultural studies for its connivance in free market ideologies of consumer sovereignity (e.g. Morris 1988a). What is important to note here, however, is not so much the apologetic political consequences of Fiske's

position, but the theoretical underpinnings of his discourse, particularly his theory of the relationship of power and meaning.

For example, in *Television Culture* he describes the relation between television and its audiences as an antagonism between 'top–down power' opposed by 'bottom–up power' (Fiske 1987a: 314). The latter is predominantly a semiotic power operating within a more or less autonomous cultural economy, to be differentiated from the economic power held by the 'top', for example the executives of the television industries, operating within the financial economy. Fiske is right in wanting to differentiate between these two forms of power – indeed, I would argue that it is precisely by making this kind of theoretical differentiation that we might begin to overcome the simplistic, one-dimensional concepts of power inherent in the transmission paradigm (and reproduced by Curran). The problem, however, is that Fiske tends to exaggerate the strength of the semiotic democracy by seeing the struggle as a 'two-way force' in which the partners are implicitly considered separate but equal. Again, this rosy conclusion could only be arrived at by isolating the communication between television and its audiences from the broader contexts in which both are shaped. Fiske's radical inclination is thus contained by his holding on to the familiar topography of communication: the Sender's sphere (production and distribution) is opposed by the Receiver's sphere (reception and consumption). Again, a closed circuit, despite the struggle taking place within it. Again, theoretical closure, systemic certainty. In this sense, Curran's liberal pluralism and Fiske's more radical pluralism tend to collude. In emphasizing this apparent collusion Curran has rushed towards the conclusion that the 'new revisionism' has led critical theorists to abandon their 'radical' concerns. This, however, is a very uninformed miscomprehension of the current state of affairs in critical theorizing.

In the last two decades or so, a transformation in the theorization of power has taken place in critical theory – largely through post-Althusserian elaborations of Gramsci's notion of hegemony and Foucault's concept of power/knowledge – not because it no longer believes in domination but because, in the words of Mark Poster, 'it is faced with the formidable task of unveiling structures of domination when no one is dominating, nothing is being dominated and no ground exists for a principle of liberation from domination' (1988: 6). This, of course, is another way of evoking the contradictory condition of 'free-yet-bounded-ness' which I noted earlier as characteristic of living in the global village. In this context, John Tomlinson's suggestion that the notion of cultural imperialism should be replaced by the much less determinist (but no less determining) one of 'globalization' is particularly relevant:

[T]he idea of imperialism contains, at least, the notion of a purposeful project: the *intended* spread of a social system from one centre of

power across the globe. The idea of 'globalisation' suggests inter-connection and interdependency of all global areas which happens in a far less purposeful way. It happens as the result of economic and cultural practices which do not, of themselves, aim at global integration, but which nonetheless produce it. More importantly, the effects of globalisation are to weaken the cultural coherence of *all* individual nation-states, including the economically powerful ones – the 'imperialist powers' of a previous era.

<div align="right">(Tomlinson 1991: 175)</div>

In other words, critical theory has changed because the structure of the capitalist order has changed. What it has to come to terms with is not the certainty of (and wholesale opposition to) the spread of a culturally coherent capitalist modernity, but the uncertainty brought about by the disturbing incoherence of a globalized capitalist postmodernity, and the mixture of resistance and complicity occurring within it. The critical import of audience ethnography, placed within the larger theoretical project of critical cultural studies, should be seen in this context: it is to document how the bottom–top, micro-powers of audience activity are both complicit with and resistive to the dominant, macro-forces within capitalist postmodernity. It has nothing to do with the complacency of Curran's liberal pluralism; on the contrary, it radicalizes the 'radical concerns' of critical theorizing. To elaborate on this point, we need to do away with any notion of the closed circuit of communication, and to embrace fully the the primacy of in-determinacy of meaning which, I would argue, is essential for understanding how and why capitalist postmodernity is a 'true realm of uncertainty'.

BEYOND ORDER AND MEANING: THE GLOBAL VILLAGE DECONSTRUCTED

I can begin to explain this by taking issue with the simplistic idea that existence of diversity is evidence of freedom from power and domination. That is to say, variation – e.g. in audience readings and pleasures – is not the result of autonomy and independence, as the liberal pluralists would have it, but emerges out of the inescapably overdetermined nature of any particular instance of subjective meaning production. The latter is traversed by a multiplicity of power relations, the specifics of which cannot be known ahead of time precisely because their articulations are always irreducibly context-bound. They are not determined by fixed predispositions but take shape within the dynamic and contradictory goings-on of everyday life, of history.[5] In this sense, the existence of different readings is by no means evidence of 'limited' power. On the contrary, it only points to the operation and intersection of a whole range of power relations at any one time, going far beyond linear 'influence'. This is one way in which the idea of

indeterminacy of meaning can be concretely qualified: indeterminacy is not grounded in freedom from (external) determinations, but is the consequence of *too many*, unpredictable determinations. Nor does a concern with specific pleasures that people get out of particular media forms 'totally displace a concern with power', as Philip Schlesinger claims (1991: 149); on the contrary, theorizing pleasure enables us to develop a much more complex understanding of how certain forms of power operate by paying attention to the intricate intertwinings of pleasure and power – an especially important issue today where 'the pleasure principle' has been incorporated in the very logic of consumer capitalism.[6]

But I am running ahead of my argument. The point I want to make about the liberal pluralist account of variation and difference is that it implicitly assumes a closed universe of readings, making up a contained diversity of audience groupings with definite identities, equivalent to the liberal pluralist conception of electoral politics where voters are distributed over a fixed repertoire of parties. It is in this sense that liberal pluralist discourse conjoins the marketing discourse of market segmentation (where consumers are neatly divided up and categorized in a grid of self-contained demographic or psychographic 'segments'), which is not so surprising given that both discourses are two sides of the coin of 'democratic capitalism'. This conception of diversity presupposes that 'society' is a finite totality, a 'unity in diversity', or, more precisely, a unity of a diversity of meanings and identities. This concept of social totality is conceived as 'the structure upon which its partial elements and processes are founded', that is to say, as 'an underlying principle of intelligibility of the social order' (Laclau 1991: 90–1). In this sense, difference and diversity refers to the structured partition of that unitary order – say, the imaginary global village – into fixed parts, such as identifiable readings and audience groupings (to be uncovered by 'audience research').

The idea of indeterminacy of meaning, however, enables us to put forward a much more radical theorization of difference and diversity, one that does away with any notion of an essence of social order, a bounded 'society' which grounds the empirical variations expressed at the surface of social life. Not order, but chaos is the starting point. Variation does not come about as a result of the division of a given social entity into a fixed range of meaningful identities, but represents the infinite play of differences which makes all identities and all meanings precarious and unstable. Any relative fixation of those identities and meanings is not the expression of a structural predetermination within a social order. On the contrary, it is the (temporary and provisional) outcome of, in Laclau's (1991) terms, the attempt to limit the infinite play of differences in the site of the social, to domesticate the potential infinitude of semiosis corroborated by the principle of indeterminacy of meaning, to embrace it within the finitude of an order, a social totality which can be called a 'society'. From this perspective, this ordered

172

social totality is no longer a pregiven structure which establishes the limits within which diverse meanings and identities are constituted. Rather, since the social is the site of potentially infinite semiosis, it always *exceeds* the limits of any attempt to constitute 'society', to demarcate its boundaries. This is why, as we all know, a 'society' can accomplish only a partial closure, a partial fixing of meanings and identities, a partial imposition of order in the face of chaos.[7] That is, any containment of variation and difference within a limited universe of diversity is always-already the product of a determinate ordering by a structuring, hegemonizing power, not, as the functionalist discourse of liberal pluralism would have it, evidence of a *lack* of order, absence of power. In this sense, the question to ask about the complex relation between media and audiences is not why there isn't more homogeneity, but why there isn't more heterogeneity!

To illuminate how this altered notion of difference effectively subverts the closure of liberal pluralist discourse, let me briefly return to the argument I have put forward in *Desperately Seeking the Audience* (1991), where I have discussed the history of the corporate practice of 'audience measurement', or, more popularly, 'ratings'. Over the years, there has been a progressive sophistication of measurement methods and technologies, aimed at the ever more detailed and accurate determination of size and demographic composition of the audience at any particular moment, for any particular programme or channel. As I have already noted in chapter 3, the latest device currently being tested in this respect is the so-called 'passive people meter', a kind of computerized eye roaming people's living rooms in order to catch their gaze whenever it is directed to the TV screen. The industry's hope is that this technology will deliver ratings statistics that can tell the television companies exactly who is watching what at any split second of the day. However, this very search for the perfect measurement method, which I have characterized as desperate, is based on the implicit assumption that there is such a thing as an 'audience' as a finite totality, made up of subdivisions or segments whose identities can be synchronically and diachronically 'fixed'. I have suggested that this assumption is a fiction, but a *necessary* fiction for a television industry which increasingly experiences the audience as volatile and fickle. A hegemonic, empowering fiction which is positively constructed as true by the creation of simulations of order in the ranks of the audience in the form of ratings statistics and other market research profiles.

The paradox of the passive people meter, however, is that it is propelled by a desire to produce a fully precise representation, a completely accurate map of the social world of actual audience practices. This progressive rapprochement of representational strategies and the social, I suggest, is bound ultimately to reveal chaos rather than order. That is to say, it will turn out that the universe of television-viewing practices can only be represented as an ordered totality by imposing (discursive) closure on it, because these infinite, contradictory, dispersed and dynamic everyday

173

practices will always be in excess of any constructed totality, no matter how 'accurate'. In attempting to determine the identity of this universe we will, as Laclau puts it, 'find nothing else but the kaleidoscopic movement of differences' (1991: 92), which will probably only result in further, more insistent and more desperate attempts to map it.

In concrete, historically specific terms, the chaos I am referring to relates to the enormous proliferation of possible television-viewing practices in the last few decades, possibilities which have been created by the expansion of the television industries in capitalist modernity in the first place. From transnational 24-hour satellite channels (e.g. CNN and MTV) to a myriad of local or regional cable channels dishing up unmanageable volumes of specialized programming, from video recorders and remote control devices (which have encouraged 'zipping' and 'zapping') to TVs watched in 'uncommon' places (laundries, campsites, airports, and so on), and, above all, the very ubiquitousness of television which makes it bleed into every corner of day-to-day social life – all this can surely only make for an endless, unruly and uncontrollable play of differences in social practices related to television viewing: continuous social differentiation bordering on chaos. It is this chaos which the discourse of liberal pluralism cannot account for, and which the functionalist rationality of audience measurement technology is designed to suppress and tame in the form of a statistical order. But it is precisely this chaos which I suggest we need to take into consideration in understanding the logic of power relations in capitalist postmodernity. Capitalist postmodernity may have constructed a spatially integrated, interconnected global village, but at the same time it encourages social *dis*integration.

CAPITALIST POSTMODERNITY AS A CHAOTIC SYSTEM

But it is important to properly theorize 'chaos'. Often chaos is associated with loss of control, lack of order. Such a conception of chaos – or, in our context, the infinitude of the social, infinite semiosis – leads to a romanticized view of the practices of everyday life (such as audience practices) as always evading the structures – institutional, ideological – imposed upon them, that is to say, as the site of resistance *per se*. This, of course, is the position taken up by Fiske. But such a position is informed by a negative theory of chaos: chaos as lack.

It is instructive here to draw comparisons with the emergence of chaos theory in the physical sciences. Katherine Hayles, author of *Chaos Bound* (1990), has given a, for our purposes, rather fortuitous example of how chaos can be acknowledged as a positive force in our experience as media consumers:

> Every time we keep a TV or radio going in the background, even though we are not really listening to it, we are acting out a behavior

174

that helps to reinforce and deepen the attitudes that underwrite a positive view of chaos.

(Hayles 1990: 7)

This *positive* view of chaos implies the transvaluation of chaos as having primacy over order. However, Hayles continues, chaos theory does not *oppose* chaos to order; rather, it sees chaos as 'the engine that drives a system toward a more complex kind of order' (1990: 23). This is not dissimilar to Laclau's idea of how 'society', or, for that matter, 'audience' (as a functional sub-totality within 'society'), is created out of the attempt to put an order to the (chaotic) infinitude of the social. In this sense, 'society' (or 'audience') is, in Hayles's terms, a chaotic system, or a complex kind of order, an order whose ultimate suture is impossible because it is a system born out of the precarious structuration of chaos. If chaos is ultimately impossible to domesticate it is because it is, as chaos theory would have it, 'an inexhaustible ocean of information' rather than a lack, 'a void signifying absence' (ibid.: 8). The more chaotic a system is, the more information it contains, and the more complex the order established out of it. In other words, what characterizes chaotic systems – and, by extension, social systems – is not so much that they are poor in order, but that they are rich in information (ibid.: 6). This formulation illuminates why the passive people meter is likely to be counterproductive (in creating order in the audience measurement field): it is because it will elicit too *much*, not too little information. Too much information will only aggravate the possibility of constructing the (simulated) orderliness of the 'audience', therefore threatening to foreground the return of the repressed: chaos.

Chaos theory is in fact one more example of the recognition that we live in a 'true realm of uncertainty'. In this sense, Hayles rightly brings the emergence of chaos theory in the physical sciences into connection with the increasing importance of poststructuralist and postmodern theory in the humanities and the social sciences, not least in cultural studies. As Hayles puts it, '[d]ifferent disciplines are drawn to similar problems because the concerns underlying them are highly charged within a prevailing cultural context' (1990: xi). This context, we can add, is precisely the context of capitalist postmodernity. It is in capitalist postmodernity that the presence of chaos constantly lurking behind any institution of order has become a systemic force. Capitalist postmodernity, in other words, is a truly chaotic system.

What, then, is the historical specificity of this system, and how can we theorize the structural uncertainty engendered by and within it? It is illuminating here to reinvoke the demise of the transmission paradigm of communication theory, as it finds its parallel, at the level of the social, in the demise of the paradigm of the modern. The modern paradigm was predicated, as I have said earlier, upon the assumption that modernity, under

the aegis of the expansion of capitalism, is a universal destination for the whole world, so that history could be conceived as a linear development in which the modern is designated as the most advanced end-point – literally the End of History – towards which the less modern, those termed 'traditional' or 'less-developed', must and will of necessity evolve. The postmodern paradigm, however, has shattered the certainty of this universalizing evolutionary discourse. It challenges the assumptions of modern discourse by questioning the binary counterposing of the modern/Western/present/Sender/self and pre-modern/non-Western/past/Receiver/other. The modern and the Western do not necessarily coincide, and the present has many different, complex and contradictory faces, projecting many different, uncertain futures. It is this overdetermined, convoluted and contradictory heterogeneity of the present – characterized by a multiplicity of coeval, overlapping and conflicting cultural self/other relationships[8] – which is foregrounded in postmodernity.

It is important to be precise about the character of this heterogeneity of the present, and it is here that the notion of chaos, as outlined above, and the force of the infinitude of the social takes effect. This heterogeneity of the present does not just refer to the juxtaposed coexistence of a liberal plurality of distinct, mutually independent cultures and societies (which could be said to have existed to a certain extent before the Europeans imposed capitalism on the rest of the world). In the capitalist postmodern world, heterogeneity is not based on foundational essences, but is a contingent articulation of the fluid and moving play of differences in which 'cultures' and 'societies', tumbled as they are into endless interconnections (to paraphrase Clifford Geertz 1988: 147), constantly construct, reconstruct and deconstruct themselves. Any identity of a 'culture', a 'society', and any other social entity ('nation', 'ethnicity', 'gender', 'audience', 'the people', and so on) is merely the conjunctural articulation of constantly changing positionalities, a precarious positivity formed out a temporary fixation of meaning within the capitalist world-system. Paradoxically, then, heterogeneity arises precisely as a result of the hegemonizing, globalizing, integrating forces of the modern capitalist order. It is for this reason that the system, this totalizing system of global capitalism in which we are all trapped, is nevertheless a profoundly unstable one, whose closure can never be completed.

Crucially, however, this postmodern heterogeneity is not *just* the consequence of the excessive flux of the social which produces a surplus of meaning that the system is unable to master, that is, put in order. To assert this would be tantamount to making a romantic metaphysical statement. What is historically particular about capitalist postmodernity's 'true realm of uncertainty' has to do with the system's ambiguous stance towards the infinitude of the social itself: as much as it wants to control it, it also depends on exploiting it. It is in the very nature of capitalism, particularly consumption capitalism, to inscribe excess in its very mode of (re)production.

176

The dynamic of perpetual change is of course characteristic of capitalism *per se*, not just consumption capitalism. But what distinguishes the latter is the way in which perpetual *cultural* (de)construction, perpetual (de)construction of meanings and identities through for example the fashion system and planned obsolescence, has become the linchpin of the economy. That is to say, the culture of consumerism is founded on the idea that constant transformation of identities (through consumption) is pleasurable and meaningful. This exploitation of the pleasure principle implies that consumption capitalism is, as Jon Stratton has remarked, based on an excess of desire: in contrast with earlier, production-oriented capitalism, which catered to given, and thus *limited*, needs and demands, consumption capitalism relies on providing for socially produced, and therefore in principle *limitless*, needs and wants (Stratton 1990: 297–8). This occurs not only at the level of consumption, where the consumer is constructed as always 'wanting'. In postmodern culture the poststructuralist dictum that subjects do not have fixed identities but are always in process of being (re)constructed and (re)defined is not just a theoretical axiom, but has become a generalized cultural principle. The historical institutionalization of excess of desire in the culture of capitalist postmodernity (most directly for example through the discourses of advertising and marketing) exploits the fundamental excessiveness of the social in the creation of an escalating, and ultimately uncontrollable, proliferation of difference and identity, or identities-in-difference. Excess of desire opens up the cultural space for the formulation and proliferation of unpredictable needs and wants – i.e. meanings and identities – not all of which can be absorbed and incorporated in the postmodern order of the capitalist world-system (see, e.g., Ahmed 1992). In other words, at the heart of capitalist postmodernity is an extreme contradiction: on the one hand, its very operation depends on encouraging infinite semiosis, but, on the other hand, like every systemic order, it cannot let infinite semiosis go totally unchecked.

So, the capitalist world-system today is not a single, undifferentiated, all-encompassing whole, but a fractured one, in which forces of order and incorporation (e.g. those of globalization, unification and 'Westernization') are always undercut (though not necessarily subverted) by forces of chaos and fragmentation (e.g. localization, diversification and 'indigenization'). In this world-system there are still dominant forces (it would be ludicrous to deny this), although there is never a guarantee in advance that their attempts to impose order – which is what the dominant will always do – will be successful: think only of former President Bush's failure to create a 'New World Order' – now a quaint idea! Nor does relative failure to impose order mean that the dominant are any less powerful; on the contrary: it only means that the effectivity of their resources and forms of exercise of power is uncertain. Stronger still, it is precisely because of this uncertainty that order is consciously conceived as a task, a problem, an obsession; a matter of

design, management, engineering, policy (Bauman 1991: 6). In this sense, the very insecurity of order in capitalist postmodernity – contradictorily based as it is on both fixing and unfixing meanings and identities, both the delimitation and the instrumental expansion of the social – only encourages the dominant to feverishly step up both the intensity and the range of their ordering practices. But the work will never be done: in the capitalist world-system the moment of absolute order will never come. Even worse, precisely because global capitalism becomes ever more totalizing, the task of order making will become ever more grandiose and complex, the suturing of the fragments of the system into a totality an ever more unfinishable, Sisyphean labour. As Zygmunt Bauman puts it, '[p]roblems are created by problem-solving, new areas of chaos are generated by ordering activity' (1991: 14). For one thing, this is how we can interpret the ceaseless search for better measurement methods and technologies in the ratings industry, or the frantic, neverending quest for new advertising and marketing strategies to capture the elusive consumer.

But if the forces of order are continuously deployed without ever achieving complete order (ultimate closure, a finite and finished totality, totalized structure), then the forces of chaos are also continuously impinging on the system without ever resulting in total chaos (inexhaustible openness, unbounded infinitude, unfettered process). Instead, capitalist postmodernity is an orderly disorder, or disorderly order, whose hegemony rests on the setting of structural limits, themselves precarious, to the possibilities of random excess. It is within these limits that 'resistance' to the dominant takes place (except in the rare situations of 'revolutions', which are temporary moments of limitlessness). In Wallerstein's words:

> Universalism [of capitalist modernity] is a 'gift' of the powerful to the weak which confronts the latter with a double bind: to refuse the gift is to lose; to accept the gift is to lose. The only plausible reaction of the weak is neither to refuse nor to accept, or both to refuse and to accept – in short, the path of the seemingly irrational zigzags (both cultural and political) of the weak that has characterized most of nineteenth- and especially twentieth-century history.
>
> (Wallerstein 1991: 217)

In other words, the negotiations and resistances of the subordinate, bounded as they are within the boundaries of the system, unsettle (but do not destroy) those boundaries.

It is convenient at this point to return to John Fiske and to recontextualize his celebration of the bottom–up power that television audiences evince in the construction of their own meanings and pleasures. To be fair to Fiske, his writings are much more complex than the simplified reiterations would have us believe. In no way is he simply an apologist for liberal pluralism. On the contrary, he derives his relative optimism from his analysis of (mainly

US) commercial television as 'the prime site where the dominant have to recognize the insecurity of their power, and where they have to encourage cultural difference with all the threat to their own position that this implies' (1987a: 326). The problem is that Fiske tends to overestimate (and romanticize) precisely that threat. This threat simply makes the task of the television industries to retain their dominance more complicated and expensive (but not impossible), just as the dispersion and proliferation of viewing practices makes the task of audience measurement more complicated and expensive – and therefore, it should be said, more wasteful, more nasty, more aggressive. Furthermore, it should be noted that the encouragement of cultural difference is, as I have argued above, part and parcel of the chaotic system of capitalist postmodernity itself. In this sense, it would be mistaken to see the acting out of difference unambiguously as an act of resistance; what needs to be emphasized, rather, is that the desire to be different can be simultaneously complicit with and defiant against the institutionalization of excess of desire in capitalist postmodernity. At most, the resistive element in popular practices is, as Michel de Certeau (1984) has suggested in *The Practice of Everyday Life*, a matter of 'escaping without leaving'.

Meaghan Morris has criticized the fact that the idea of what she terms 'excess of process over structure' has led to 'a cultural studies that celebrates "resistance" as a programmed feature of capitalist culture', and to 'a theoretical myth of the Evasive Everyday' (1992: 464–5). Indeed, such a celebration can easily take place when the acts of 'evasive everydayness' are taken at face value, in the context, say, of closed circuits of communication (where departure from 'preferred readings' can be straightforwardly read as 'evasion', this in turn heroized as 'resistance'). However, if we place these acts in the more global and historical context of the chaotic system of capitalist postmodernity, then their 'political' status becomes much more ambivalent. Then we have to take into account their significance in a system which already incorporates a celebration of limitless flux as a mechanism within its ordering principle. What is built-in in the culture of capitalist postmodernity is not 'resistance', but uncertainty, ambiguity, the chaos that emanates from the institutionalization of infinite semiosis.

This, then, is how the true realm of uncertainty which characterizes the 'global village' should be specified – if we still want to retain that metaphor. It should be clear, finally, that the unstable multiplicity of this 'essentially deconstructive world' (Marcus 1992: 327) no longer makes it possible, as modern discourse would have it, to tell a single, total story about the world 'today'. As Stratton has put it, in the postmodern episteme 'there is no fixed site of truth, no absolute presence; there are just multiple representations, an infinite number of rewritings' (1990: 287). Theorizing in the postmodern context has to give up on the search for totalizing and universalizing forms of knowledge and truth. Put more positively, if there is no position from which a fixed and absolute truth (i.e. a Grand Theory) can be put forward,

then we can only strive for the construction of 'partial truths', to use James Clifford's (1986) term. Critical theorizing, then, always has to imply an acknowledgement of its own open-endedness, its own partiality in its inevitable drive towards narrative closure, in its attempts to impose order in the stories it tells. At the very least, a critical understanding of what it means to live in the true realm of uncertainty that is capitalist postmodernity must take on board a positive uncertainty about its own 'communicative' effect, its own attempts to construct meaningful discourse in which the chaos of the world 'today' is rendered in 'sceptical, if not paranoid assessment' (Morris 1988b: 197). Or in the words of Laclau: 'Utopia is the essence of any communication and social practice' (1991: 93).

Notes

INTRODUCTION

1 For an exhaustive historical account of the 'dominant paradigm' and its collusion with the requirements of the modern capitalist media industries in the United States, see Gitlin (1978).
2 The emphasis on 'uses' (in 'uses and gratifications research') is often presented as diametrically opposed to that on 'effects', but because they share the same functionalist theoretical framework they can be seen as two sides of the same coin.
3 For an insightful discussion of the meaning of everyday 'resistance' as 'weapons of the weak' in a very different context, i.e. peasants in rural Third World areas, see J. C. Scott (1985).

1 THE BATTLE BETWEEN TELEVISION AND ITS AUDIENCES

1 It is impossible to describe in detail here the complex structure and development of Dutch television. For an established but adequate overview in English see Herman Wigbold (1979). See also Ang (1987).
2 In other words, what predominates here is a very *folkish* idea of audiences, which contradicts the conception of the audience as an anonymous mass as usually implied in mass-media systems.
3 Veronica is a controversial broadcasting organization which stemmed from a very popular pirate radio transmitter, which introduced round-the-clock pop music to Dutch youth in the 1960s. In 1976 Veronica applied for TV transmission time and finally was allowed into the legal broadcasting system, although it was not clear which religious or cultural 'pillar' it represented. Being more aggressive and noisy than TROS, Veronica developed a very distinctive popular mode of address, which was based on the slogan: 'You are young and you want things!' and which is often deliberately truculent ('Veronica fears nothing!'). In terms of programming, this means a lot of pop music, spectacular films and 'sex-'n'-violence'. It was Veronica which, by the 1990s, brought about the final breakdown of the Dutch public broadcasting system by deliberately stepping out of its ideological framework and going fully commercial.
4 Of course, we should not overlook the conflicts and the unequal relations of power within the family here, in which the father or husband is mostly in the dominant position. An analysis of popular television and of constructions of the

181

pleasurable in televisual discourse should take into account the ways in which representations and modes of address assume positions which are specific to gender, ethnicity, age, etc.

2 ON THE POLITICS OF EMPIRICAL AUDIENCE RESEARCH

1 It should be noted that the term 'ethnography' is somewhat misplaced in this context. Within anthropology, ethnography refers to an in-depth field study of a culture and its inhabitants in their natural location, which would require the researcher to spend a fair amount of time in that location, allowing her/him to acquire a nuanced and comprehensive insight into the dynamics of the social relationships in the culture under study, and enabling her/him to produce a 'thick description' of it. Most qualitative studies of media audiences do not meet these requirements. In Morley's *Nationwide* study, for example, the informants were extracted from their natural viewing environment and interviewed in groups that were put together according to socio-economic criteria. In a looser sense, however, the use of the term 'ethnographic' can be justified here in so far as the approach is aimed at getting a thorough insight into the 'lived experience' of media consumption. For a further discussion, see chapter 4.
2 It should be stressed, however, that the 'critical' tradition is not a monolithic whole: there is not one 'critical theory' with generally shared axioms, but many different, and often conflicting, 'critical perspectives', e.g. political economy and cultural studies.
3 Thus, the dichotomization of 'critical' and 'empirical' schools in communication studies, particularly in the United States, should be considered with some flexibility. See, e.g., the famous 'Ferment in the Field' issue of the *Journal of Communication* (1983).
4 The direct theoretical inspiration of Morley's research was the so-called encoding/decoding model as launched by Stuart Hall, which presented a theoretical intervention against '*Screen* theory'. See Hall (1980a, 1980b). Morley himself has elaborated on the 'interdiscursive' nature of encounters between text and subjects. See Morley (1980b).
5 See also Tamar Liebes (1986) and Kim Christian Schrøder (1987). Such an insistence upon convergence is not new among 'mainstream' communication researchers. For example, Jennifer Slack and Martin Allor have recalled how in the late 1930s Lazarsfeld hired Adorno in the expectation that the latter's critical theory could be used to 'revitalize' American empiricist research by supplying it with 'new research ideas'. The collaboration ended only one year later because it proved to be impossible to translate Adorno's critical analysis into the methods and goals of Lazarsfeld's project. Lazarsfeld has never given up the idea of a convergence, however (Slack and Allor 1983: 210).
6 Note, for instance, the striking similarities between the following two sentences, one from a uses and gratifications source, the other from a cultural studies one: 'There seems to be growing support for that branch of communications research which asserts that television viewing is an active and social process' (Katz and Liebes 1985: 187); 'Television viewing, the choices which shape it and the many social uses to which we put it, now turn out to be irrevocably active and social process' (Hall 1986a: 8).
7 In stating this I do not want to suggest that cultural studies is a closed paradigm, nor that all cultural studies scholars share one – say, Foucauldian – conception

of power. For example, the Birmingham version of cultural studies, with its distinctly Gramscian inflection, has been criticized by Lawrence Grossberg for its lack of a theory of pleasure. An alternative, postmodernist perspective on cultural studies is developed in Grossberg (1983).

8 Strategic interpretations, that is, interpretations that are 'political' in the sense that they are aware of the fact that interpretations are always concrete interventions into an already existing discursive field. They are therefore always partial in both senses of the word (i.e. partisan and incomplete), and involved in making sense of the world in specific, power-laden ways. See Mary Louise Pratt (1986).

9 Rosengren expresses this view in very clearcut terms, where he reduces the existence of disagreements between 'critical' and 'mainstream' researchers to 'psychological reasons' (1983: 191).

10 I have borrowed this formulation from Virginia Nightingale (1986: 21–2). Nightingale remarks that audience research has generally been 'on the side' of those with vested interests in influencing the organization of the mass-media in society, and that it is important to develop a research perspective that is 'on the side' of the audience. However, it is far from simple to work out exactly what such a perspective would mean. The notion of the 'active audience', for example, often put forward by uses and gratifications researchers not just as an object of empirical investigation but also as on article of faith, as an axiom to mark the distinctive identity of the 'paradigm', is not in itself a guarantee of a stance 'on the side of the audience'. In fact, the whole passive/active dichotomy in accounts of audiences has now become so ideologized that it all too often serves as a mystification of the real commitments behind the research at stake.

11 Reflections on the predicaments and politics of research on and with living historical subjects have already played an important role in, for example, feminist studies and anthropology, particularly ethnography. At least two problems are highlighted in these reflections. First, there is the rather awkward but seldom discussed concrete relation between researcher and researched as concrete subjects occupying differential social positions, more and less invested with power; second, there is the problem of the discursive form in which the cultures of 'others' can be represented in non-objectifying (or, better, less objectifying) ways. See, e.g., Angela McRobbie (1982); James Clifford (1983); James Clifford and George Marcus (1986); Lila Abu-Lughold (1991). Researchers of media audiences have, as far as I know, generally been silent about these issues. However, for a thought-provoking engagement with the problem, see Valerie Walkerdine (1986). See also chapter 4.

12 See, for a more general overview of the interpretive or hermeneutic turn in the social sciences, Paul Rabinow and William M. Sullivan (1979). A more radical, Foucauldian conception of what they call 'interpretive analytics' is developed by Hubert Dreyfuss and Paul Rabinow (1982).

13 A concise and useful criticism of empiricist mass communication research is offered by Robert C. Allen (1985: chapter 2).

14 Morley's main objection to the uses and gratifications approach concerns 'its psychologistic problematic and its emphasis on individual differences of inter-pretation' (1983: 117). Elsewhere Morley even more emphatically expresses his distance from the uses and gratifications approach: 'Any superficial resemblance between this study of television audience and the "uses and gratifications" perspective in media research is misleading' (ibid.).

15 Note that in positivist epistemology intersubjectivity is considered as one of the main criteria for scientific 'objectivity'. One of the myths by which the institution

of Science establishes itself is that scientific discourse is a process without a subject. Hence the normative rule that the concrete historical subject of scientific practice, the researcher, should be interchangeable with any other so as to erase all marks of idiosyncratic subjectivity.

16 All sorts of cautious qualifications as to the generalizability of such 'findings', so routinely put forward in research reports so that the validity of the given typifications are said to be limited to certain demographic or subcultural categories (e.g. the urban working class), do not in principle affect this reification of experiential structures.

17 An image of the television audience as consisting of harmonious collectivities is suggested by Elihu Katz and Tamar Liebes, when they describe the process of decoding a television programme as an activity of 'mutual aid' (1985). While this idea is useful in that it highlights the social nature of processes of decoding, it represses the possibility of tension, conflict and antagonism between different decodings within the same group.

18 For epistemological deconstructions of the category of 'audience' as object of power/knowledge, see Briankle G. Chang (1987); Martin Allor (1988); Ang (1991).

3 NEW TECHNOLOGIES, AUDIENCE MEASUREMENT AND THE TACTICS OF TELEVISION CONSUMPTION

1 This statement should not be interpreted monolithically. Discourses of audience produced by and within television institutions are certainly neither homogeneous nor without contradiction. In Ang (1991) I discuss in detail the differing assumptions about the 'television audience' and its sustaining 'viewing behaviour' as operative in the historical practices of American commercial television and European public service television, respectively.

2 For a comprehensive overview of the audience measurement industry in the United States, see Hugh M. Beville Jr (1985).

3 I discuss extensively the introduction of the people meter in the American television industry in part II of Ang (1991). The people meter is currently seen as the standard technology for television audience measurement in countries with developed (i.e. commercial, multichannel) TV systems, including most West European countries and Australia.

4 The study was part of the huge Report to the Surgeon General's Scientific Advisory Committee on Television and Social Behavior, which was commissioned to establish facts about the effects of television violence. Even in that context, however, Bechtel et al.'s (1972) project was marginalized. As Willard Rowland has noted:

> [A]s provocative as this research was, its design violated so many of the normal science requirements for acceptable survey research that it had little impact on the major directions taken by the overall advisory committee program. Indeed this study was permitted only as a way of testing the validity of survey questionnaires. The somewhat radical theoretical implications of its findings were largely overlooked at all levels of review in the project.
>
> (Rowland 1983: 155)

5 The evidence dug up by HHCL was already substantiated in an earlier,

Independent Broadcast Authority-funded research by Peter Collett and Roger Lamb (1986), similar in set-up to Bechtel *et al.*'s (1972) study, in which they confirmed the widespread occurrence of 'inattentive viewing' in the home.

6 In this respect, it is interesting to note that the American national TV networks, faced with declining viewing figures for their programmes, are now insisting on the incorporation of television viewing *outside* the home (in bars, college dormitories, hotels, and so on) in Nielsen's audience measurement procedures (Huff 1990).

4 ETHNOGRAPHY AND RADICAL CONTEXTUALISM IN AUDIENCE STUDIES

1 This international conference was organized at the University of Illinois, Urbana-Champaign, in September 1990, where an earlier version of this chapter was presented.

2 I borrow this spatial characterization of the epistemological quest of radical contextualism from Susan Bordo (1990).

3 In this respect, it is useful to note anthropologist Lila Abu-Lughold's (1991) provocative suggestion that the problem lies in the very concept of 'culture' itself, which she thinks almost inevitably points to a privileging of organic metaphors of wholeness and coherence, and to holistic methodologies. To counter this, she suggests that we develop ways of 'writing *against* culture'.

4 This is what makes some recent discussions of ethnographic writing problematic. For example, John van Maanen (1988) seems to have been seduced by the lure of literary effect in his favoured 'impressionist tales'. As a result, he tends to slight the importance of theoretical categories and political perspectives in the construction of meaningful understandings in ethnographic discourse.

5 MELODRAMATIC IDENTIFICATIONS

1 At one point, Sue Ellen decided to become a businesswoman – and with great success. However, even this major structural change in her life was motivated by a wish to mess up J.R.'s schemes and plans. She started her business (Valentine Lingerie) as a shrewd tactic to get rid of J.R.'s mistress.

2 These figures come from a survey of the Department of Viewing and Listening Research, NOS, Hilversum, the Netherlands, May 1982.

3 Of course, watching a television programme does not necessarily involve identification with only one character. On the contrary, numerous subject positions can be taken up by viewers while reading a television text. Consequently, a *Dallas* viewer may alternate between positions of identification and positions of distance and thus inhabit several, sometimes contradictory imaginary structures at the same time.

4 The moment a soap opera becomes self-conscious about its own excess, which was sometimes the case with *Dynasty*, and no longer takes its own story seriously, it presents itself as a parody of the genre, as it were, accentuating its status as discourse through stylization and formalism (such as slow motion techniques). Sections of the *Dynasty* audience that read the show as a form of camp, for instance, are responding to this postmodern aspect of the *Dynasty* text. Jon Stratton and I have discussed the so-called postmodernization of the soap opera genre with respect to the Australian 'post-realist' soap *Chances* (Ang and

Stratton 1995) and the 'real life' soap *Sylvania Waters* (Stratton and Ang 1994).

6 FEMINIST DESIRE AND FEMALE PLEASURE

1 I would like to emphasize that in doing this I cannot do full justice to the accomplishments and problems of the book. Many aspects of Radway's distinctly innovative book, such as her discussion of the differences between the ideal romance and the failed romance, and her application of Nancy Chodorow's version of psychoanalysis to explain women's 'need' for romance reading, will therefore not be discussed here. I would also like to draw attention to Radway's preface to the British edition of *Reading the Romance* (1987), in which she raises some of the issues I go into in this chapter.
2 See, for a lengthy and insightful review of this book, Lynn Spigel (1985).
3 It should be noted that Radway's discussion of the narrative discourse of romantic fiction is very similar to the theory of the 'classic realist text' as developed in film theory by Colin MacCabe and others.

7 GENDER AND/IN MEDIA CONSUMPTION

1 The hypodermic needle model of media effects assumes that the media directly 'inject' values, ideas and information into a presumably passive audience. It assumes a mechanistic stimulus–response relation between media and audiences.
2 For example, several authors have pointed to the fact that feminine subject positions constructed in mass cultural texts do not simply reproduce patriarchial definitions of femininity, but also offer utopian opportunities for phantasmatic transgression. See, e.g., Modleski (1982); Light (1984); McRobbie (1985); Kaplan (1986). See also chapter 5.
3 This is not to say that generalizations as such should at all cost be avoided (indeed, this would make the production of knowledge virtually impossible); it is merely to point to the importance, in understanding social phenomena, of complementing the generalizing tendency with an opposite, *particularizing* one. See Billig (1987) and Abu-Lughold (1991).
4 Frow's (1987) criticism of Bourdieu comes despite the latter's explicit rejection of objectivist sociology and its 'substantialist' conception of reality, and his commitment to apply a relational mode of thinking in his analysis of cultural differentiation. See e.g. Bourdieu (1989).
5 See Potter and Wetherell (1987) for the importance of paying attention to inconsistency and variation in discourse analysis.
6 It won't come quite as a surprise that what we know about men and media consumption has for a greater part been written by or about homosexual men (R. Dyer 1980; Easthope 1986; Gross 1989).
7 For an introduction to poststructuralism and feminism, see Weedon (1987).
8 It is exactly these terms that were used by uses and gratifications researchers to describe individuals' media uses and consumption.
9 Personal communication of Joke Hermes with Ann Gray, July 1990.
10 In our view, this would be a viable way of theorizing the mechanisms of 'routines' and 'regularities' in everyday life.
11 Obviously, genres such as the news and travel literature, and certainly pornography, do contain gendered subject positionings in the way they substantially and formally address their spectators. But such positionings cannot be assumed

to exhaust the textual effectivity of these genres. Here, work in the field of textual analysis can offer us much more detailed insight. For example, Charlotte Brunsdon (1987) has explored this issue in her analysis of the British crime series *Widows*.

12 That such positions are often in the second instance articulated in gendered terms, for example in the stereotyping of professional women as unfeminine or in the call for treating male and female hostages differently (as, for example, in the Gulf crisis), is precisely the result of the hegemonic work of patriarchal discourse. It is important for feminism to *disarticulate* such discursive genderings.

13 For conceptualizations of ethnography as storytelling, see, e.g., Clifford and Marcus (1986); Geertz (1988); van Maanen (1988).

14 Nicholson (1990) is an excellent collection of articles pro and contra the feminism/postmodernism connection.

8 CULTURAL STUDIES, MEDIA RECEPTION AND THE TRANSNATIONAL MEDIA SYSTEM

1 It is precisely the ethnographic turn in the analysis of media consumption which is appealing for cultural studies, as opposed to more formal and formalizing approaches to reception. From an anthropological point of view, however, the ethnographic method has only been applied in a limited way in the study of media audiences. For a further discussion of the ethnographic turn in audience studies, see esp. chapters 2 and 4.

2 A similar point has been made with regard to reader-response criticism, the literary variant of reception analysis, by Pratt (1986).

3 Radical empiricism should emphatically be distinguished from vulgar empiricism. While vulgar empiricism has a built-in tendency towards conservatism because it takes reality-as-it-is for granted, radical empiricism questions that taken-for-grantedness precisely because it fully engages itself with the messiness of the world we live in and, as a result, forces us to confront the *limits* of this 'reality'. See Higgins (1986: 120).

4 According to Hall, such open-ended theorizing is necessary in order to keep cultural studies sensitive to historical conjunctures: 'It is theorizing in the postmodern context, if you like, in the sense that it does not believe in the finality of a finished theoretical paradigm.' (Hall 1986b: 60).

10 IN THE REALM OF UNCERTAINTY

1 This sense of reassurance (and thus of certainty) applies to both the proponents and the opponents of the 'global village'.

2 As is well known, the passing of the dominant paradigm has been widely felt within the discipline as a 'ferment in the field', as documented in the special issue of the *Journal of Communication* (1983).

3 In this respect, Carey aligns himself with the liberal pragmatism of American philosophers such as John Dewey and Richard Rorty. It should be noted that the scope of Carey's 'Great Community' never seems to become thoroughly global: his 'we' remains firmly located within the boundaries of the United States of America.

4 The most well-known exemplar of such a liberal pluralist inflection of the 'new audience research' is Tamar Liebes and Elihu Katz (1990).

5 For a further elaboration of this point, see chapter 7.

6 This idea, of course, was first developed by Herbert Marcuse in his *One-Dimensional Man* (1964).
7 This exposition draws heavily on Ernesto Laclau's concise essay 'The Impossibility of Society', in his *New Reflections on the Revolution of Our Time* (1991).
8 For a further elaboration of the concept of coevalness in contemporary global culture, see Johannes Fabian (1983).

References

Abu-Lughold, L. (1991) 'Writing Against Culture', in R.G. Fox (ed.) *Recapturing Anthropology*, Sante Fe, NM: School of American Research Press.

Ahmed, A.S. (1992) *Postmodernism and Islam: Predicament and Promise*, London: Routledge.

Allen, R.C. (1985) *Speaking of Soap Operas*, Chapel Hill/London: University of North Carolina Press.

Allor, M. (1988) 'Relocating the Site of the Audience', *Critical Studies in Mass Communication* 5(3): 217–33.

Anderson, B. (1983) *Imagined Communities*, London: Verso.

Ang, I. (1985) *Watching Dallas: Soap Opera and the Melodramatic Imagination*, London/New York: Methuen.

—— (1987) 'The Vicissitudes of "Progressive Television"', *New Formations* 2, Summer: 91–106.

—— (1991) *Desperately Seeking the Audience*, London/New York: Routledge.

Ang, I. and Morley, D. (1989) 'Mayonnaise Culture and Other European Follies', *Cultural Studies* 3(2): 133–44.

Ang, I. and Stratton, J. (1995) 'The End of Civilization as We Knew It: *Chances* and the Postrealist Soap Opera', in R.C. Allen (ed.) *To Be Continued. . . Soap Operas Around the World*, London: Routledge.

—— (1996) 'Asianing Australia: Notes Toward a Critical Transnationalism in Cultural Studies', *Cultural Studies* 10 (1).

Appadurai, A. (1990) 'Disjuncture and Difference in the Global Cultural Economy', *Public Culture* 2(2): 1–24.

Asad, T. (1990) 'Ethnography, Literature and Politics: Some Readings and Uses of Salman Rushdie's *The Satanic Verses*', *Cultural Anthropology* 5(3): 239–69.

Asiaweek (1994) 'An Asian Sky', 19 October.

Baehr, H. and Dyer, G. (eds) (1987) *Boxed In: Women and Television*, New York/London: Pandora Press.

Baker, W.F. (1986) 'Viewpoints', *Television/Radio Age* 10 November.

Bartos, R. (1982) *The Moving Target: What Every Marketer Should Know About Women*, New York: Free Press.

Baudrillard, J. (1983) *In the Shadow of the Silent Majorities*, trans. P. Foss, P. Patton and J. Johnston, New York: Semiotext(e).

—— (1988) 'Consumer Society' [1970], in his *Selected Writings*, ed. M. Poster, Stanford, CA: Stanford University Press.

Bauman, Z. (1987) *Legislators and Interpreters*, Cambridge: Polity Press.

—— (1991) *Modernity and Ambivalence*, Oxford: Polity Press.

REFERENCES

Bausinger, H. (1984) 'Media, Technology and Daily Life', *Media, Culture and Society* 6(4): 343–51.

Bechtel, R.B., Achelpohl, C. and Akers, R. (1972) 'Correlates between Observed Behavior and Questionnaire Responses on Television Viewing', in E. Rubinstein, G. Comstock and J. Murray (eds) *Television and Social Behavior, vol. 4: Television in Day-to-Day Life: Patterns of Use*, Washington, DC: United States Government Printing Office.

Bedell Smith, S. (1985) 'Who's Watching TV? It's Getting Hard to Tell', *New York Times* 6 January.

Bennett, T., Mercer, C. and Woollacott, J. (eds) (1986) *Popular Culture and Social Relations*, Milton Keynes: Open University Press.

Berland, J. (1992) 'Angels Dancing: Cultural Technologies and the Production of Space', in L. Grossberg, C. Nelson and P. Treichler (eds) *Cultural Studies*, New York/London: Routledge.

Berman, M. (1982) *All That is Solid Melts into Air*, New York: Simon & Schuster.

Beville H.M., Jr (1985) *Audience Ratings: Radio, Television, Cable*, Hillsdale, NJ: Lawrence Erlbaum.

Beville, M. (1986a) 'People Meter Will Impact All Segments of TV Industry', *Television/Radio Age* 27 October.

—— (1986b) 'Industry is Only Dimly Aware of People Meter Differences', *Television/Radio Age* 10 November.

Billig, M. (1987) *Arguing and Thinking*, Cambridge: Cambridge University Press.

Blumler, J.G., Gurevitch, M. and Katz, E. (1985) 'Reaching Out: A Future for Gratifications Research', in K.E. Rosengren, L.A. Wenner and P. Palmgreen (eds) *Media Gratifications Research: Current Perspectives*, Beverly Hills, CA: Sage.

Blundell, V., Shepherd, J. and Taylor, I. (eds) (1993) *Relocating Cultural Studies*, London/New York: Routledge

Bobo, J. (1988) '*The Color Purple*: Black Women as Cultural Readers', in E.D. Pribram (ed.) *Female Spectators: Looking at Film and Television*, London/New York: Verso.

Bordo, S. (1990) 'Feminism, Postmodernism and Gender-Scepticism', in L.J. Nicholson (ed.) *Feminism/Postmodernism*, New York/London: Routledge.

Bourdieu, P. (1984) *Distinction: A Social Critique of the Judgment of Taste*, trans. R. Nice, Cambridge, MA: Harvard University Press.

—— (1989) 'Social Space and Symbolic Power', *Sociological Theory* 7(1): 14–25.

Branegan, J. (1989) 'Bubbling Up from Below', *Time* 21 August.

Broadcasting (1988) 'Arbitron to Go With Peoplemeter' 27 June.

Brooks, P. (1976) *The Melodramatic Imagination: Balzac, Henry James, Melodrama, and the Mode of Excess*, New Haven: Yale University Press.

Brown, M.E. (1990) 'Motley Moments: Soap Operas, Carnival, Gossip and the Power of the Utterance', in M.E. Brown (ed.) *Television and Women's Culture The Politics of the Popular*, London: Sage.

Brunsdon, C. (1981) '*Crossroads*: Notes on Soap Opera', *Screen* 22(4): 32–7.

—— (1986) 'Women Watching Television', *MedieKultur* 4.

—— (1987) 'Men's Genres for Women', in H. Baehr and G. Dyer (eds) *Boxed In: Women and Television*, New York/London: Pandora Press.

—— (1989) 'Text and Audience', in E. Seiter, H. Borchers, G. Kreutzner and E.M. Warth (eds) *Remote Control: Television Audiences, and Cultural Power*, London/New York: Routledge.

—— (1991) 'Pedagogies of the Feminine: Feminist Teaching and Women's Genres', *Screen* 32(4): 364–81.

REFERENCES

Budd, M., Entman, R.M. and Steinman, C. (1990) 'The Affirmative Character of U.S. Cultural Studies', *Critical Studies in Mass Communication* 7(2): 169–84.

Butler, J. (1990) *Gender Trouble: Feminism and the Subversion of Identity*, New York: Routledge.

Canape, C. (1984) 'Split Image', *Madison Avenue* August: 38–44.

Carey, J. (1983) 'Introduction', in M.S. Mander (ed) *Communications in Transition*, New York: Praeger.

Carey, J. (1989) *Communication as Culture*, Boston: Unwin Hyman.

Chaney, D. (1994) *The Cultural Turn*, London/New York: Routledge.

Chang, B.G. (1987) 'Deconstructing the Audience: Who Are They and What Do We Know About Them?', in M.L. McLaughlin (ed.) *Communication Yearbook* 10, Beverly Hills CA: Sage.

Clancey, M. (1993) 'To Be or Not To Be (Counted)?', *Journal of Advertising Research* 33(3): RC3–RC5.

Clark, D. (1990) '*Cagney and Lacey*: Feminist Strategies of Detection', in M.E. Brown (ed.) *Television and Women's Culture: The Politics of the Popular*, London: Sage.

Clifford, J. (1983) 'On Ethnographic Authority', *Representations* 1 (Spring) 2: 118–46.

—— (1986) 'Introduction: Partial Truths', in J. Clifford and G.E. Marcus (eds) *Writing Culture: The Poetics and Politics of Ethnography*, Berkeley/Los Angeles/London: University of California Press.

Clifford, J. and Marcus, G.E. (eds) (1986) *Writing Culture: The Poetics and Politics of Ethnography*, Berkeley/Los Angeles/London: University of California Press.

Collett, P. and Lamb, R. (1986) *Watching People Watching Television*, London: Independent Broadcasting Authority.

Comstock, G., Chaffee, S., Katzman, N., McCombs. M. and Roberts, D. (1978) *Television and Human Behavior*, New York: Columbia University Press.

Connell, I. (1983) 'Commercial Broadcasting and the British Left', *Screen* 24(6): 70–80.

Corner, J. (1991) 'Meaning, Genre and Context: The Problematics of "Public Knowledge" in the New Audience Studies', in J. Curran and M. Gurevitch (eds) *Mass Media and Society*, London/New York: Edward Arnold.

Corrigan, P. and Willis, P. (1980) 'Cultural Forms and Class Mediations', *Media, Culture and Society* 2(3): 297–312.

Coward, R. (1983) *Patriarchal Precedents: Sexuality and Social Relations*, London: Routledge & Kegan Paul.

—— (1984) *Female Desire: Women's Sexuality Today*, London: Paladin.

Cowie, E. (1984) 'Fantasia', *m/f* 9: 71–105.

Crowley, D. and Mitchell, D. (eds) (1994) *Communication Theory Today*, Oxford: Polity Press.

Culler, J. (1983) *On Deconstruction*, London: Routledge.

Curran, J. (1990) 'The New Revisionism in Mass Communication Research: A Reappraisal', *European Journal of Communication* 5(2–3): 135–64.

—— (1991) 'Introduction', in J. Curran and M. Gurevitch (eds) *Mass Media and Society*, London/New York: Edward Arnold.

D'Acci, J. (1987) 'The Case of *Cagney and Lacey*', in H. Baehr and G. Dyer (eds) *Boxed In: Women and Television*, New York/London: Pandora Press.

Dahlgren, P. (1983) 'Die Bedeutung von Fernsehnachrichten', *Rundfunk und Fernsehen* 31(3/4): 307–18.

Davis, B. (1986) 'Single Source Seen as "New Kid on Block" in TV Audience Data', *Television/Radio Age* 29 September.

191

REFERENCES

Dayan, D. and Katz, E. (1992) *Media Events: The Live Broadcasting of History*, Cambridge, MA: Harvard University Press.

de Certeau, M. (1984) *The Practice of Everyday Life*, trans. S. Randall, Berkeley: University of California Press.

de Lauretis, T. (1984) *Alice Doesn't: Feminism, Semiotics, Cinema*, Bloomington: Indiana University Press.

—— (1987) *Technologies of Gender*, Bloomington/Indianapolis: Indiana University Press.

Diamond, A. H. (1993) 'Chaos Science', *Marketing Research* 5(4): 9–12.

Dimling, J.A. (1994) 'Television Ratings in the US: What Does the Future Hold?', paper presented at Media Seminar 'Fine Tuning the Future', hosted by A.C. Nielsen Australia, Sydney, 7 March.

Doane, M.A. (1987) *The Desire to Desire*, London: Macmillan.

Dreyfuss, H. and Rabinow, P. (1982) *Michel Foucault: Beyond Structuralism and Hermeneutics*, Chicago: University of Chicago Press.

Drotner, K. (1994) 'Ethnographic Enigmas: "The Everyday" in Recent Media Studies', *Cultural Studies* 8(2): 341–57.

Dyer, G. (1987) 'Women and Television: An Overview', in H. Baehr and G. Dyer (eds) *Boxed In: Women and Television*, New York/London: Pandora Press.

Dyer, R. (ed.) (1980) *Gays and Film*, London: BFI.

Eagleton, T. (1994) 'Discourse and Discos', *Times Literary Supplement* 15 July: 3–4.

Easthope, A. (1986) *What a Man's Gotta Do: The Masculine Myth in Popular Culture*, London: Paladin.

Elliott, P. (1974) 'Uses and Gratifications Research: A Critique and a Sociological Alternative', in J.G. Blumler and E. Katz (eds) *The Uses of Mass Communications*, Beverly Hills, CA/London: Sage.

Ellis, J. (1982) *Visible Fictions*, London: Routledge & Kegan Paul.

Fabian, J. (1983) *Time and the Other*, New York: Columbia University Press.

Featherstone, M. (ed.) (1990) *Global Culture*, London: Sage.

—— (1991) *Consumer Culture and Postmodernism*, London: Sage.

Fejes, F. (1984) 'Critical Communications Research and Media Effects: The Problem of the Disappearing Audience', *Media, Culture and Society* 6: 219–32.

Feuer, J. (1984) 'Melodrama, Serial Form and Television Today', *Screen* 25(1): 4–16.

Fish, S. (1980) *Is There A Text in This Class? The Authority of Interpretive Communities*, Cambridge, MA: Harvard University Press.

Fiske, J. (1987a) *Television Culture*, London: Methuen.

—— (1987b) 'British Cultural Studies and Television', in R.C. Allen (ed.) *Channels of Discourse*, Chapel Hill/London: University of North Carolina Press.

—— (1991) 'Postmodernism and Television', in J. Curran and M. Gurevitch (eds) *Mass Media and Society*, London/New York: Edward Arnold.

—— (1993) *Power Plays/Power Works*, London: Verso.

Flax, J. (1990) 'Postmodernism and Gender Relations in Feminist Theory', in L.J. Nicholson (ed.) *Feminism/Postmodernism*, New York/London: Routledge.

Foucault, M. (1979) *Discipline and Punishment*, trans. A. Sheridan, Harmondsworth: Penguin.

Fox, R. G. (1980) *Power/Knowledge*, ed. C. Gordon, New York: Pantheon.

—— (ed.) (1991) *Recapturing Anthropology*, Santa Fe, NM: School of American Research Press.

Fraser, N. and Nicholson, L.J. (1990) 'Social Criticism Without Philosophy: An Encounter between Feminism and Postmodernism', in L. J. Nicholson (ed.) *Feminism/Postmodernism*, New York/London: Routledge.

Frow, J. (1987) 'Accounting for Tastes: Some Problems in Bourdieu's Sociology of Culture', *Cultural Studies* 1(1): 59–73.

Frow, J. and Morris, M. (eds) (1993) *Australian Cultural Studies: A Reader*, St Leonards: Allen & Unwin.

Gamman, L. and Marshment, M. (eds) (1988) *The Female Gaze: Women as Viewers of Popular Culture*, London: Women's Press.

Gardner, C. and Sheppard, J. (1984) 'Transforming Television: Part I, The Limits of Left Policy', *Screen*, 25(2): 26–38.

Geertz, C. (1983) *Local Knowledge*, New York: Basic Books.

—— (1988) *Works and Lives: The Anthropologist as Author*, Cambridge: Polity Press.

Gellner, E. (1983) *Nations and Nationalism*, Oxford: Basil Blackwell.

Gillespie, M. (1989) 'Technology and Tradition: Audiovisual Culture Among South Asian Families in West London', *Cultural Studies* 3(2): 226–39.

Gitlin, T. (1978) 'Media Sociology: The Dominant Paradigm', *Theory and Society* 6: 205–53.

—— (1983) *Inside Prime Time*, New York: Pantheon.

—— (1991) 'The Politics of Communication and the Communication of Politics', in J. Curran and M. Gurevitch (eds) *Mass Media and Society*, London/New York: Edward Arnold.

Gledhill, C. (ed.) (1987) *Home is Where the Heart is*, London: BFI.

—— (1988) 'Pleasurable Negotiations', in E.D. Pribram (ed.) *Female Spectators: Looking at Film and Television*, London/New York: Verso.

Gold, L.N. (1988) 'The Evolution of Television Advertising-Sales Measurement: Past, Present and Future', *Journal of Advertising Research* 28(3): 18–24.

Golding, P. and Murdock, G. (1991) 'Culture, Communication and Political Economy', in J. Curran and M. Gurevitch (eds) *Mass Media and Society*, London/New York: Edward Arnold.

Goldstein, C. (1989) 'The Selling of Asia', *Far Eastern Economic Review* 29 June.

Gray, A. (1987) 'Behind Closed Doors: Video Recorders in the Home', in H. Baehr and G. Dyer (eds) *Boxed In: Women and Television*, New York/London: Pandora Press.

—— (1992) *Video Playtime: The Gendering of a Leisure Technology*, London: Routledge.

Greer, G. (1971) *The Female Eunuch*, London: Paladin.

Gripsrud, J. (1989) '"High Culture" Revisited', *Cultural Studies* 3(2): 194–207.

Groen, J. (1990) 'Consument thuis per video begluurd', *De Volkskrant* 20 January.

Gross, L. (1989) 'Out of the Mainstream: Sexual Minorities and the Mass Media', in E. Seiter, H. Borchers, G. Kreutzner and E-M. Warth (eds) *Remote Control: Television, Audiences, and Cultural Power*, London/New York: Routledge.

Grossberg, L. (1983) 'Cultural Studies Revisited and Revised', in M.S. Mander (ed.) *Communications in Transition*, New York: Praeger.

—— (1987) 'Critical Theory and the Politics of Empirical Research', in M. Gurevitch and M.R. Levy (eds) *Mass Communication Review Yearbook* 6, Newbury Park, CA: Sage.

—— (1988a) *It's a Sin: Essays on Postmodernism, Politics and Culture*, Sydney: Power Publications.

—— (1988b) 'Wandering Audiences, Nomadic Critics', *Cultural Studies* 2(3): 377–92.

Grossberg, L., Nelson, C. and Treichler, P. (eds) (1992) *Cultural Studies*, New York/London: Routledge.

Habermas, J. (1983) 'Modernity – An Incomplete Project', in H. Foster (ed.) *The Anti-Aesthetic*, Port Townsend, WA: Bay Press.

Hall, S. (1980a) 'Encoding/Decoding', in S. Hall, D. Hobson, A. Lowe and P. Willis (eds) *Culture, Media, Language*, London: Hutchinson.

193

REFERENCES

—— (1980b) 'Recent Developments in Theories of Language and Ideology: A Critical Note', in S. Hall, D. Hobson, A. Lowe and P. Willis (eds) *Culture, Media, Language*, London: Hutchinson.

—— (1982) 'The Rediscovery of "Ideology": Return of the Repressed in Media Studies', in M. Gurevitch, T. Bennett and J. Woollacott (eds) *Culture, Society, and the Media*, London/New York: Methuen.

—— (1986a) 'Introduction', in D. Morley, *Family Television: Cultural Power and Domestic Leisure*, London: Comedia/Routledge.

—— (1986b) 'On Postmodernism and Articulation: An Interview with Stuart Hall', *Journal of Communication Inquiry* 10(2): 45–60.

—— (1986c) 'The Problem of Ideology – Marxism without Guarantees', *Journal of Communication Inquiry* 10(2): 5–27.

—— (1987) 'Minimal Selves', *ICA Documents 6: Identity*, London: Institute of Contemporary Arts.

Hall, S. and Jefferson, T. (eds) (1976) *Resistance Through Rituals*, London: Hutchinson.

Hall, S., Hobson, D., Lowe, A. and Willis, P. (eds) (1980) *Culture, Media, Language*, London: Hutchinson.

Hamelink, C. (1983) *Cultural Autonomy in Global Communications*, New York: Longman.

Hammer, J. (1990) 'Advertising in the Dark', *Newsweek* 9 April.

Hammersley, M. and Atkinson, P. (1983) *Ethnography: Principles in Practice*, London/New York: Tavistock.

Hannerz, U. (1989) 'Notes on the Global Ecumene', *Public Culture* 1(2): 66–75.

—— (1991), 'Scenarios for Peripheral Cultures', in A.D. King (ed.) *Culture, Globalization and the World-System*, Basingstoke: Macmillan.

—— (1992) *Cultural Complexity*, New York: Columbia University Press.

Haraway, D. (1985) 'A Manifesto for Cyborgs: Science, Technology, and Socialist Feminism in the 1980s', *Socialist Review* 15(80): 65– 107.

—— (1988) 'Situated Knowledges: The Science Question in Feminism and the Privilege of Partial Perspective', *Feminist Studies* 14(3): 575–99.

Hardt, H. (1989) 'The Return of the "Critical" and the Challenge of Radical Dissent: Critical Theory, Cultural Studies, and American Mass Communication Research', in J. Anderson (ed.) *Communication Yearbook* 12, Newbury Park, CA: Sage.

Harvey, D. (1989) *The Condition of Postmodernity*, Oxford: Basil Blackwell.

Hayles, N. K. (1990) *Chaos Bound: Orderly Disorder in contemporary Literature and Science*, Ithaca, NY: Cornell University Press.

Heath, S. and Skirrow, G. (1977) 'Television: A World of Action', *Screen* 18(2): 7–61.

Hebdige, D. (1979) *Subculture: The Meaning of Style*, London: Methuen.

—— (1988) *Hiding in the Light*, Comedia/London: Routledge.

Henriques, J., Hollway, W., Urwin, C., Venn, C. and Walkerdine, V. (1984) *Changing the Subject*, London/New York: Methuen.

Hermes, J. (1995) *Reading Women's Magazines*, Cambridge: Polity Press.

Herzog, M. H. (1987) 'Decoding *Dallas*: Comparing American and German Viewers', in A. A. Berger (ed.) *Television in Society*, New Brunswick, NJ: Transaction Books.

Higgins, J. (1986) 'Raymond Williams and the Problem of Ideology', in J. Arac (ed.) *Postmodernism and Politics*, Minneapolis: University of Minnesota Press.

Hobsbawm, E. (1990) *Nations and Nationalism since 1780*, Cambridge: Cambridge University Press.

Hobson, D. (1980) 'Housewives and the Mass Media', in S. Hall, D. Hobson, A. Lowe and P. Willis (eds) *Culture, Media, Language*, London: Hutchinson.

—— (1982) *Crossroads: The Drama of a Soap Opera*, London: Methuen.

Hollway, W. (1989) *Subjectivity and Method in Psychology*, London: Sage.

Huff, R. (1990) 'New Nielsen Study Boosts Numbers', *Variety* 26 November.

Innis, H. (1951) *The Bias of Communication*, Toronto: University of Toronto Press.

Jacka, E. (ed.) (1992) *Continental Shift: Globalisation and Culture*, Double Bay, NSW: Local Consumption Publications.

Jameson, F. (1991) *Postmodernism, or the Cultural Logic of Late Capitalism*, London: Verso.

Jenkins, H. (1992) *Textual Poachers: Television Fans and Participatory Culture*, New York: Routledge.

Jensen, K.B. (1986) *Making Sense of the News*, Århus: University of Århus Press.

—— (1987) 'Qualitative Audience Research: Towards an Integrative Approach to Reception', *Critical Studies in Mass Communication* 4: 21–36.

Jensen, K.B. and Rosengren, K.E. (1990) 'Five Traditions in Search of the Audience', *European Journal of Communication* 5(2–3): 207–38.

Jhally, S. and Lewis, J. (1992) *Enlightened Racism: The Cosby Show, Audiences and the Myth of the American Dream*, Boulder, CO: Westview Press.

Journal of Communication (1983) 'Ferment in the Field', 33(3).

Jungman, W. (1975) 'TROS wint op alle fronten', *Het Parool* 16 December.

Kaplan, C. (1986) 'The Thornbirds: Fiction, Fantasy, Femininity', in V. Burgin, J. Donald and C. Kaplan (eds) *Formations of Fantasy*, London/New York: Methuen.

Katz, E. and Liebes, T. (1985) 'Mutual Aid in the Decoding of *Dallas*: Preliminary Notes from a Cross-Cultural Study', in P. Drummond and R. Paterson (eds) *Television in Transition*, London: BFI.

Kaufman, M. (ed.) (1987) *Beyond Patriarchy: Essays by Men on Pleasure, Power and Change*, Toronto/New York: Oxford University Press.

Kelsey, T. (1990) 'The Earth Moves for the Ratings Industry', *The Independent on Sunday* 18 February.

Kolar-Panov, D. (1994) 'Ethnic Cleansing, Plastic Bags and Throwaway People', *Continuum: The Australian Journal of Media and Culture*, 8(2): 159–87.

Kuhn, A. (1982) *Women's Pictures: Feminism and Cinema*, London: Routledge & Kegan Paul.

—— (1984) 'Women's Genres', *Screen* 25(1):18–29.

Laclau, E. (1991) *New Reflections on the Revolution of Our Time*, London: Verso.

Laclau, E. and Mouffe, C. (1985) *Hegemony and Socialist Strategy*, London: Verso.

Lash, S. and Urry, J. (1987) *The End of Organized Capitalism*, Cambridge: Polity Press.

—— (1994) *Economies of Signs and Space*, London: Sage.

Lee, P.S.N. (1991) 'The Absorption and Indigenisation of Foreign Media Culture – A study on a Cultural Meeting Point of the East and West: Hong Kong', *Asian Journal of Communication* 1(2): 52–72.

Levy, M.R. and Windahl, S. (1984) 'Audience Activity and Gratifications: A Conceptual Clarification and Exploration', *Communication Research* 11: 51–78.

—— (1986) 'The Concept of Audience Activity', in K.E. Rosengren, L. Wenner and P. Palmgreen (eds) *Media Gratifications Research*, Beverly Hills: Sage.

Lewis, J. (1991) *The Ideological Octopus*, New York: Routledge..

Lewis, L. A. (1990) *Gender, Politics and MTV: Voicing the Difference*, Philadelphia: Temple University Press.

Liebes, T. (1986) 'On the Convergence of Theories of Mass Communication and Literature Regarding the Role of the Reader', paper presented to the Sixth International Conference on Culture and Communication, October.

Liebes, T. and Katz, E. (1986) 'Patterns of Involvement in Television Fiction: A Comparative Analysis', *European Journal of Communication* 1: 151–71.

—— (1990) *The Export of Meaning: Cross-Cultural Readings of Dallas*, New York: Oxford University Press.

Light, A. (1984) 'Returning to *Manderley*: Romantic Fiction, Female Sexuality and Class', *Feminist Review* 16 (Summer): 7–25.

Lindlof, T.R. (ed.) (1987) *Natural Audiences*, Norwood, NJ: Ablex.

Lindlof, T.R. and Meyer, T.P. (1987) 'Mediated Communication as Ways of Seeing, Acting, and Constructing Culture: The Tools and Foundations of Qualitative Research', in T.R. Lindlof (ed.) *Natural Audiences*, Norwood, NJ: Ablex Publishing Company.

Livingston, V. (1986) 'Statistical Skirmish: Nielsen Cable Stats Vex Cable Net Execs', *Television/Radio Age* 17 March.

Livingstone, S.M. (1991) 'Audience Reception: The Role of the Viewer in Retelling Romantic Drama', in J. Curran and M. Gurevitch (eds) *Mass Media and Society*, London/New York: Edward Arnold.

Lull, J. (1980) 'The Social Uses of Television', *Human Communication Research* 6(3): 198–209.

—— (1986) 'The Naturalistic Study of Media Use and Youth Culture', in K.E. Rosengren, L.A. Wenner and P. Palmgreen (eds) *Media Gratifications Research: Current Perspectives*, Beverly Hills, CA: Sage.

—— (ed.) (1988) *World Families Watch Television*, Newbury Park, CA: Sage.

Lyotard, J.-F. (1984) *The Postmodern Condition: A Report on Knowledge*, trans. G. Bennington and B. Massumi, Minneapolis: University of Minnesota Press.

McGuigan, J. (1992) *Cultural Populism*, London: Routledge.

McNeely, C. and Soysal, Y. N. (1989) 'International Flows of Television Programming: A Revisionist Research Orientation', *Public Culture* 2(1): 136–44.

McQuail, D. (1994) *Mass Communication Theory*, 4th edn., London: Sage.

McRobbie, A. (1982) 'The Politics of Feminist Research: Between Talk, Text and Action', *Feminist Review* 12 (October): 46–57.

—— (1985) 'Dance and Social Fantasy', in A. McRobbie and M. Nava (eds) *Gender and Generation*, London: Macmillan.

—— (1994) *Postmodernism and Popular Culture*, London/New York: Routledge.

Marcus, G.E. (1986) 'Contemporary Problems of Ethnography in the Modern World System', in J. Clifford and G.E. Marcus (eds) *Writing Culture The Poetics and Politics of Ethnography*, Berkeley/Los Angeles/London: University of California Press.

—— (1992) 'Past, Present and Emergent Identities: Requirements for Ethnographies of Late Twentieth-Century Modernity Worldwide', in S. Lash and J. Friedman (eds) *Modernity and Identity*, Oxford: Basil Blackwell.

Marcus, G.E. and Fischer, M.M.J. (1986) *Anthropology as Cultural Critique*, Chicago/London: University of Chicago Press.

Marcuse, H. (1964) *One-Dimensional Man*, Boston: Beacon Press.

Marlowe, H. (1946) 'What does the Tele Audience Want?', *The Televiser* Jan./Feb.

Martín-Barbero, J. (1988) 'Communication from Culture: The Crisis of the National and the Emergence of the Popular', *Media, Culture and Society* 10(4): 447–65.

—— (1993) *Communication, Culture and Hegemony*, trans. E. Fox and R.A. White, London: Sage.

Mattelart, M. and Matterlart, A. (1990) *The Carnival of Images*, trans. D. Buxton, New York: Bergin and Garvey.

Meehan, E. (1984) 'Ratings and the Institutional Approach: A Third Answer to the Commodity Question', *Critical Studies in Mass Communication* 1(2): 216–25.

Metz, C. (1975) 'The Imaginary Signifier', *Screen* 16(2): 14–76.

Michaels, E. (1994) 'Hollywood Iconography: A Warlpiri Reading' [1987], in his *Bad Aboriginal Art*, Minneapolis: University of Minnesota Press.

Miller, D. (1992) 'The Young and Restless in Trinidad: A Case of the Local and the Global in Mass Consumption', in R. Silverstone and E. Hirsch (eds) Consuming Technologies, London: Routledge.

Mills, C. W. (1970) The Sociological Imagination, Harmondsworth: Penguin.

Modleski, T. (1982) Loving with a Vengeance: Mass Produced Fantasies for Women, London: Methuen.

—— (1986) 'Introduction', in T. Modleski (ed.) Studies in Entertainment: Critical Approaches to Mass Culture, Bloomington/Indianapolis: Indiana University Press.

Moi, T. (1985) Sexual/Textual Politics, London: Methuen.

Moores, S. (1993) Interpreting Audiences, London: Sage.

Morley, D. (1980a) The 'Nationwide' Audience: Structure and Decoding, London: BFI.

—— (1980b) 'Texts, Readers, Subjects', in S. Hall, D. Hobson, A. Lowe and P. Willis (eds) Culture, Media, Language, London: Hutchinson.

—— (1981) '"The Nationwide Audience" – A Critical Postscript', Screen Education 39 (Summer): 3–14.

—— (1983) 'Cultural Transformations: The Politics of Resistance', in H. Davies and P. Walton (eds) Language, Image, Media, Oxford: Basil Blackwell.

—— (1986) Family Television: Cultural Power and Domestic Leisure, London: Comedia/Routledge.

—— (1992) Television, Audiences and Cultural Studies, London: Routledge.

Morley, D. and Robins, K. (1989) 'Spaces of Identity: Communications, Technologies and the Reconfiguration of Europe', Screen 30(4): 10–34.

Morley, D. and Silverstone, R. (1990) 'Domestic Communications: Technologies and Meanings', Media, Culture and Society 12(1): 31–55.

Morris, M. (1988a) 'Banality in Cultural Studies', Block 14: 15–25; reprinted in P. Mellencamp (ed.) Logics of Television: Essays in Cultural Criticism, Bloomington: Indiana University Press, 1990.

—— (1988b) 'Things To Do With Shopping Centres', in S. Sheridan (ed.) Grafts, London: Verso.

—— (1992) 'On the Beach', in L. Grossberg, C. Nelson and P. Treichler (eds) Cultural Studies, New York/London: Routledge.

Mulvey, L. (1975) 'Visual Pleasure and Narrative Cinema', Screen 16(3): 6–18.

—— (1978) 'Notes on Sirk and Melodrama', Movie 25: 53–7.

—— (1990) 'Afterthoughts on "Visual Pleasure and Narrative Cinema" inspired by Duel in the Sun', in T. Bennett (ed.) Popular Fiction: Technology, Ideology, Production, Reading, London/ New York: Routledge.

Naficy, H. (1993) The Making of Exile Cultures: Iranian Television in Los Angeles, Minneapolis: University of Minnesota Press.

Newcomb, H. (1974) TV: The Most Popular Art, New York: Anchor Books.

Nicholson, L. J. (ed.) (1990) Feminism/Postmodernism, New York/London: Routledge.

Nightingale, V. (1986) 'What's Happening to Audience Research?', Media Information Australia 39 (February): 21–2.

—— (1990) 'Women as Audiences', in M. E. Brown (ed.) Television and Women's Culture: The Politics of the Popular, London: Sage.

Olsen, S. R. (1987) 'Meta-television: Popular Postmodernism', Critical Studies in Mass Communication 4: 284–300.

Poster, M. (1988) 'Introduction', in J. Baudrillard, Selected Writings, ed. M. Poster, Stanford, CA: Stanford University Press.

Potter, J. and Wetherell, M. (1987) Discourse and Social Psychology: Beyond Attitudes and Behaviour, London: Sage

Poynton, B. and Hartley, J. (1990) 'Male-Gazing: Australian Rules Football, Gender

and Television', in M.E. Brown (ed.) *Television and Women's Culture: The Politics of the Popular*, London: Sage.

Pratt, M.L. (1986) 'Interpretive Strategies/Strategic Interpretations: On Anglo-American Reader-Response Criticism', in J. Arac (ed.) *Postmodernism and Politics*, Minneapolis: University of Minnesota Press.

Press, A.L. (1990) 'Class, Gender and the Female Viewer: Women's Responses to Dynasty', in M.E. Brown (ed.) *Television and Women's Culture: The Politics of the Popular*, London: Sage.

Pribram, E.D. (ed.) (1988) *Female Spectators: Looking at Film and Television*, London/New York: Verso.

Rabinow, P. (1977) *Reflections on Fieldwork in Morocco*, Berkeley/Los Angeles/London: University of California Press.

—— (1986) 'Representations Are Social Facts: Modernity and Post-Modernity in Anthropology', in J. Clifford and G.E. Marcus (eds) *Writing Culture: The Poetics and Politics of Ethnography*, Berkeley/Los Angeles/London: University of California Press.

Rabinow, P. and Sullivan, W.M. (eds) (1979) *Interpretive Social Science*, Berkeley/Los Angeles/London: University of California Press.

Radway, J. (1984) *Reading the Romance: Women, Patriarchy, and Popular Literature*, Chapell Hill: University of North Carolina Press.

—— (1986) 'Identifying Ideological Seams: Mass Culture, Analytical Method, and Political Practice', *Communication* 9: 93–123.

—— (1988) 'Reception Study: Ethnography and the Problems of Dispersed Audiences and Nomadic subjects', *Cultural Studies* 2(3): 359–76.

Rakow, L.F. (1986) 'Feminist Approaches to Popular Culture: Giving Patriarchy Its Due', *Communication* 9: 19–41.

—— (1988) 'Women and the Telephone: The Gendering of a Communications Technology', in C. Kramarae (ed.) *Technology and Women's Voices*, London: Routledge.

Richardson, L. (1990) 'Narrative and Sociology', *Journal of Contemporary Sociology*, 19(1): 116–35.

Riley, D. (1988) *'Am I That Name?' Feminism and the Category of 'Women' in History*, Basingstoke/London: Macmillan.

Robertson, R. (1990) 'Mapping the Global Condition: Globalization as the Central Concept', in M. Featherstone (ed.) *Global Culture*, London: Sage.

Robins, K. (1989) 'Reimagined Communities? European Image Spaces, Beyond Fordism', *Cultural Studies* 3(2):145–65.

Rogers, E. M. (1962) *The Diffusion of Innovations*, Glencoe, IL.: Free Press.

—— (1976) 'Communication and Development: The Passing of a Dominant Paradigm', *Communications Research* 3: 213–40.

Rorty, R. (1989) *Contingency, Irony, and Solidarity*, Cambridge: Cambridge University Press.

Rosengren, K.E. (1983) 'Communication Research: One Paradigm, or Four?', *Journal of Communication* 33: 185–207

—— (1988) *The Study of Media Culture: Ideas, Actions, and Artefact*, Lund Research Papers in the Sociology of Communication, Report No 10. Lund: University of Lund.

Rosenthal, E.M. (1987) 'VCRs Having More Impact on Network Viewing, Negotiation', *Television/Radio Age* 25 May.

Ross, A. (ed.) (1988) *Universal Abandon? The Politics of Postmodernism*, Minneapolis: University of Minnesota Press.

—— (1989) *No Respect: Intellectuals and Popular Culture*, New York/London: Routledge.

Rowland, W. (1983) *The Politics of TV Violence*, Beverly Hills, CA: Sage.

Said, E. (1978) *Orientalism*, New York: Pantheon Books.

San Francisco Chronicle (1989) 'New "People Meter" Device Spies on TV Ratings Families', 1 June.

Schaafsma, H. (1965) *Beeldperspectieven*, Amsterdam: Het Wereldvensder.

Schlesinger, P. (1987) 'On National Identity: Some Conceptions and Misconceptions Criticized', *Social Science Information* 26(2): 219– 64.

—— (1991) *Media, State and Nation*, London: Sage.

Schrøder, K.C. (1987) 'Convergence of Antagonistic Traditions? The Case of Audience Research', *European Journal of Communication* 2(1): 7–31.

—— (1988) 'The Pleasure of *Dynasty*: The Weekly Reconstruction of Self-Confidence', in P. Drummond and R. Paterson (eds) *Television and Its Audience*, London: BFI.

Schudson, M. (1987) 'The New Validation of Popular Culture: Sense and Sentimentality in Academia', *Critical Studies in Mass Communication* 4(1): 51–68.

Scott, J.C. (1985) *Weapons of the Weak: Everyday Forms of Peasant Resistance*, New Haven/London: Yale University Press.

Scott, J.W. (1988) 'Deconstructing Equality-Versus-Difference: Or, the Uses of Poststructuralist Theory for Feminism', *Feminist Studies* 14(1): 33–50.

Seidler, V.J. (1989) *Rediscovering Masculinity: Reason, Language and Sexuality*, London: Routledge.

Seiter, E., Borchers, H., Kreutzner, G. and Warth, E.M. (1989) '"Don't Treat Us Like We're So Stupid and Naive": Towards an Ethnography of Soap Opera Viewers', in E. Seiter, H. Borchers, G. Kreutzner and E.M. Warth (eds) *Remote Control: Television, Audiences, and Cultural Power*, London/New York: Routledge.

Sepstrup, P. (1986) 'The Electronic Dilemma of Television Advertising', *European Journal of Communication* 1(4): 383–405.

Sharpe, S. (1976) *'Just Like a Girl': How Girls Learn to be Women*, Harmondsworth: Penguin.

Silj, A. (1988) *East of Dallas: The European Challenge to American Television*, London: BFI.

Silverstone, R. (1990) 'Television and Everyday Life: Towards an Anthropology of the Television Audience', in M. Ferguson (ed.) *Public Communication: The New Imperatives*, London: Sage.

—— (1994) *Television and Everyday Life*, London: Sage.

Slack, J.D and Allor, M. (1983) 'The Political and Epistemological Constituents of Critical Communication Research', *Journal of Communication* 33(3): 208–18

Smart, B. (1993) *Postmodernity*, London: Routledge.

Smiers, J. (1977) *Cultuurpolitiek in Netherland: 1945–1955*, Nijmegen: SUN.

Smythe, D. (1981) *Dependency Road*, Norwood, NJ: Ablex.

Spigel, L. (1985) 'Detours in the Search for Tomorrow', *Camera Obscura* 13/14 215–34.

—— (1988) 'Installing the Television Set: Popular Discourses on Television and Domestic Space; 1948–1955', *Camera Obscura* 16: 11–48.

—— (1992) *Make Room for TV: Television and the Family Ideal and Post-War America*, Chicago: University of Chicago Press.

Spitulnik, D. (1993) 'Anthropology and Mass Media', *Annual Review of Anthropology* 22: 293–315.

Stacey, J. (1994) *Star Gazing: Hollywood Cinema and Female Spectatorship*, London: Routledge.

Stern, L. (1982) 'The Body as Evidence', *Screen* 23(5): 38–60.

Strathern, M. (1987) 'Out of Context: The Persuasive Fictions of Anthropology', *Current Anthropology* 28(3): 251–81

Stratton, J. (1990) *Writing Sites: A Genealogy of the Postmodern World*, Hemel Hempstead: Harvester Wheatsheaf.

Stratton, J. and Ang, I. (1994) '*Sylvania Waters* and the Spectacular Exploding Family', *Screen* 35(1): 1–21.

—— (1995) 'On the Impossibility of a Global Cultural Studies', in D. Morley and K.H. Chen (eds) *Stuart Hall: Critical Dialogues in Cultural Studies*, London: Routledge.

Streeter, T. (1984) 'An Alternative Approach to Television Research: Developments in British Cultural Studies in Birmingham', in W.D. Rowland Jr and B. Watkins (eds) *Interpreting Television*, Beverly Hills, CA: Sage.

Stuart, A. (1988) '*The Color Purple*: In Defence of Happy Endings', in L. Gamman and M. Marshment (eds) *The Female Gaze: Women as Viewers of Popular Culture*, London: Women's Press.

Tobin, J.J. (1992) 'Introduction: Domesticating the West', in J.J. Tobin (ed.) *Re-Made in Japan: Everyday Life and Consumer Taste in a Changing Society*, New Haven/London: Yale University Press.

Tomlinson, J. (1991) *Cultural Imperialism*, London: Pinter Publishers.

Tompkins, J.P. (ed.) (1980) *Reader Response Criticism: From Formalism to Post-Structuralism*, Baltimore: Johns Hopkins University Press.

Tuchman, G. (1978) 'Introduction: The Symbolic Annihilation of Women by the Mass Media', in G. Tuchman, K. Daniels and J. Benet (eds) *Hearth and Home: Images of Women in the Mass Media*, New York: Oxford University Press.

Tuchman, G., Daniels, A.K. and Benet, J. (eds) (1978) *Hearth and Home: Images of Women in the Mass Media*, New York: Oxford University Press.

Tunstall, J. (1977) *The Media are American*, London: Constable.

Turkle, S. (1988) 'Computational Reticence: Why Women Fear the Intimate Machine', in C. Kramarae (ed.) *Technology and Women's Voices*, London: Routledge.

TV World (1987) 'The US is Watching', September.

Tyler, S. (1987) *The Unspeakable: Discourse, Dialogue and Rhetoric in the Postmodern World*, Madison: University of Wisconsin Press.

van Maanen, J. (1988) *Tales of the Field*, Chicago/London: University of Chicago Press.

van Zoonen, L. (1991) 'Feminist Perspectives on the Media', in J. Curran and M. Gurevitch (eds) *Mass Media and Society*, London/ New York: Edward Arnold.

Vink, N. (1988) *The Telenovela and Emancipation*, Amsterdam: Royal Tropical Institute.

Wagner, R. (1981) *The Invention of Culture*, Chicago: University of Chicago Press (revised and expanded edition)

Walkerdine, V. (1983) 'Some Day My Prince Will Come: Young Girls and the Preparation for Adolescent Sexuality', in A. McRobbie and M. Nava (eds) *Gender and Generation*, London: Macmillan.

—— (1986) 'Video Replay: Families, Films and Fantasy', in V. Burgin, J. Donald and C. Kaplan (eds) *Formations of Fantasy*, London/New York: Methuen.

Wallerstein, I. (1991) *Geopolitics and Geoculture*, Cambridge: Cambridge University Press.

Wark, M. (1994) *Virtual Geographies: Living with Global Media Events*, Bloomington/Indianapolis: Indiana University Press.

Weedon, C. (1987) *Feminist Practice and Poststructuralist Theory*, Oxford: Basil Blackwell.

Wigbold, H. (1979) 'The Netherlands: The Shaky Pillars of Hilversum', in A. Smith

(ed.) *Television and Political Life: Studies in Six European Countries*, London: Macmillan.

Williams, R. (1974) *Television: Technology and Cultural Form*, London: Fontana.

—— (1977) *Marxism and Literature*, Oxford: Oxford University Press.

Willis, P. (1977) *Learning to Labour*, London: Saxon House.

—— (1980) 'Notes on Method', in S. Hall, D. Hobson, A. Lowe and P. Willis (eds) *Culture, Media, Language*, London: Hutchinson.

Wilson, E. (1986) 'Forbidden Love', in E. Wilson (with A. Weir), *Hidden Agendas*, London/New York: Tavistock.

Wren-Lewis, J. (1983) 'The Encoding/Decoding Model: Criticisms and Redevelopments for Research on Decoding', *Media, Culture and Society* 5(2): 179–97.

Index

ABG 54
Aborigines 158–9
Abu-Lughold, Lila 79–80, 81, 185*n*
Addison, David (*Moonlighting*) 85
address: direct 23, 25; modes of
 27, 30–1, 32, 182*n*
Adorno, Theodor 182*n*
advertising 154, 177
AIDS virus 162
Alexis (*Dynasty*) 97
Allen, Robert C. 112
Allor, Martin *see* Slack, Jennifer, and
 Allor, Martin
Althusser, Louis 170
Amanda (*Melrose Place*) 97
Americocentrism 141, 148, 152, 155,
 160–1, 165; *see also* United States of
 America
Amsterdam, University of 151, 161
Ang, Ien: *Desperately Seeking the
 Audience* 3, 173; *Watching Dallas*
 3, 7, 86, 135
anthropology 75, 77
Aquino, Cory 146
Arbitron 54, 62
Asad, Talal 76, 78
Asia, Eastern 13
Asia, Southeast 148
audience: active 9–13, 39, 40–2, 46,
 139–40, 183*n*; categorization of 77;
 creativity 114; as cultural hero 8;
 demarcation of 68, 72, 126, 172–3;
 detecting behaviour of 59–60, 62;
 fragmentation 67; as ideal
 consumers 55, 64; as meaning
 maker 11, 136, 139, 178–9;
 measurement techniques 54–64, 71,
 173, 174, 175, 178, 179; as object

of study 43, 67; and power 170–2,
 178–9; research *see* mass media
 research; social 112; specific 11, 12;
 strategies for attracting 23–4;
 targeting of 10–11, 59, 77, 80, 118;
 transnationalization of 81; *see also*
 television
Australia 134, 158–9, 161
authenticity 141, 153, 154–5,
 160, 161
authorship, burden of 76, 78
AVRO 28, 29

bacchanal 160
Baudrillard, Jean 54, 167
Bauman, Zygmunt 9, 178
Bausinger, Hermann 109–10, 126
Bechtel, Robert, *et al.* 61, 184*n*, 185*n*
Bedell Smith, S. 60
Berland, Jody 12, 14, 15
Berlin Wall 150
Berlusconi, Silvio 142
Berman, Marshall 156, 157
Bertelsmann 142
Birmingham Centre for Contemporary
 Cultural Studies 37, 104, 134, 182*n*
Blumler, Jay, Gurevitch, Michael and
 Katz, Elihu 39–40
Bordo, Susan 125
Bosnia 150
Bourdieu, Pierre 116
Britain, cultural studies in 141
Broadcasting Act (Netherlands), 1967
 27, 28
Brooks, Peter 87
Brunsdon, Charlotte 20, 49–50, 51,
 187*n*
Bush, George 177